WE PROTEST

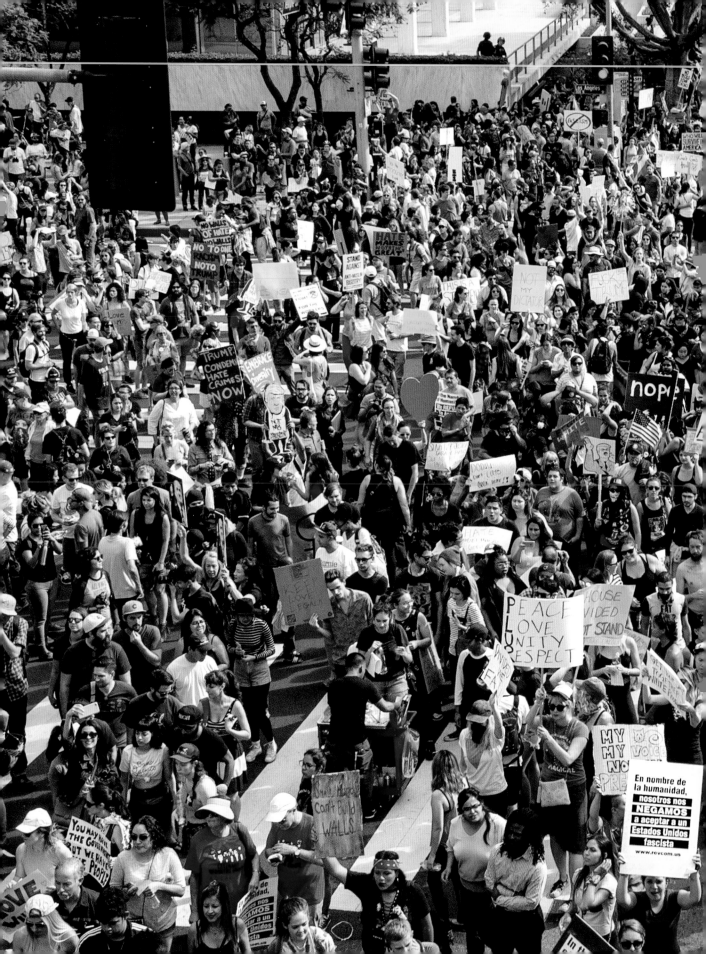

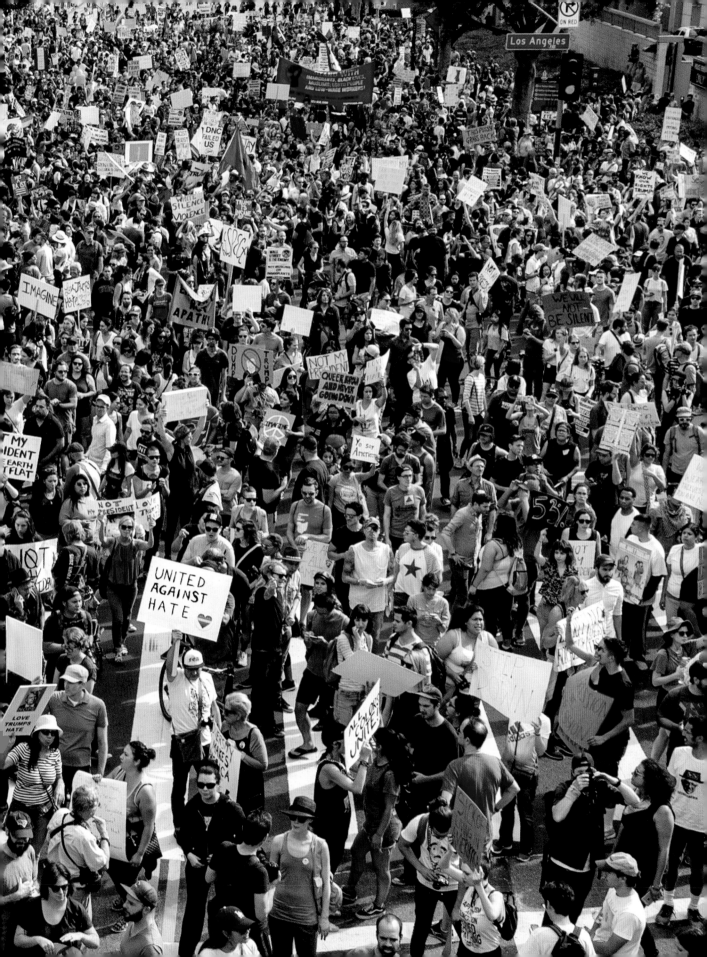

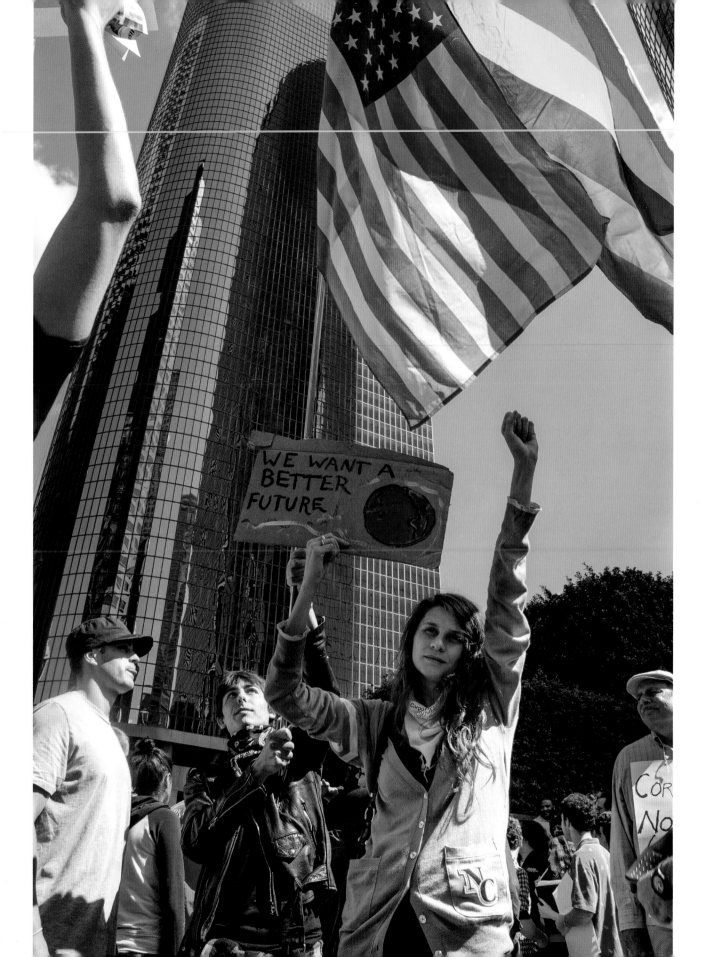

TISH LAMPERT

WE PROTEST

FIGHTING FOR WHAT WE BELIEVE IN

RIZZOLI
NEW YORK

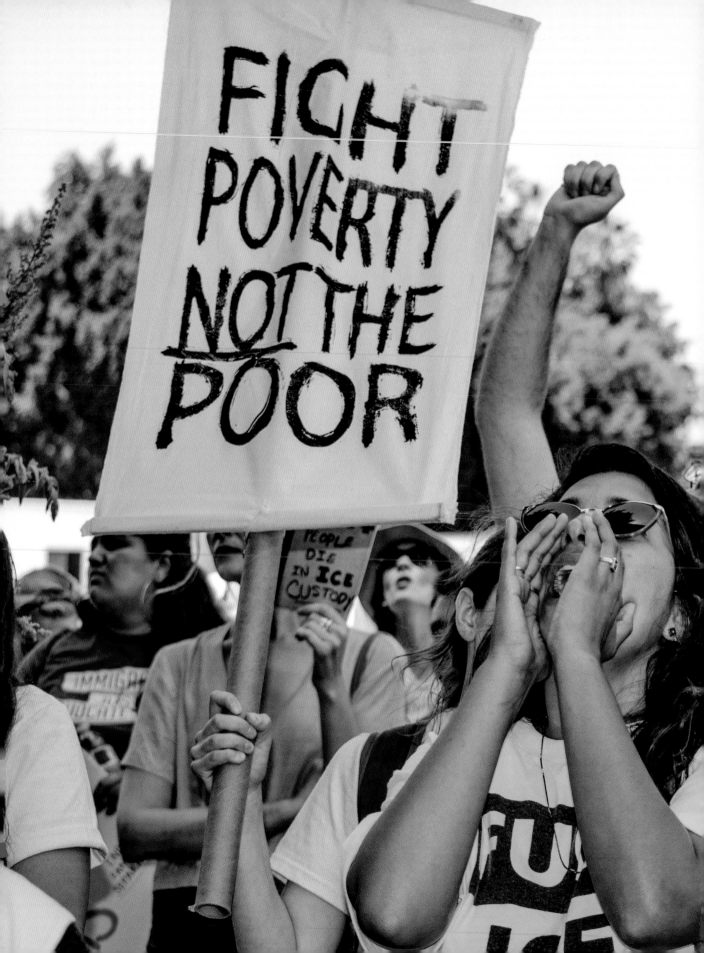

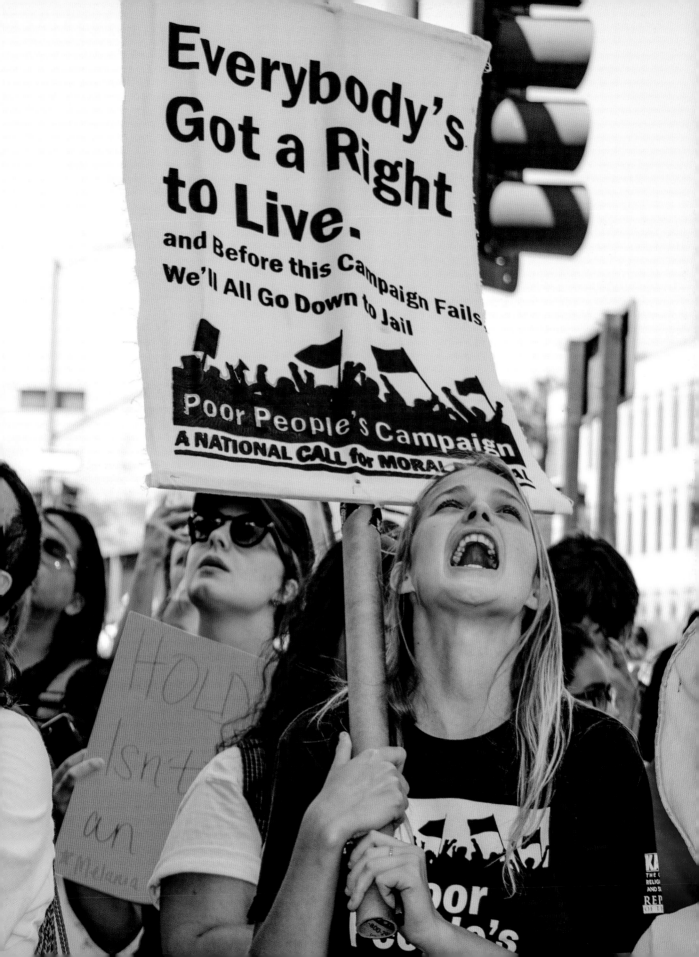

COVER · Family Separation Rally, Los Angeles, 2018
OPENING SPREAD · Not My President Rally, Los Angeles, 2016
OPPOSITE TITLE PAGE · Protest against Citizens United, Los Angeles, 2015
PREVIOUS SPREAD · Family Separation Rally, Metropolitan Detention Center, Los Angeles, 2018
OPPOSITE · May Day March, Los Angeles, 2018
FOLLOWING SPREAD · Women's March, Washington, DC, 2017

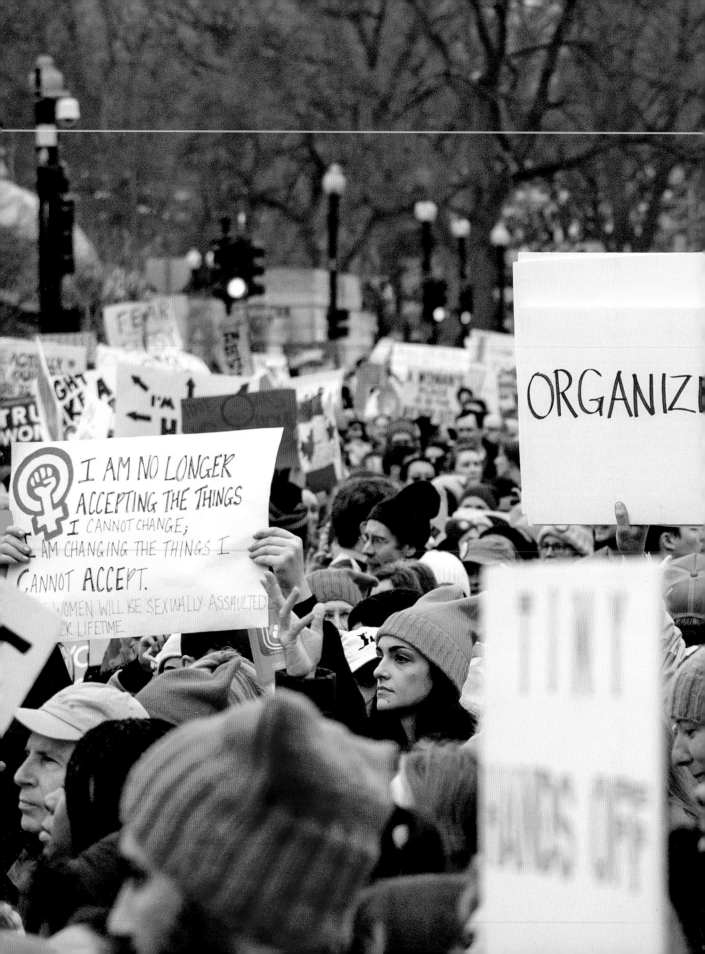

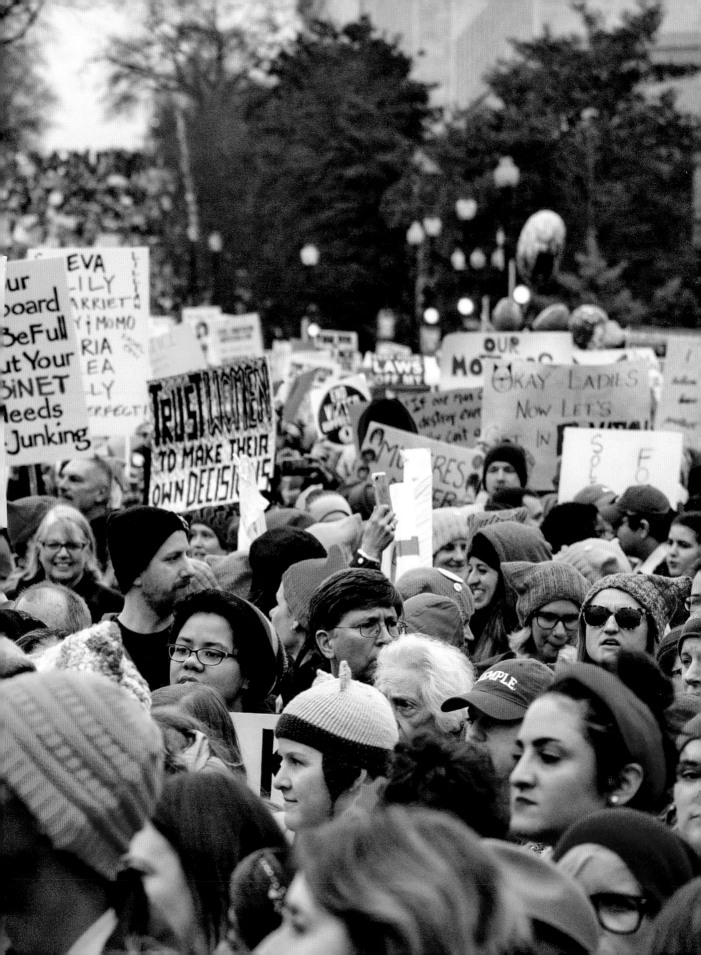

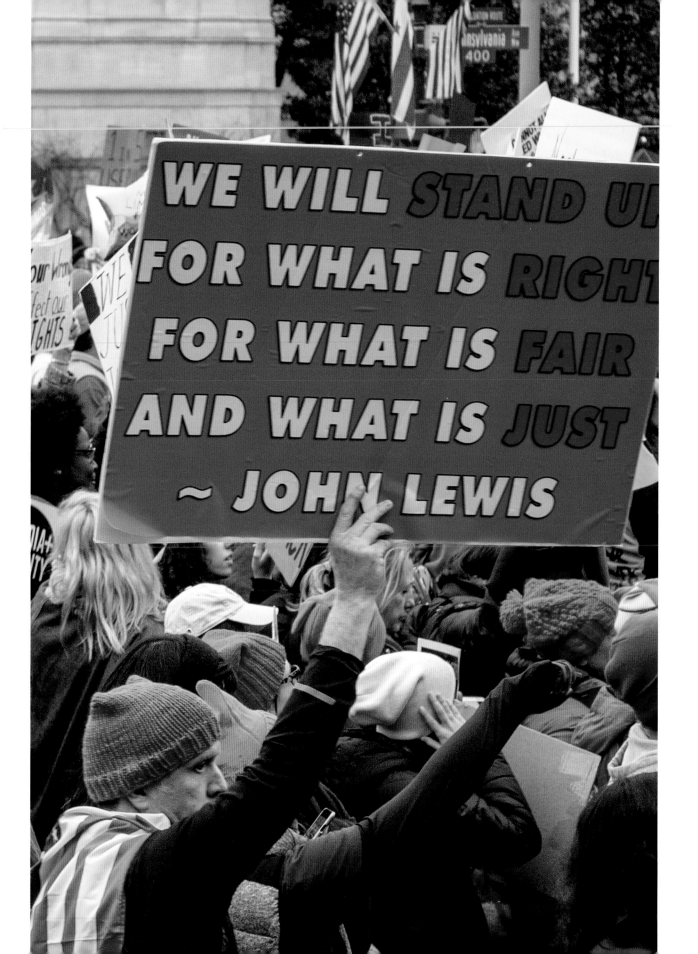

FOREWORD

The faces of America are in these pages. They are not joyful. Even the occasional thin smile has the sour taste of sorrow. Yet the rage, the stiff determination in the eyes, the lips tight in commitment, the mouths wide in some chant of defiance and hope—all combine in a pageant of inspiration.

There are placards, too, with words of anger and pain, deft slogans of stiletto wit and clever contempt. But even without the words we would have the faces. And the faces tell the story of America, not an America lost but an America found again by its great array of women and men who are white, black, and brown, their faces creased with age and unblemished with youth, citizens and immigrants, wounded and secure, comfortable and vulnerable, privileged and pained. They display seasoned values and impatient idealism. They call for rectitude. They demand—demand!—that we see in them the country's striving for moral justice.

The freedom to protest is enshrined in the First Amendment to the Constitution, but its seeds were planted nearly six centuries earlier in the Magna Carta, which codified the right of specific nobles to petition the king. That right, later extended by Parliament to every British citizen, became part of a deep heritage of liberty that has nourished the roots of the American idea.

The American Revolution was launched not only in opposition to British rule, but also in outrage that the Colonies were being denied the rights safeguarded by English law. Rebellion on that count was a backhanded compliment to England, you could say, for not meeting its own standards. The Founders then drew from Britain's rich legal traditions, and in key areas the United States became heir to English common law. The right to demonstrate is one example.

It occupies the heart of democracy. Along with freedom of speech, the press, and religion, "the right of the people peaceably to assemble, and to petition the Government for a redress of grievances" may not be prohibited, the First Amendment declares. The right is inherent, not granted by government.

Not all street protests move officialdom, of course. But some have pushed the nation around a corner. The marches of the civil rights movement exposed the ugly cruelty of the segregationists, whose attacks on nonviolent demonstrators with fists, fire hoses, and police dogs mobilized the conscience of the country. At the massive 1963 March on Washington, Martin Luther King Jr. stirred the nation: "I have a dream." The widening protests against the war in Vietnam helped tip the balance in Washington toward withdrawal.

And now we have these images from the election of Donald Trump onward. They flow and merge, moving like a river of distress from grievance to grievance. Will they push us around a corner? We can't say.

But savor these pictures of America the beautiful. These faces will be a mark of pride when history looks back in judgment on this time.

—DAVID K. SHIPLER

Former *New York Times* Correspondent, Pulitzer Prize–Winning Author of Seven Books Including *Freedom of Speech: Mightier Than the Sword*

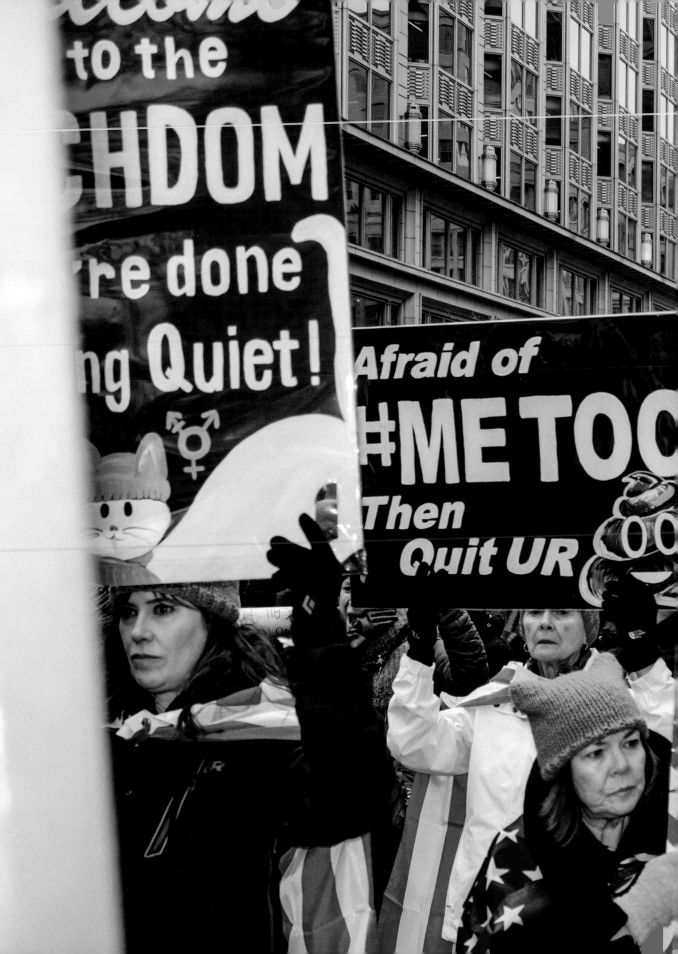

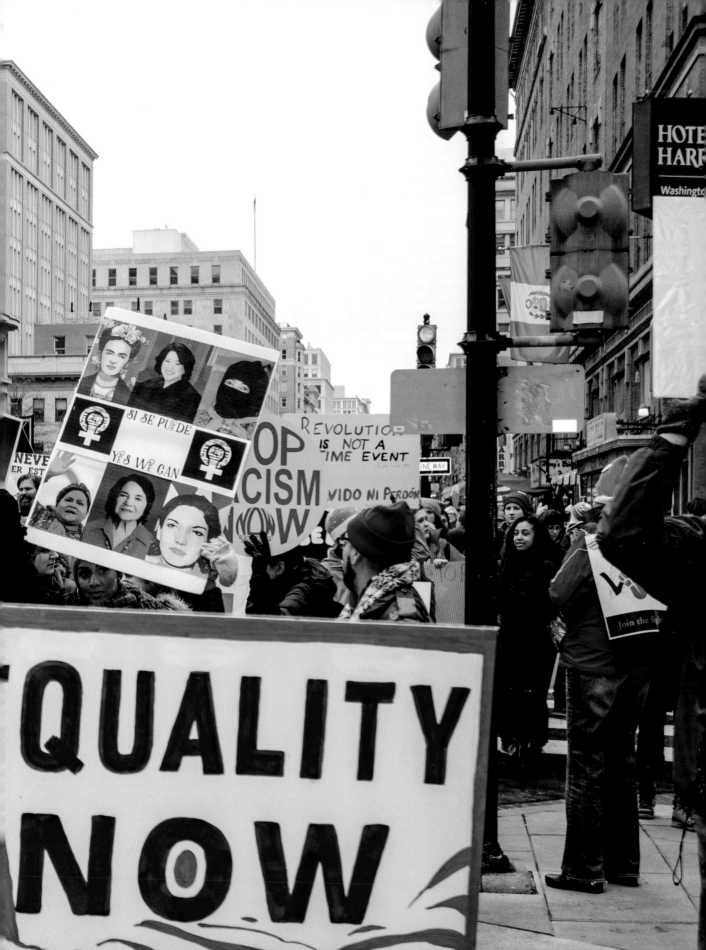

INTRODUCTION

When I see a crowd gather, placards waving, and hear the sound of feet pounding the pavement, voices rising over one another, I feel an irresistible urge to be among them—to follow the momentum and capture the spirit that compels people to rise up. The adrenaline is addictive. It's been in my blood since I first picked up a camera to march for civil rights. For two decades I've chronicled the defining social movements in America that have been catalysts for reform.

The election of Donald Trump to the presidency caused a wave of activism to wash across our nation and inspire unprecedented protest. When we look back on this turbulent period in American history, I hope we remember how it started. We came together in record-breaking numbers. We were outspoken and persistent. With the winds of resistance at our backs we linked arms and set out to defend our freedoms and one another. Trump's policies have affected every aspect of society. *We Protest* charts the core movements that have pushed back and driven change:

· Women and their families put aside their daily lives to travel to Washington. The landmark Women's March in 2017 attracted every demographic, demanding a broad range of protections beyond gender inequality. Their message was clear: our rights are not up for grabs.

· The assault on immigrants and undocumented youth struck at the core of our American identity. It woke up millennials and Gen Xers, who joined seasoned activists calling for humane solutions.

· In 2013 three young black women created #BlackLivesMatter to demand justice for the families whose boys were killed by police. Their platform, each black life matters, resonated around the world. Heroes from the civil rights era, like John Lewis and Harry Belafonte, have joined with Black Lives Matter to condemn mounting racism that is stirred up by hate groups and to mobilize for racial equality.

· The Parkland tragedy sparked groundbreaking participation by students across the United States to take an uncompromising stand on gun control. The network put in place by the Women's March gave the Parkland survivors the framework to mobilize March for Our Lives through social media.

Protest is a part of today's American culture. It is inspiring young people from coast to coast to understand their power and participate in elections. But our ultimate commitment will be how we face the greatest challenge—to protect our planet. As we look to the future, our common goal must be to unite together and insist on real action from leaders worldwide.

This book reminds us where we are and where we've been. It brings our evolving democracy into focus by framing history through the power of the printed image. My intent has been to find the individual narrative and offer a visual documentation that reflects a deeper human understanding of how and why we protest. Our strength as Americans lies in the transformative power of our individual and collective voices.

My camera and I continue to look for that iconic moment that will inspire our activism and to make personal our individual journey to protect the America we believe in.

—TISH LAMPERT

Photojournalist, Writer,
Host of *America Speaks* Podcast

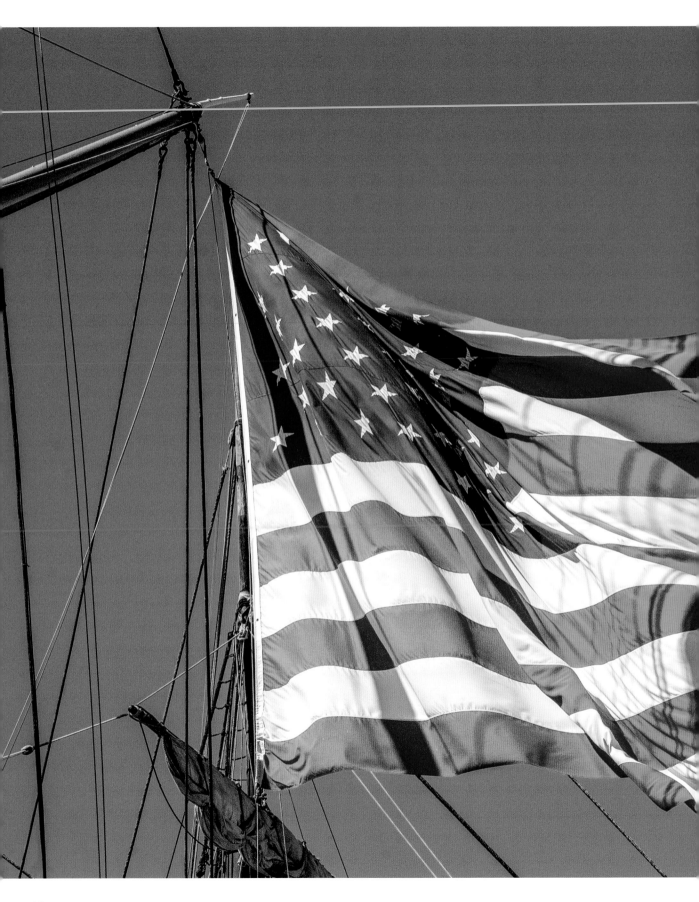

"The only way to get out the news, the truth, was to write it on a sign, to chant it in unison, to blast it through a bullhorn and thereby wake the sleeping citizenry. But protests—that photo in the paper without a story, that shout through the window—work in our nation's skull like a dream half-remembered, and the American empire spends its waking day discomfited and unquiet. The disturbance grows stronger and the marches grow longer. And fragile fingers join into a very powerful fist, the silenced majority turning into a mighty roar of Americans speaking."

—GREG PALAST

Author, Freelance Journalist, Filmmaker

San Diego Harbor, 2015
OPPOSITE FOREWORD & SPREAD FOLLOWING - Women's March, Washington, DC, 2019
OPPOSITE INTRODUCTION - Lampert's studio, Los Angeles, 2019
FOLLOWING SPREAD - Inaugural Parade Route, Washington, DC, 2017

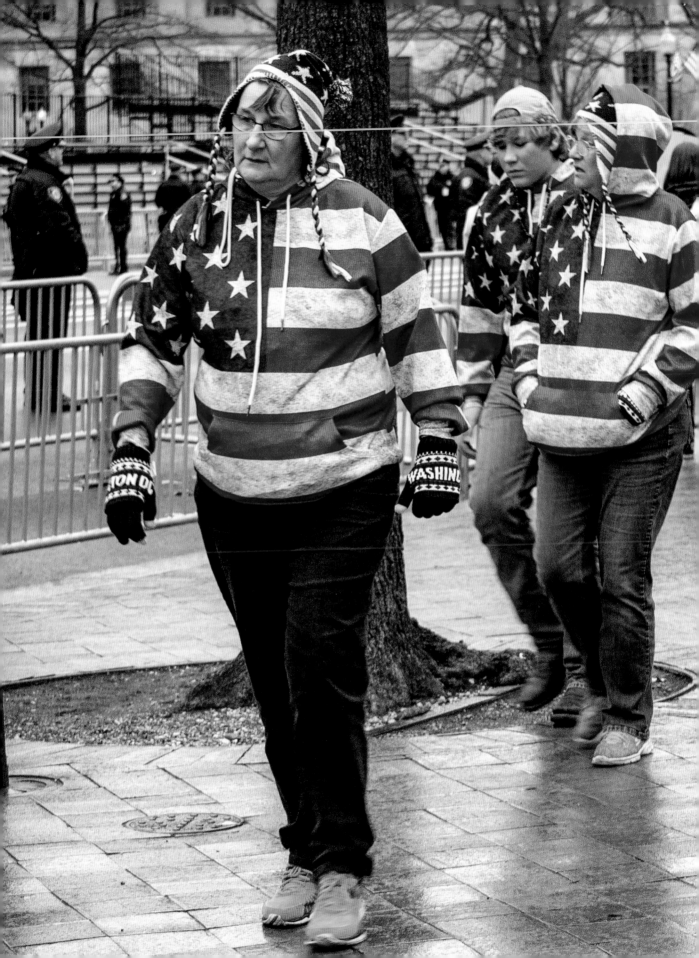

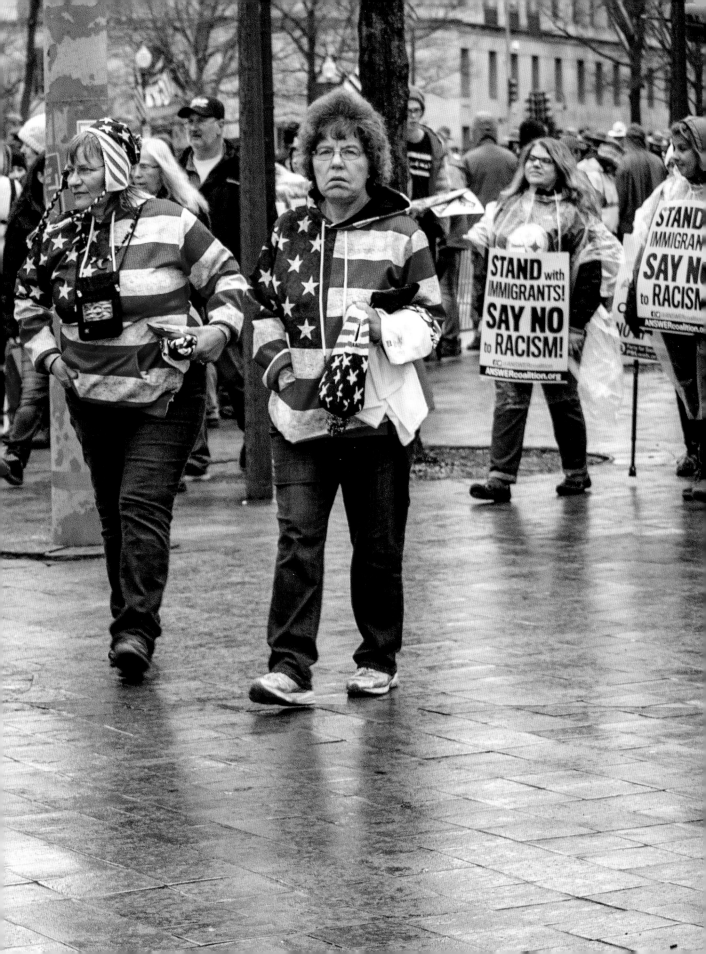

NOT MY PRESIDENT The election of Donald Trump stunned most Americans. Did the vote reflect the will of the people? Will the new commander in chief roll back the progressive agenda of his predecessor? And what will government look like during a Trump administration?

The day the forty-fifth president took the oath of office, the crowd huddled in a cold rain trying to make sense of what happened. We saw four hard years ahead of us. We would give up our weekends, stay close to the news, share information, and be vigilant. Democrats, Independents, and young people organized boot camps: how to protest, how to show up, how to make calls, how to go door-to-door. Social action platforms set up local chapters in towns across the country.

Los Angeles, a city known for progressive spirit, pushed back on Trump's threats on the undocumented community. Spontaneous demonstrations popped up. Signs read "Hate Makes Nothing Great," "Bigotry Is an Un-American Activity," and "Not My President." The resistance had come alive.

OPPOSITE & FOLLOWING SPREAD · Trump's Inauguration Protest, Navy Memorial, Washington, DC, 2017

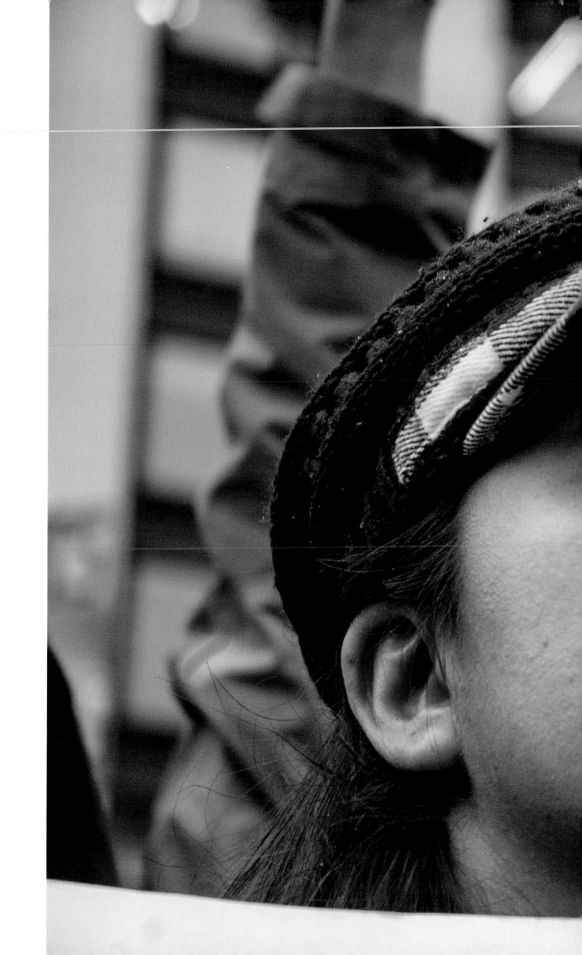

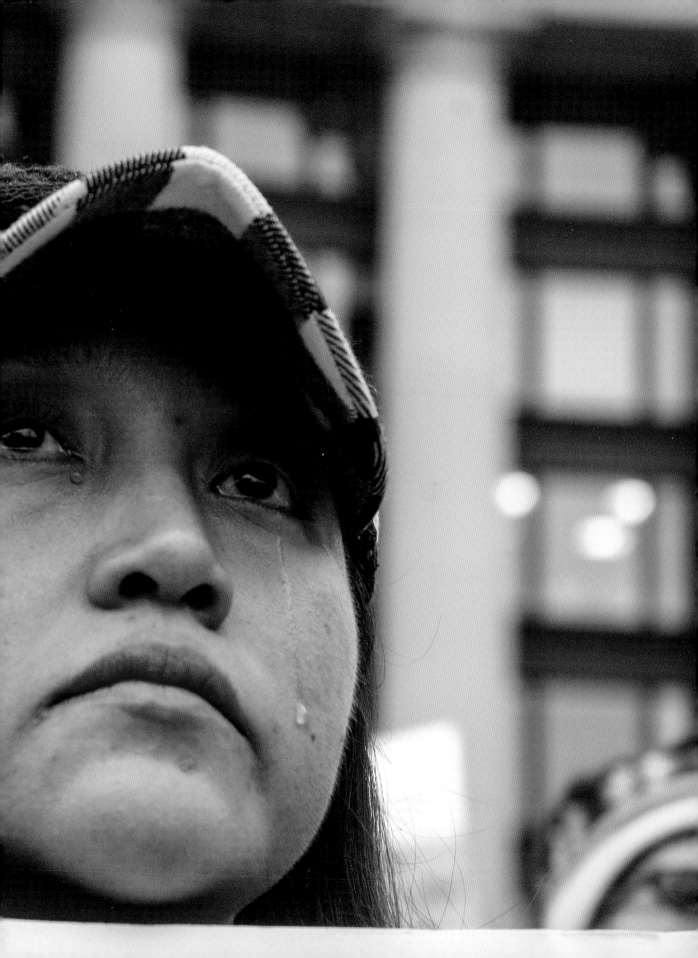

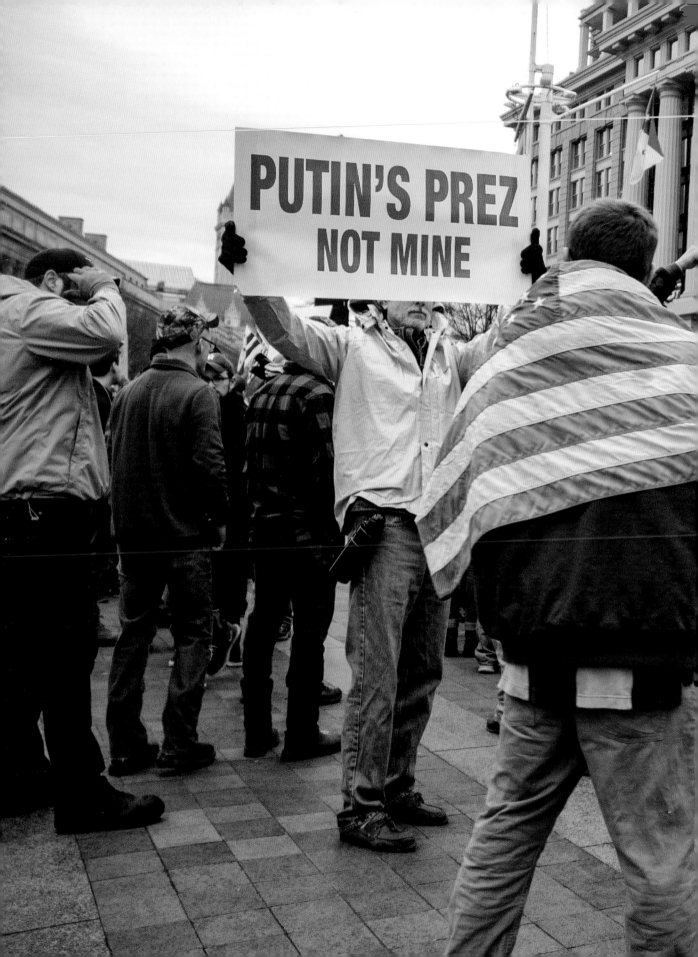

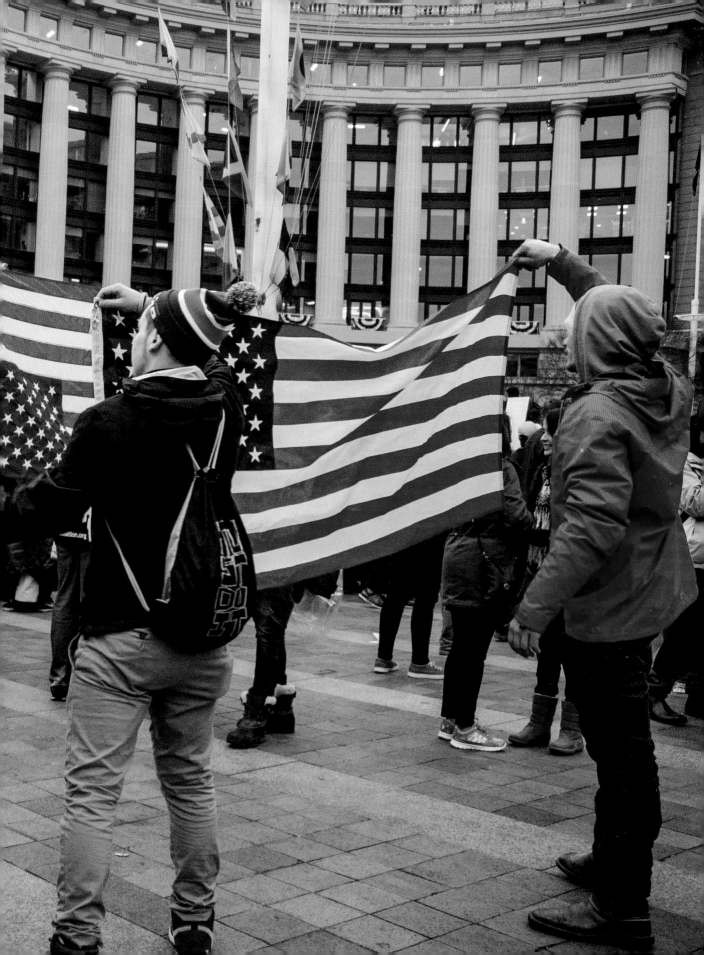

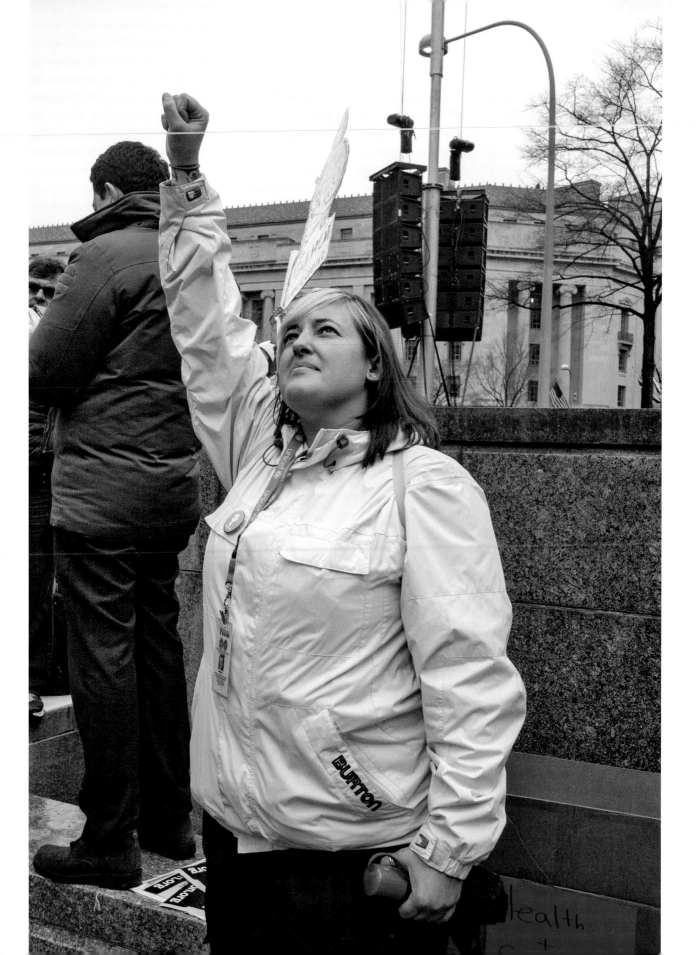

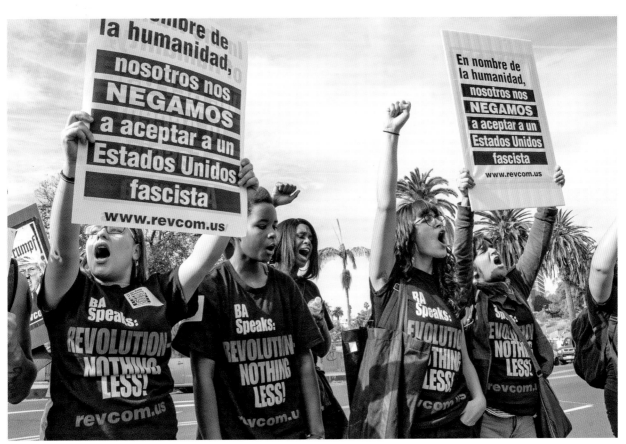

Not My President Rally, Los Angeles, 2016

OPPOSITE · Rachel Blue Belafonte Biesemeyer, Trump Inauguration, Washington, DC, 2017

PREVIOUS SPREAD · Inaugural Parade Route, Washington, DC, 2017

"Attending Trump's inauguration was one of the most empowering and depressing moments of my life. It was eye-opening to see how blind and misguided our country still is. Yet going from the action of protesting at the inauguration, full of tears, disbelief, and angst, to the Women's March the very next day, finding hope, collaboration, and empowerment, was enlightening. Trump's reign has forced us to take a stand, to reach out and call forth one another. It has made those who used to sit back and mumble about dissatisfaction, now stand up and shout for what they believe is right. The damage that may be done during his presidency may be great. But . . . what will truly *make America great again* . . . is the empowerment of its people and the elevation of their voices. Great adversity brings great courage."

—RACHEL BLUE BELAFONTE BIESEMEYER

Teacher and Cofounder of Anir Experience

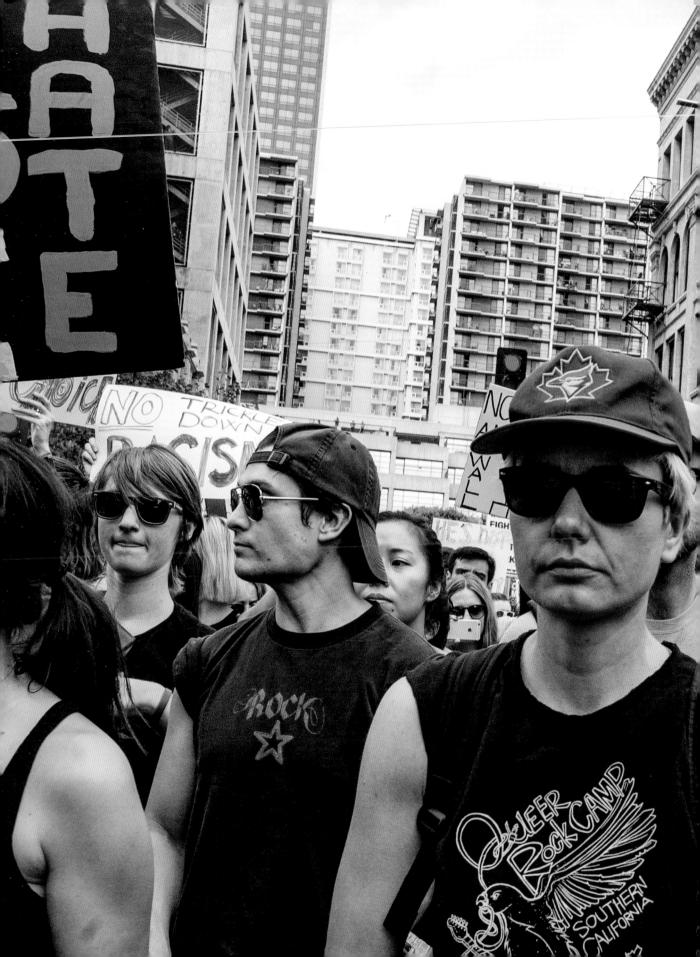

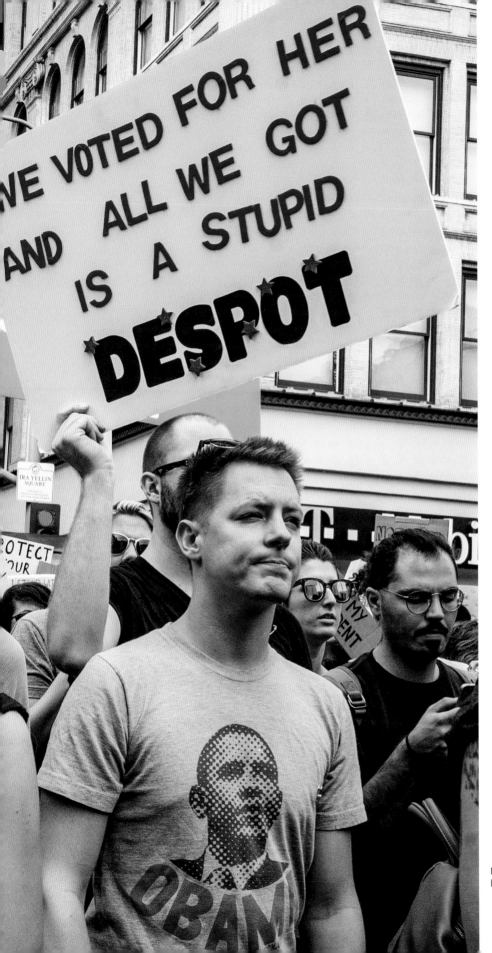

Not My President Rally,
Los Angeles, 2016

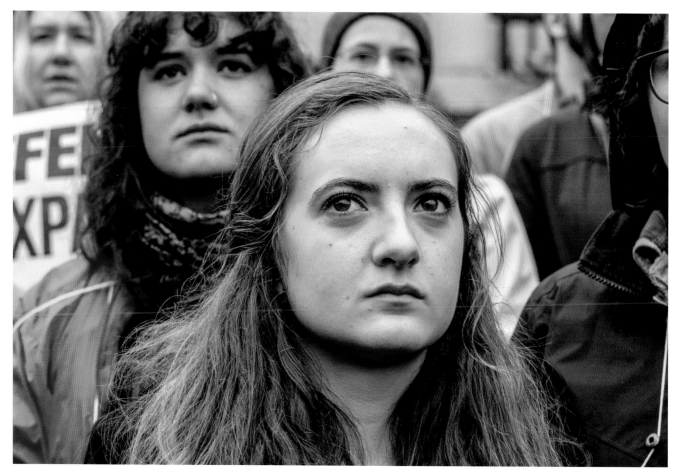

ABOVE & OPPOSITE - Trump's Inauguration Protest, Navy Memorial, Washington, DC, 2017

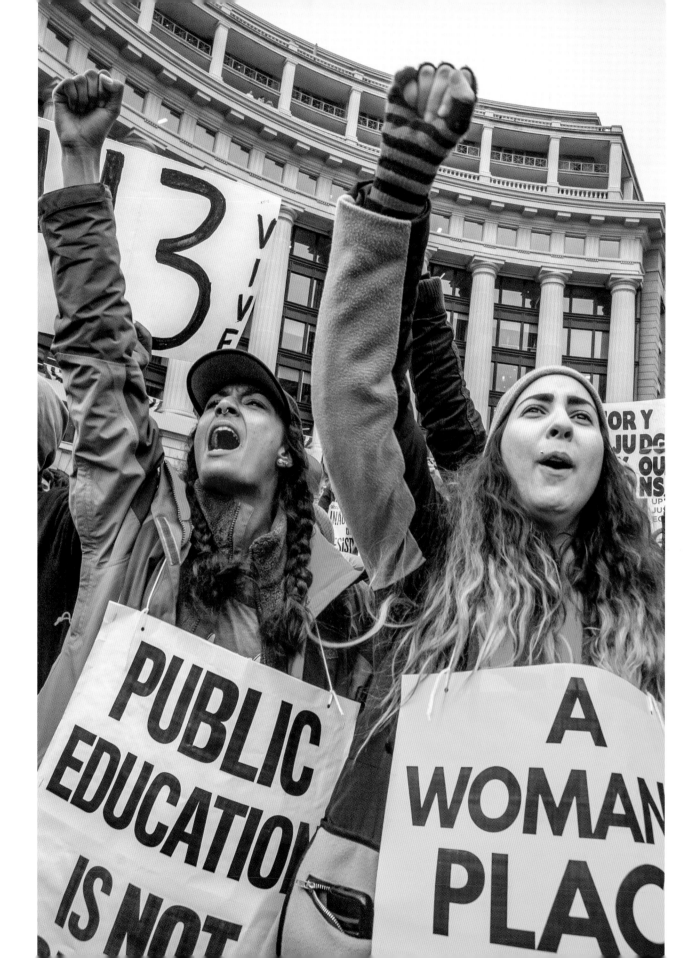

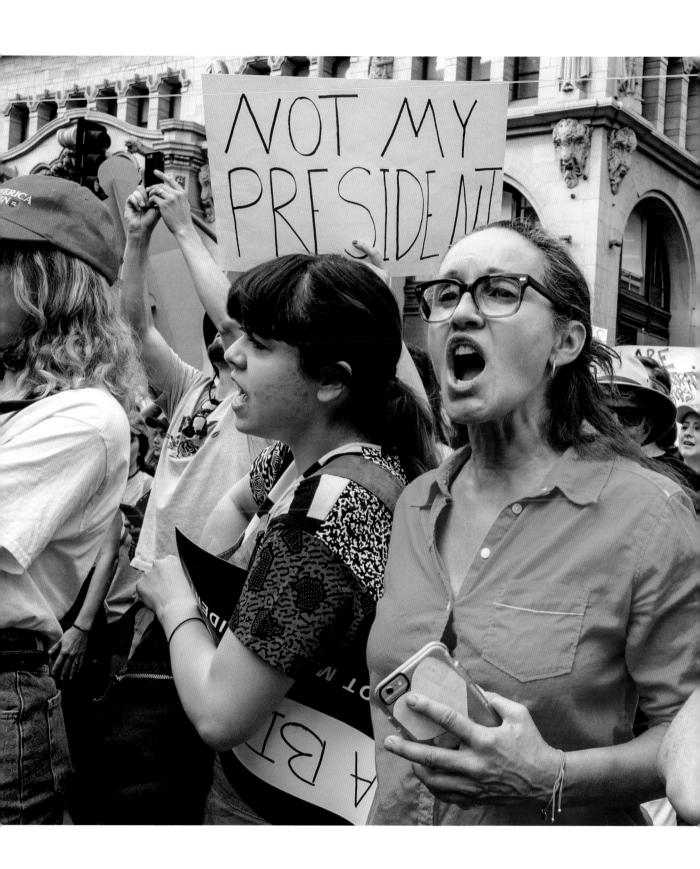

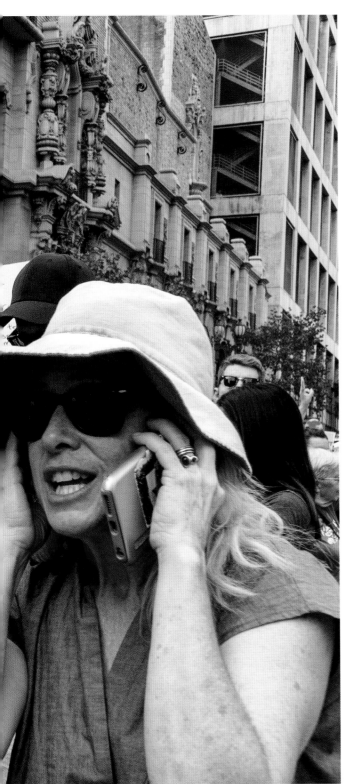

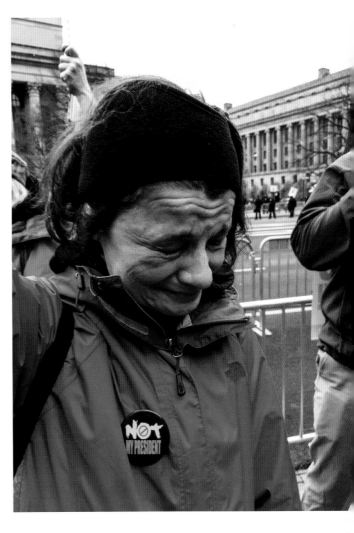

Not My President Rally,
Los Angeles, 2016
ABOVE & FOLLOWING TWO SPREADS -
Trump's Inauguration Protest,
Navy Memorial,
Washington, DC, 2017

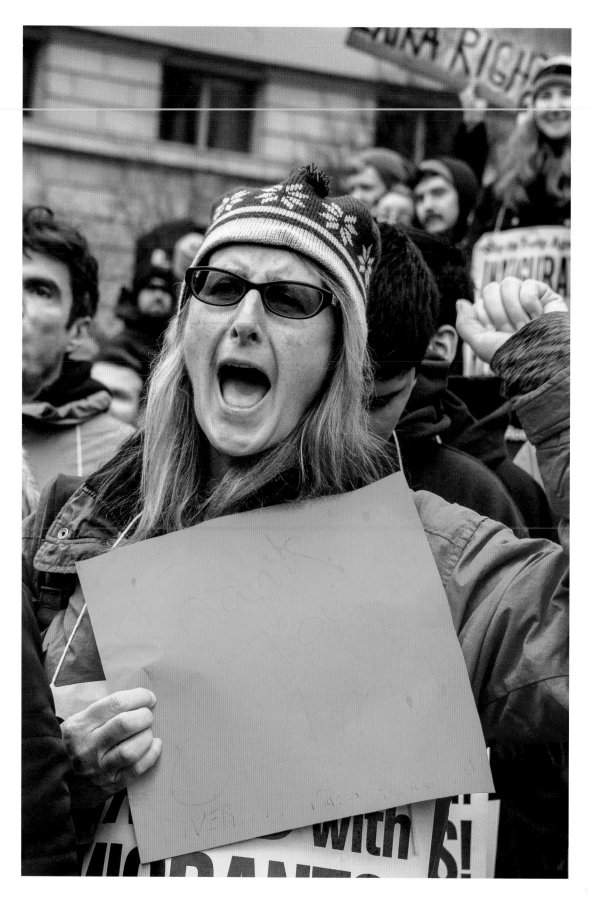

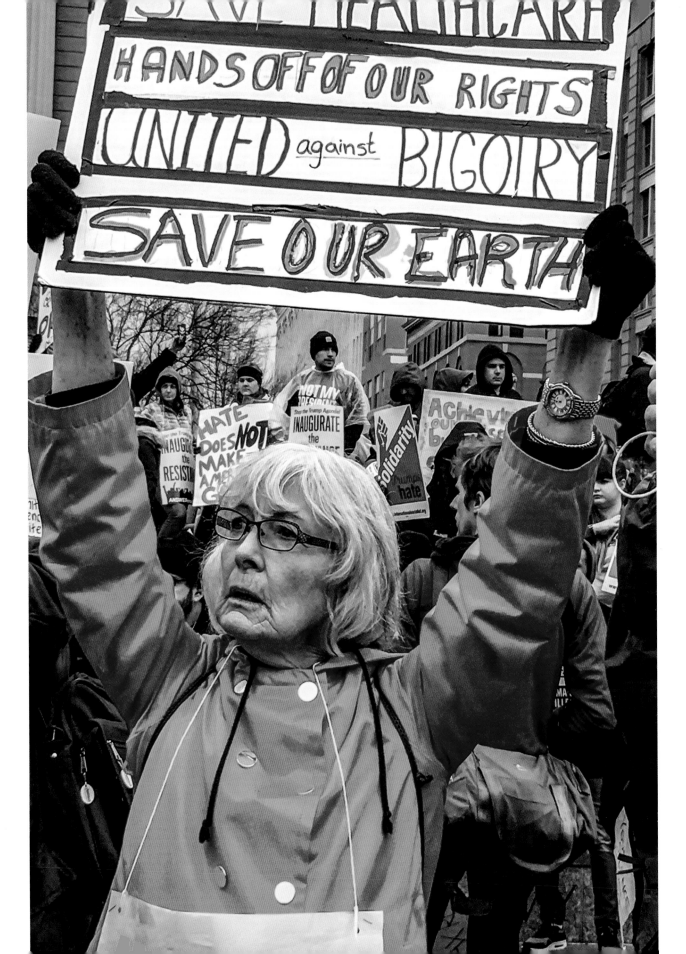

"The decision to protest at the inauguration was an easy one. I, like many others, complain a lot about things they don't like but few take action and stand up for their beliefs. What drove me to come to Trump's inauguration and make my voice known was my children. They are the children of immigrants. What is lost to many Americans is that we are all descendants of immigrants. That's what makes America great. The president of this country should inspire all of us with hope and encouragement to be better people."

—FRED SAYED

First Generation American, Protester from New York

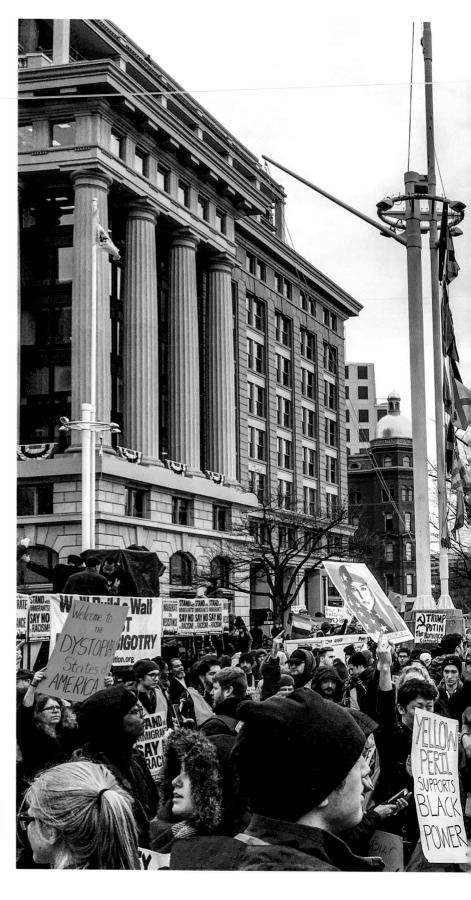

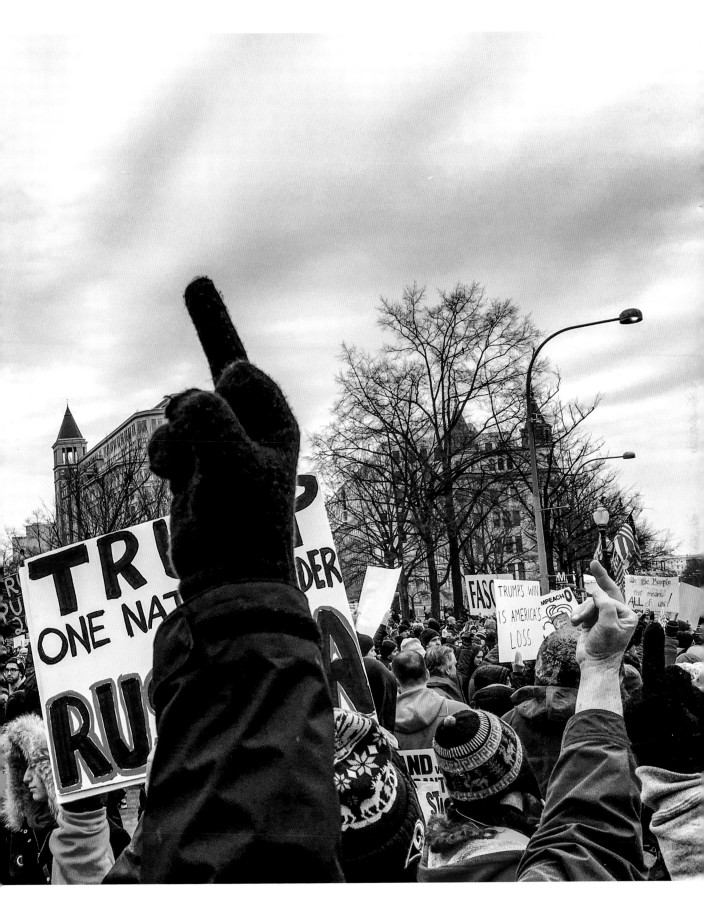

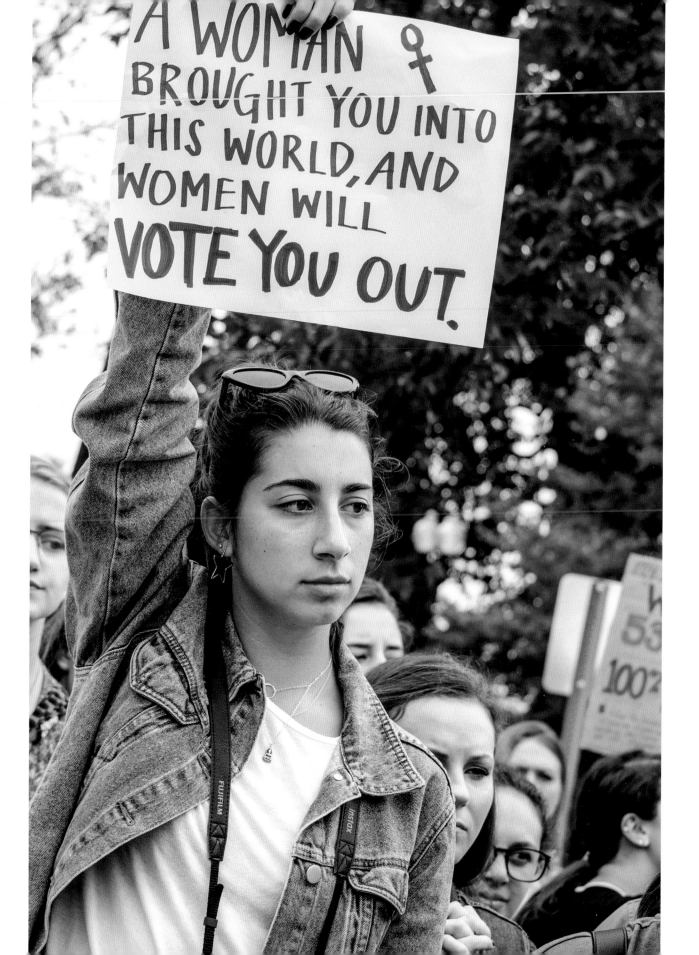

GENDER EQUALITY The Trump administration's conservative agenda is an existential threat to women and the LGBTQ community. The Women's March of 2017 in Washington, DC, and all over the country, was the first salvo. It came from Planned Parenthood, Emily's List, NARAL. The pink knit hats were a humorous response to the vulgarity brought to Washington by the new president. But the sentiment was deadly serious. Over a million people jammed the Washington Mall, from babies in strollers to seniors in their nineties. Strangers bonded with one another, their spirits roused by speeches from feminist icons Gloria Steinem, Angela Davis, and Cecile Richards. Slogans on signs told us that we have been here before. Now we are united by the victories we have won and are unwilling to turn the clock back.

As a participant that day, I sensed that the playfulness and joy of protest was over. This was going to be work. We were at the crossroads of women's rights and gender and race equality; our very civil rights were at stake. As the day ended, we paraded through our nation's capitol with pride and grit. This is what democracy looks like.

OPPOSITE - Kavanaugh Protest, Capitol Building, Washington, DC, 2018

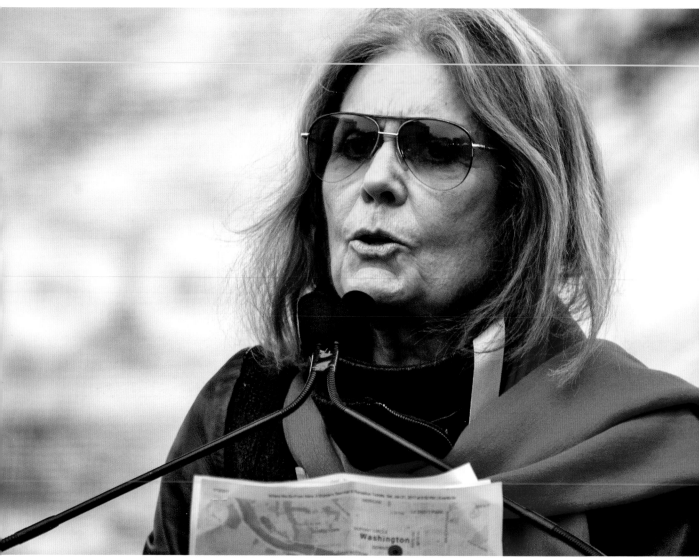

ABOVE · Gloria Steinem, & OPPOSITE · Cecile Richards, Women's March, Washington, DC, 2017

"Sometimes we must put our bodies where our beliefs are. Sometimes pressing send is not enough. This march unifies us with the many in this world who do not have computers or electricity or literacy but do have the same hopes and dreams. Women's rights are human rights. And human rights are women's rights. So crucial when, collectively, violence against females in the world has produced a world in which for the first time there are fewer females than males."

—GLORIA STEINEM

American Feminist, Actvist, Author, Cofounder of Ms. Magazine

"One of us can be dismissed. Two of us can be ignored. But together we are a movement and we are unstoppable."

—CECILE RICHARDS

Former President of Planned Parenthood

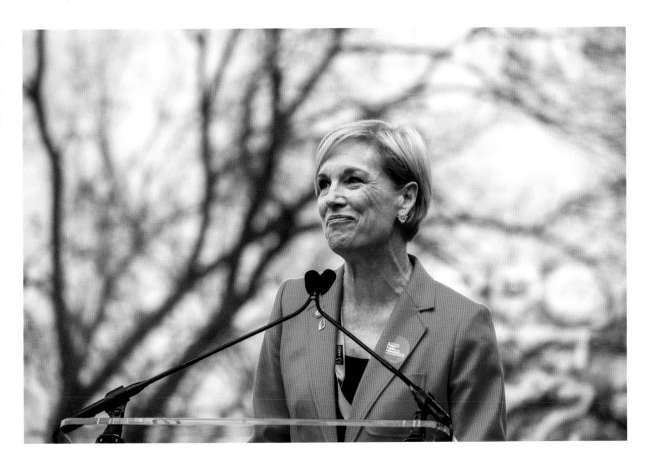

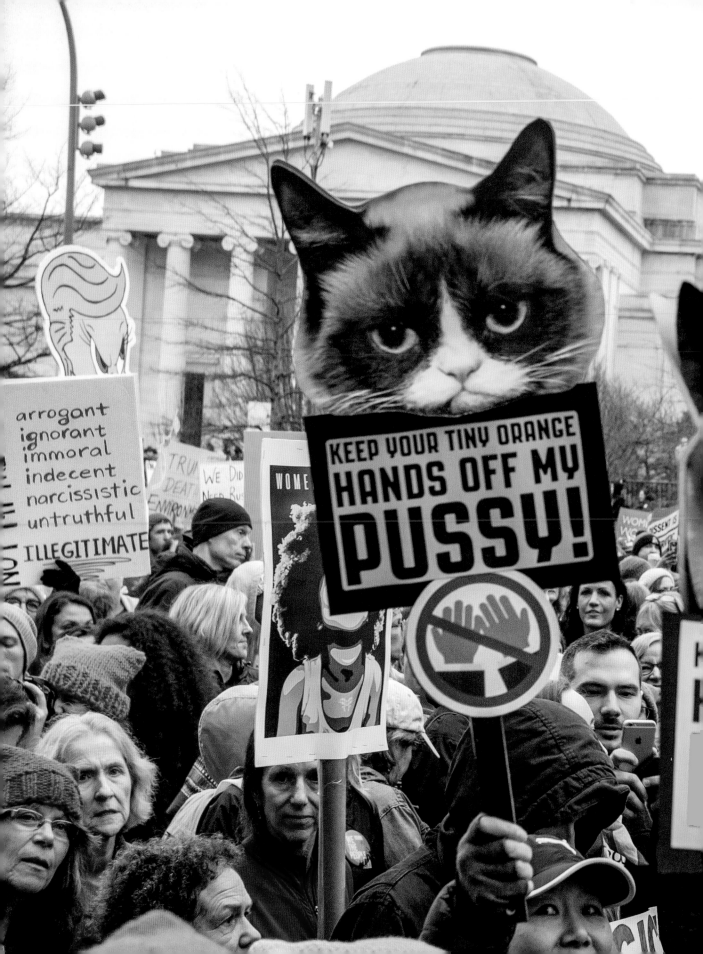

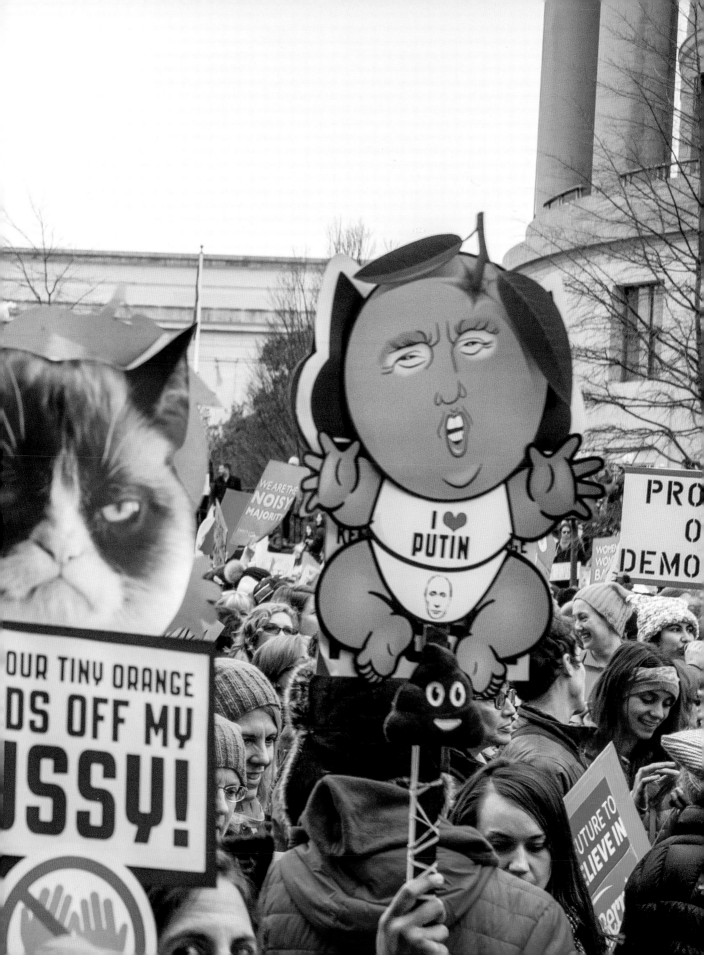

"In the early '90s, I met 'older' women who volunteered for Planned Parenthood. They wore necklaces with little hangers. In my naivety, I inquired about the hanger (I grew up with abortion being legal). They said, 'We must never go back! My friend died from an illegal abortion. Another friend could never have children. My sister hemorrhaged from a back alley abortionist.' It is appalling in the era of #MeToo that a government wants to take away women's rights over their own bodies. Against abortion? Don't have one! Respect me, respect my body!"

—SUSAN DWORK TEIXEIRA

Registered Nurse, OBGYN Nurse Practioner

PREVIOUS & THIS SPREAD
Women's March,
Washington, DC, 2017

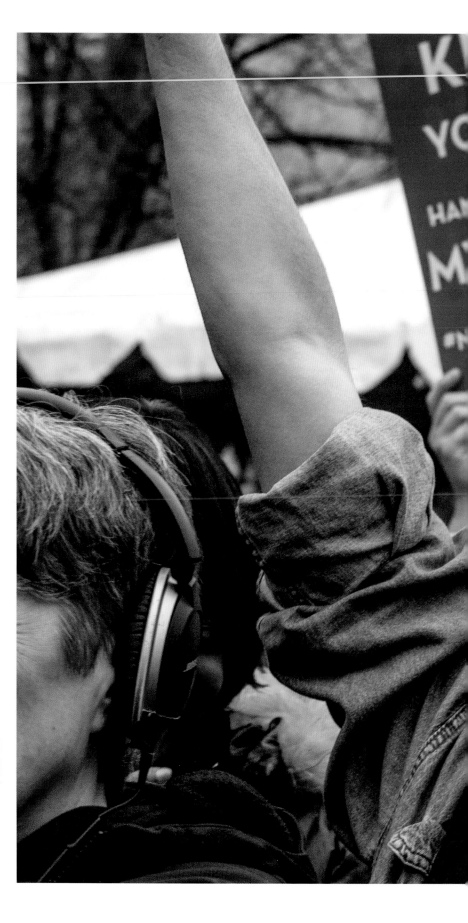

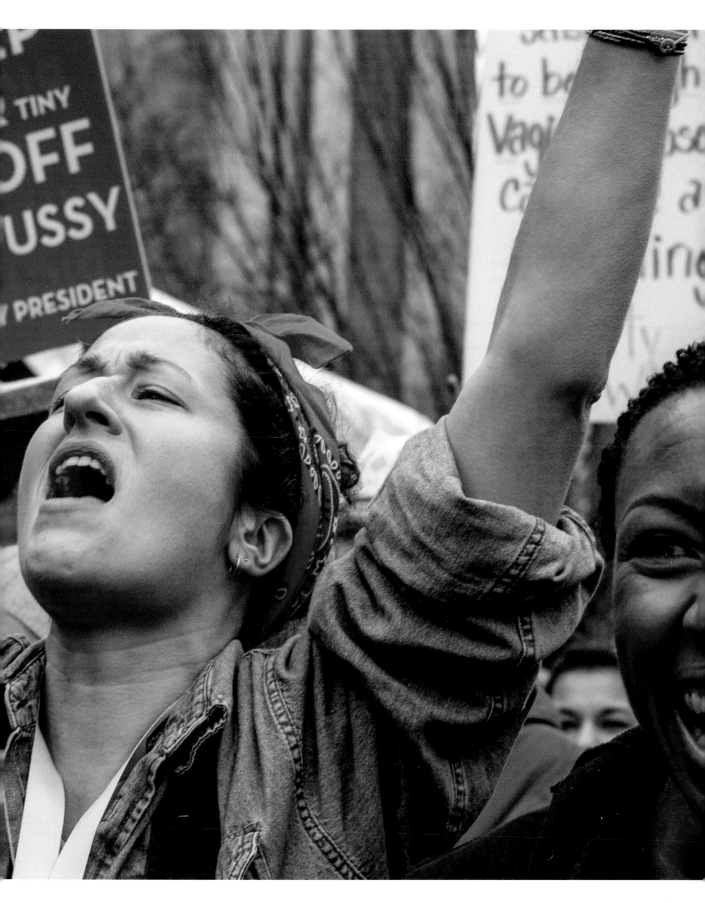

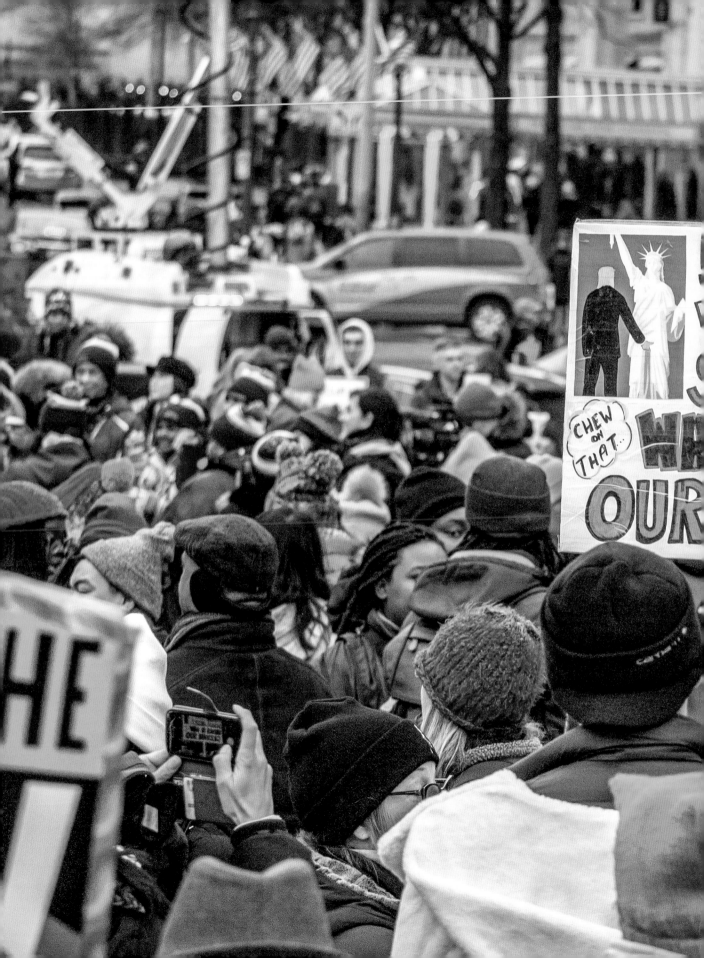

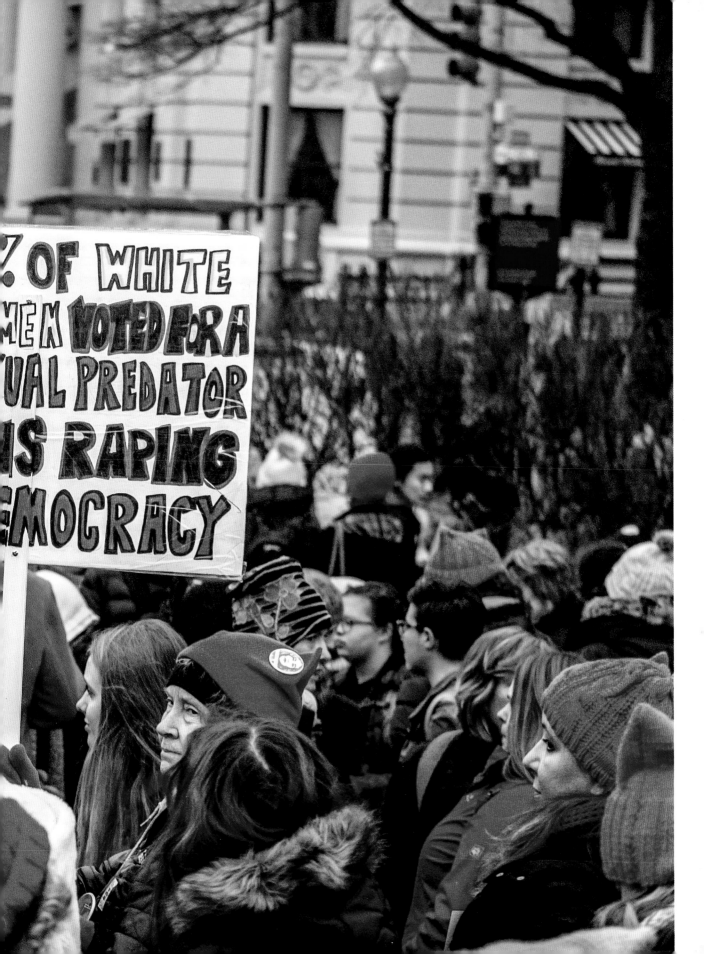

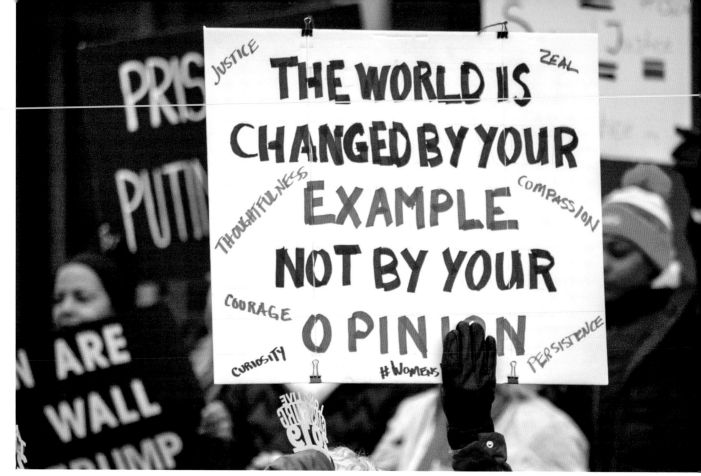

PREVIOUS & THIS SPREAD · Women's March, Washington, DC, 2017

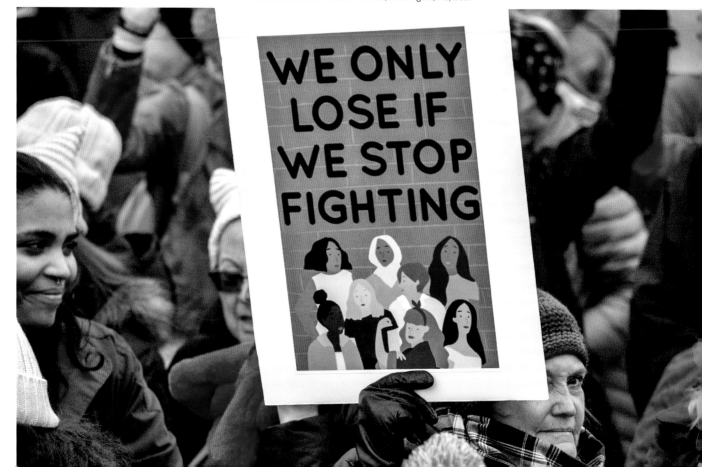

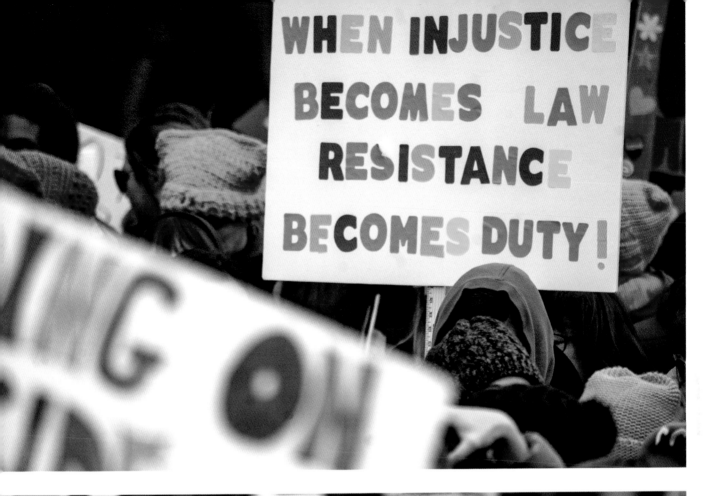

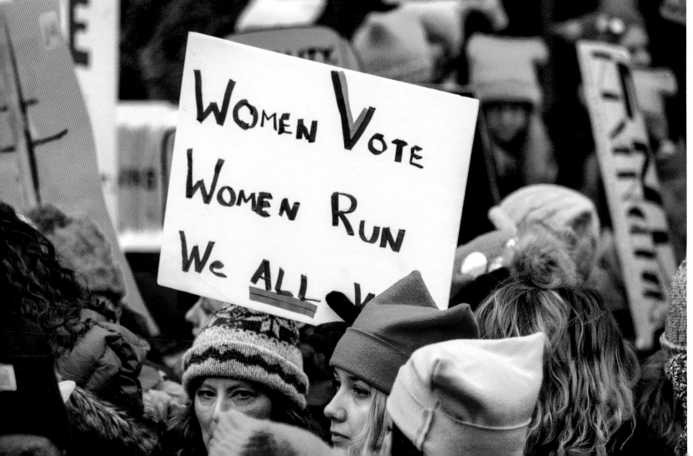

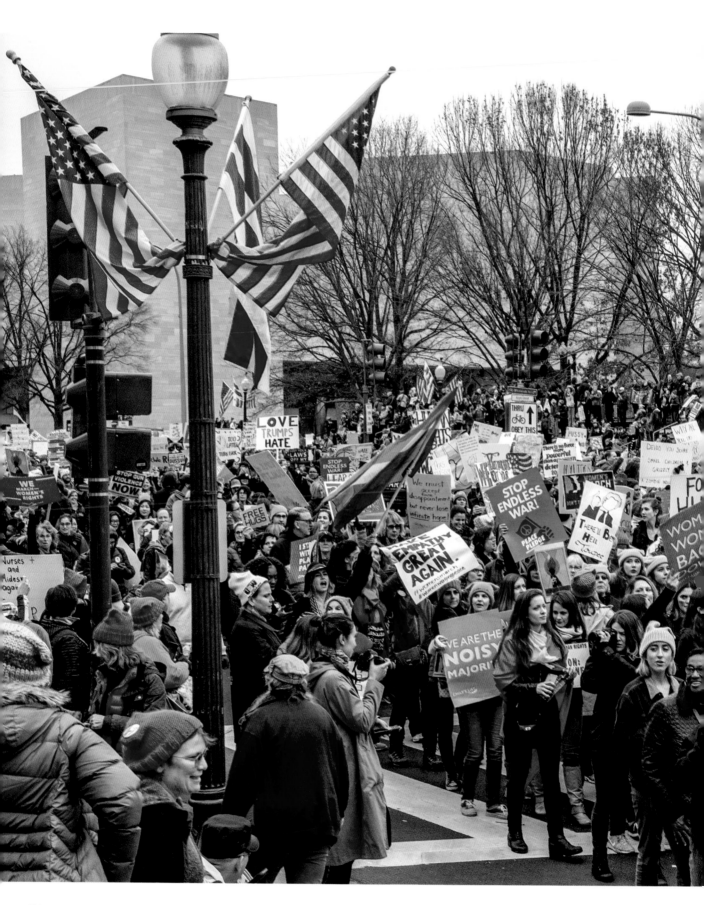

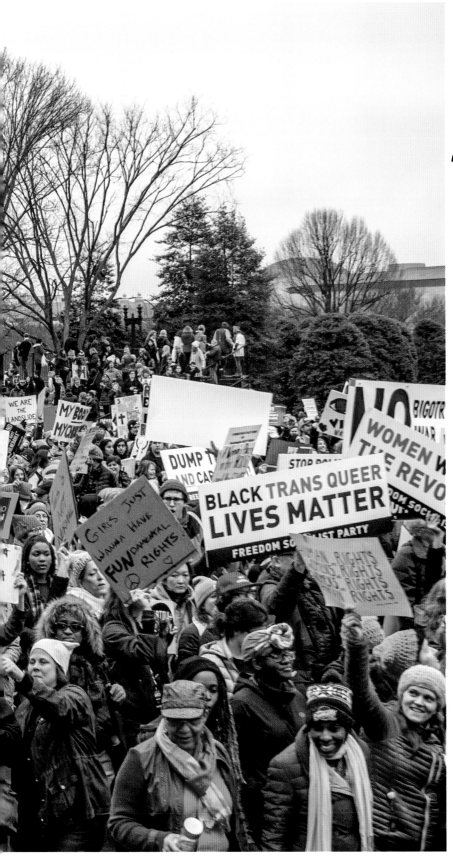

"Today is a historic day, not just for me but for many trans women. Today trans women are visible to the whole world. We have to proudly raise our voices and say that trans women are women. No one, not the government, no individuals, no companies or institutions, get to dictate who we are as individuals. My truth is that I am a woman and that I belong here . . . and I thank the Women's March for honoring that."

—BAMBY SALCEDO

President, TransLatin Coalition

Women's March,
Washington, DC, 2017

"I chose to march for those that couldn't. I march for my best friends whose bodies have been dictated by school boards run by old white men. I march for my mother who has had to follow in the footsteps of her father just for the basic sense of approval. I march for my transgender brothers and sisters, who have been told how to dress and what to say by society. I march for indigenous people, whose land has been stolen and withheld by the same old white men that have been running this country for far too long now. I march for the survivors of rape and sexual assault, who have had their validity stripped away by these same men. I march for my Jewish sisters, my Islam sisters, my queer sisters, my straight sisters, my disabled sisters, my POC sisters, as well as countless others whose voices are continuously not heard in mainstream media."

—ANDREW SCHATT
Student Protester

OPPOSITE · Women's March, Washington, DC, 2019
FOLLOWING SPREAD · Women's March, Los Angeles, 2018

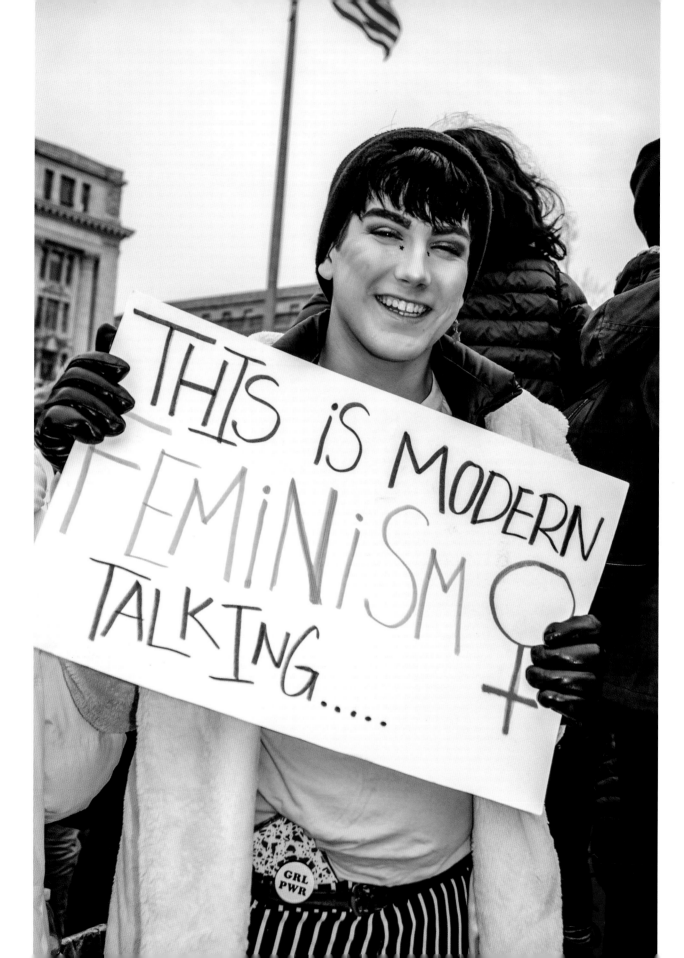

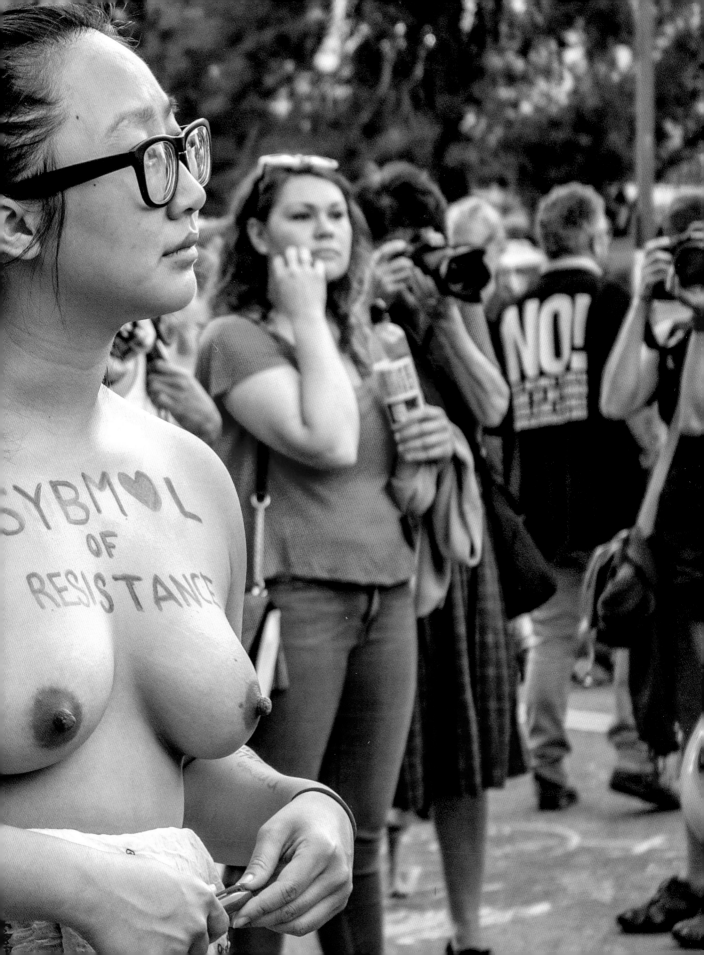

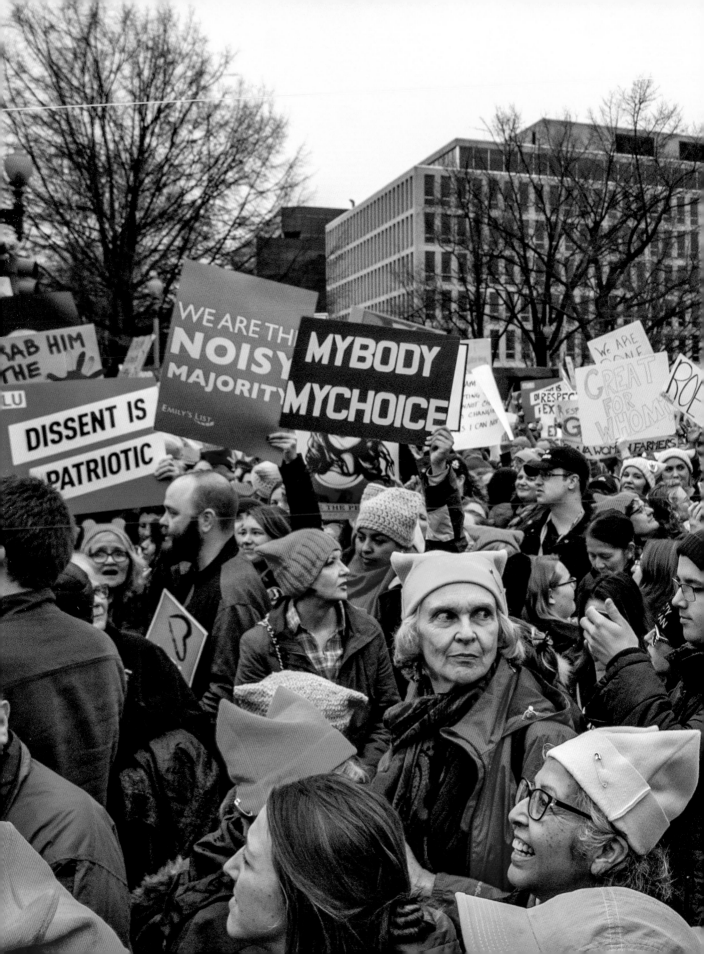

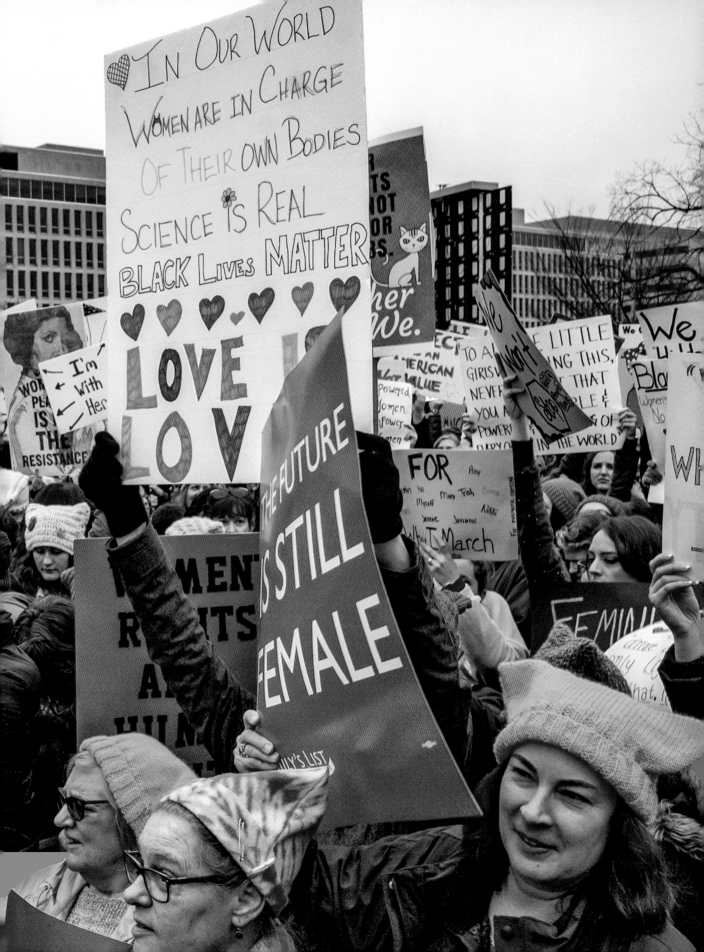

"I am really here today because I found that in my school there is some stigma with the word feminist and it has such a negative connotation. All it means is equality for both sexes, not hating men, like the boys in my generation may think. It's just about equality. So I just want to reinforce that idea and see equality happen for everyone, so women don't have to be scared. I feel like my generation is a part of a new wave, showing what feminism is really about." —MEAGAN

Student Protester from North Carolina

Emma Watson, actress,
Women's March,
Washington, DC, 2017
PREVIOUS SPREAD · Women's March,
Washington, DC, 2017

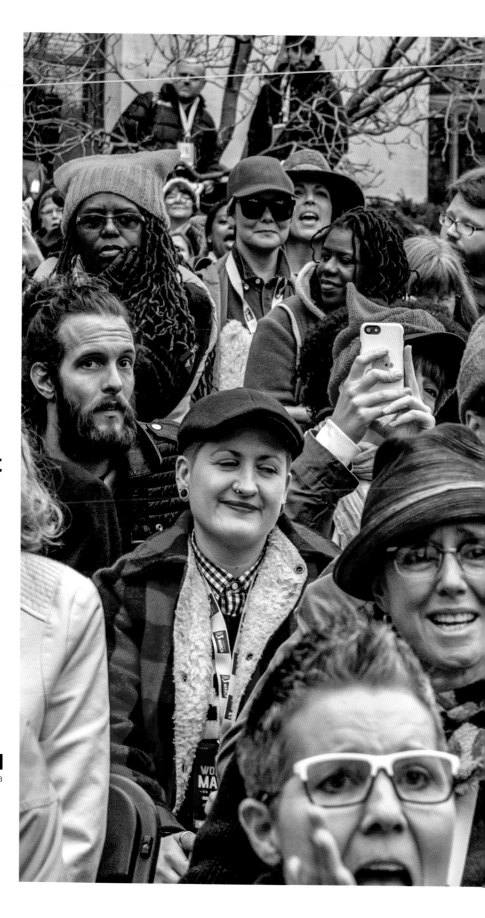

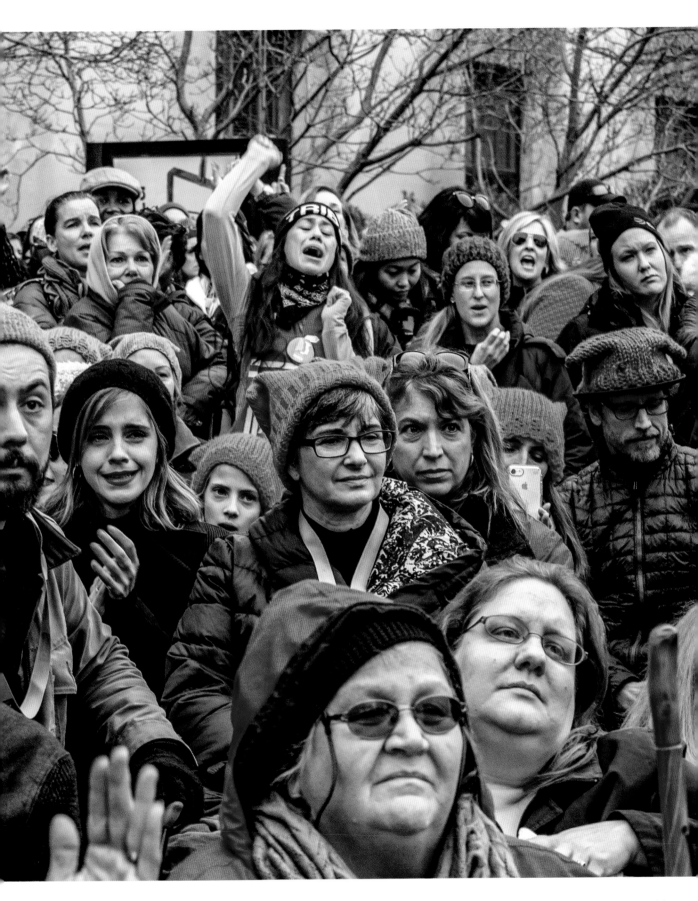

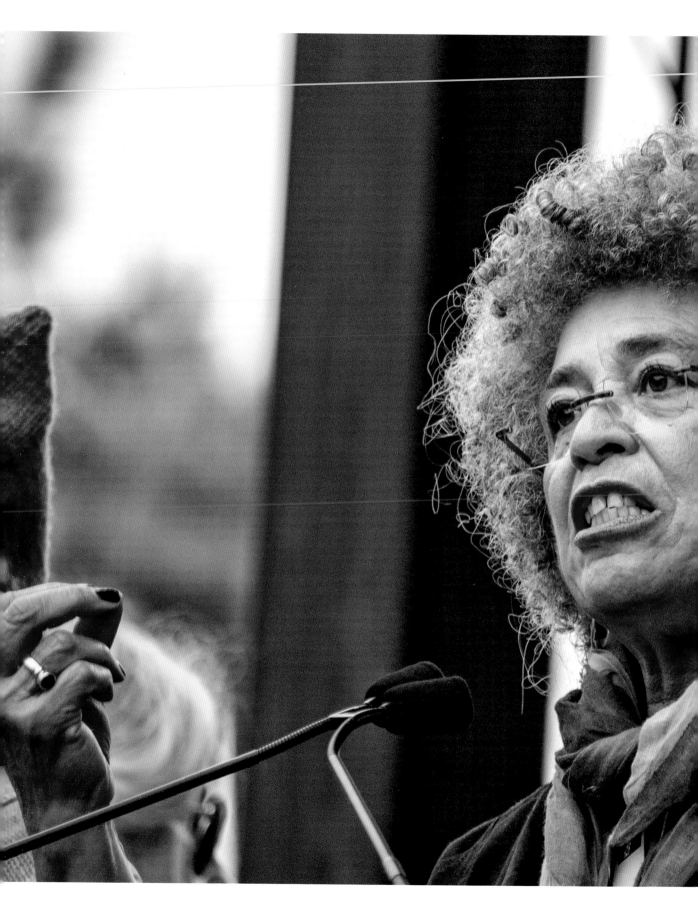

"At a challenging moment in our history, let us remind ourselves that we, the hundreds of thousands, the millions of women, trans people, men, and youth who are here at the Women's March, we represent the powerful forces of change that are determined to prevent the dying cultures of racism, hetero-patriarchy from rising again. The next 1,459 days of the Trump administration will be 1,459 days of resistance: resistance on the ground, resistance in the classrooms, resistance on the job, resistance in our art and in our music."

—ANGELA DAVIS
Political Activist, Academic, Author

Angela Davis, Women's March,
Washington, DC, 2017

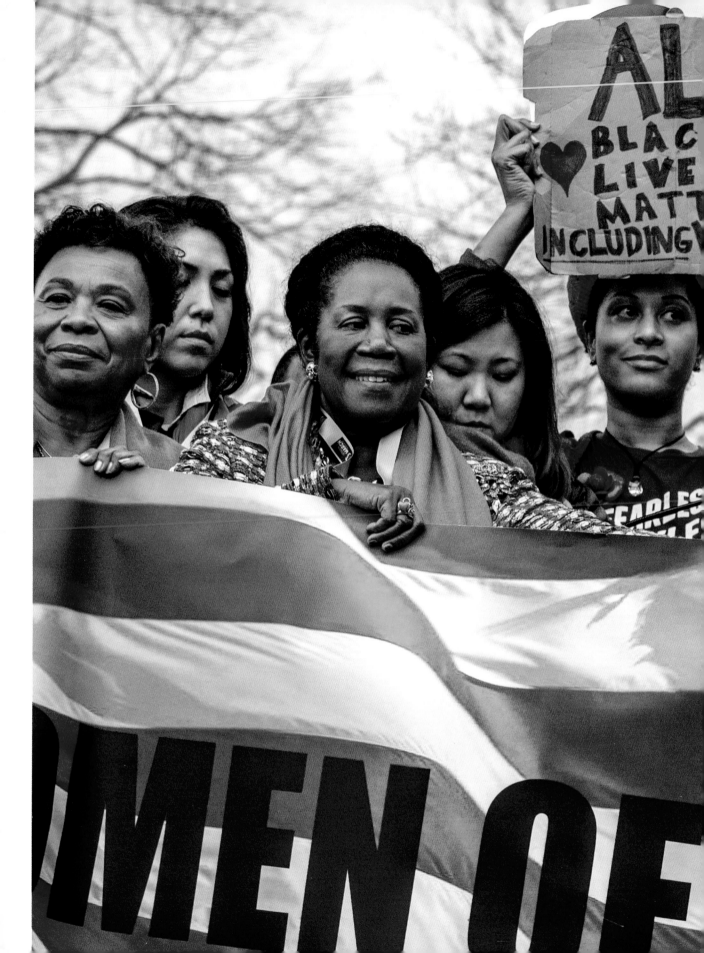

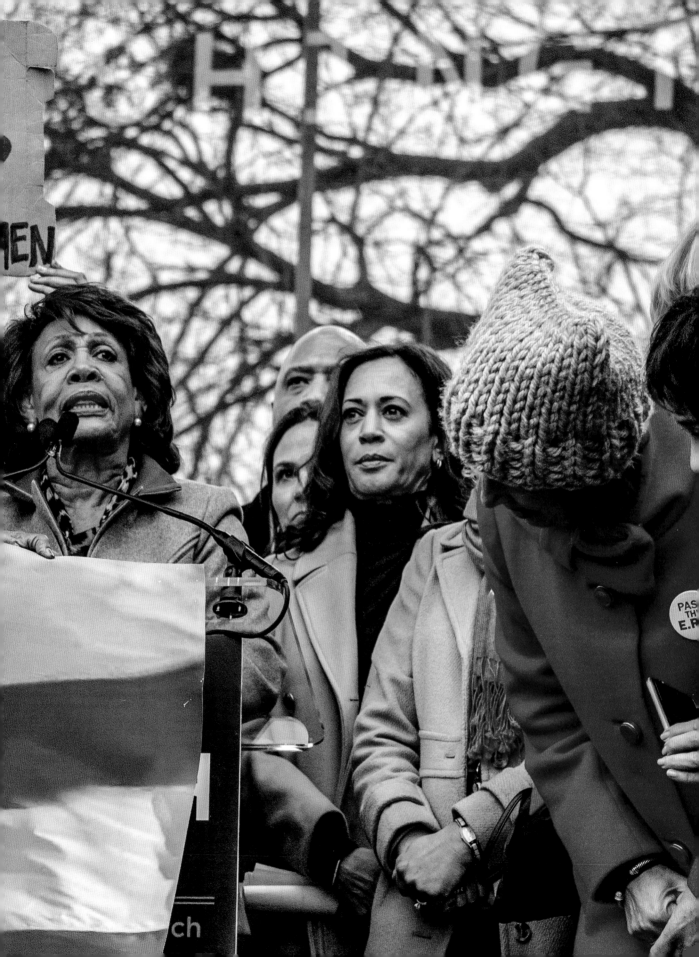

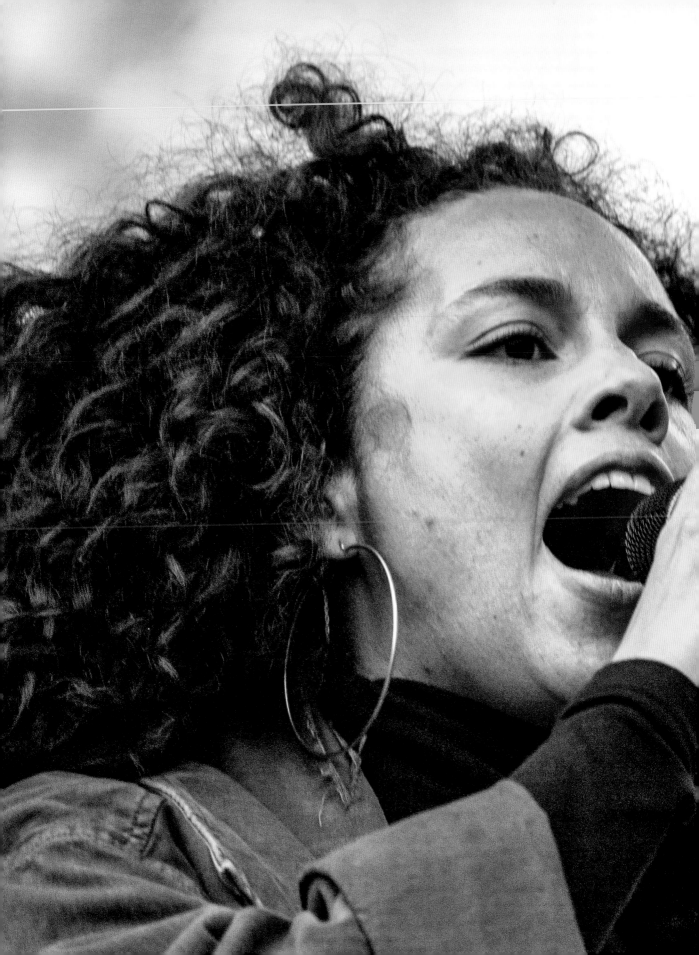

"Let us continue to honor what is so beautiful about being feminine. We are mothers, we are caregivers, we are artists, we are activists, we are entrepreneurs, we are doctors, we are leaders of industry and technology. Our potential is unlimited. We will not allow our bodies to be controlled by men in government, or men anywhere for that matter."

—ALICIA KEYS
Musician, Songwriter

Alicia Keys, Women's March, Washington, DC, 2017
PREVIOUS SPREAD · The Black Congressional Caucus, Women's March, Washington, DC, 2017

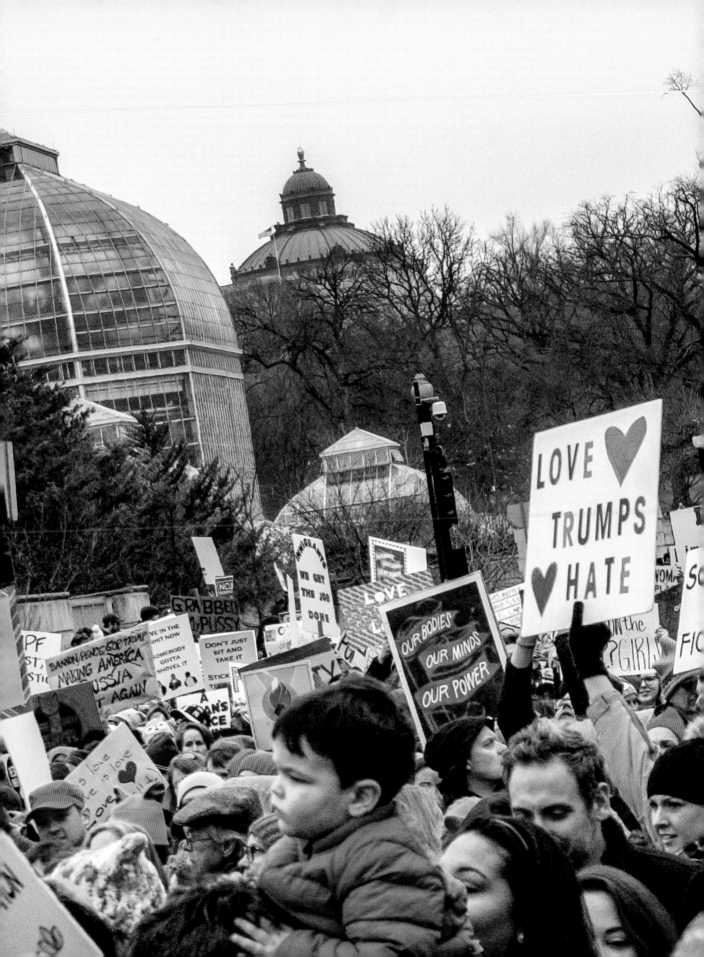

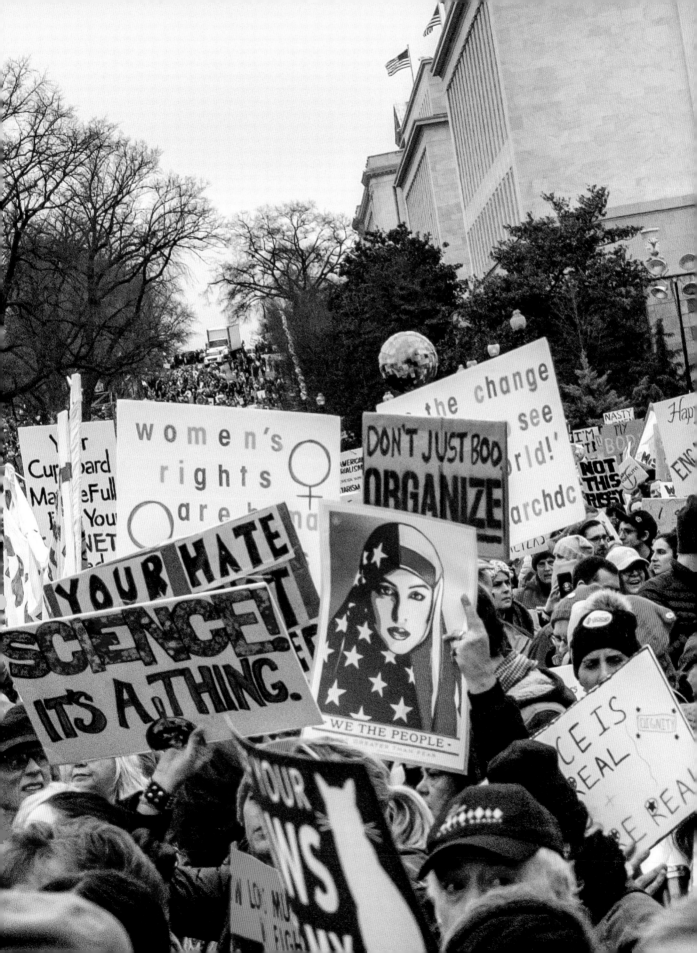

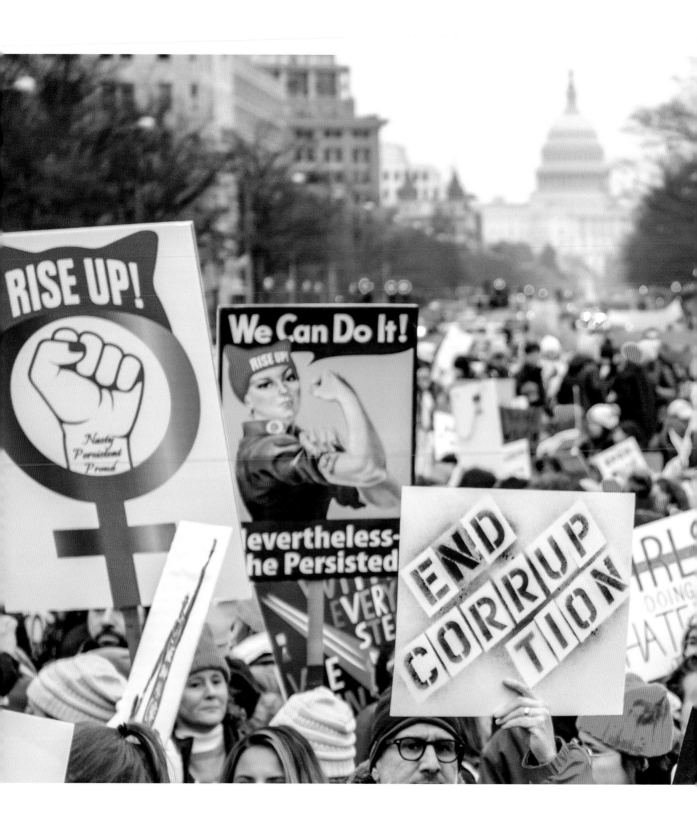

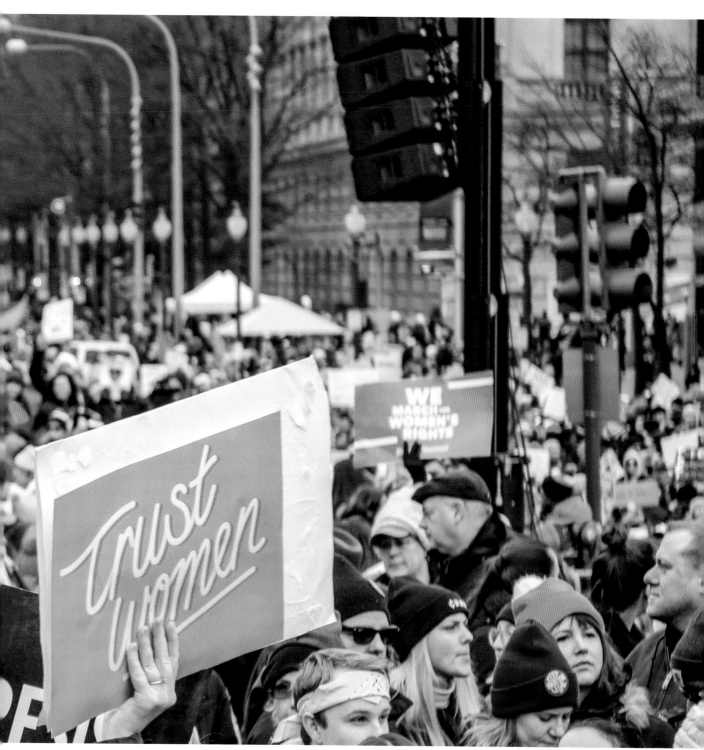

PREVIOUS SPREAD & ABOVE · Women's March, Washington, DC, 2017

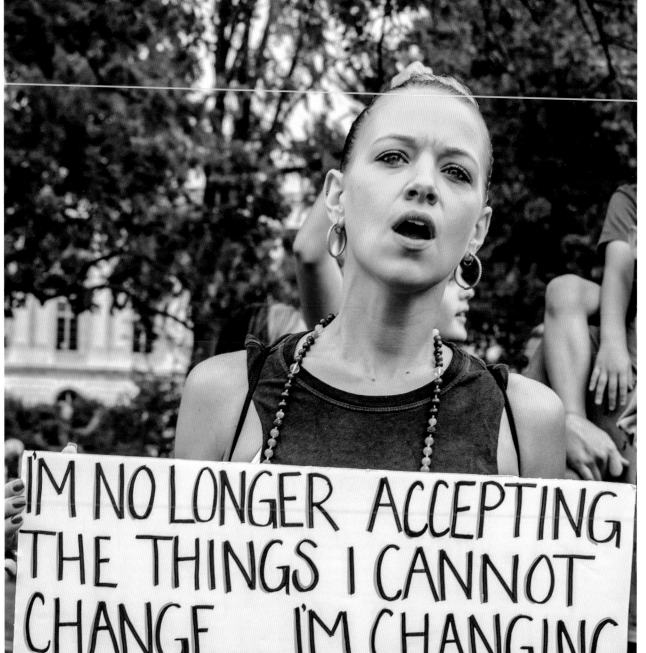

#MeToo The appointment of Brett Kavanaugh to Supreme Court justice was the shot across the bow for the #MeToo movement, a platform against sexual harassment and sexual assault. For years the far right movement had been biding their time, and with the retirement of Anthony Kennedy, in 2018, the stage was set to tilt the high court in their favor. Would Roe v. Wade be threatened? Would Obamacare be ruled unconstitutional? Dr. Christine Blasey Ford's heartfelt testimony in opposition to Brett Kavanaugh's appointment to the Supreme Court was a symbol of courage for women everywhere. She inspired a pilgrimage to our nation's Capitol. They came from as far away as Hawaii and Alaska to recount their own stories. Sympathizers displayed the "I Believe" motto as they lined up on the steps of the Supreme Court, clad in black. In a bold display of unity, over five hundred staged a sit-in on the Capitol steps. Police coordinated arrests, cuffing many who had never protested before much less been arrested. At three o'clock, on the dot, the final vote was taken to confirm. The crowd of thousands were shell-shocked into silence. There were tears. The Kavanaugh confirmation signaled a significant loss, but the counterattack would happen at the polls.

OPPOSITE & FOLLOWING SPREAD · Kavanaugh Protest, Supreme Court, Washington, DC, 2018

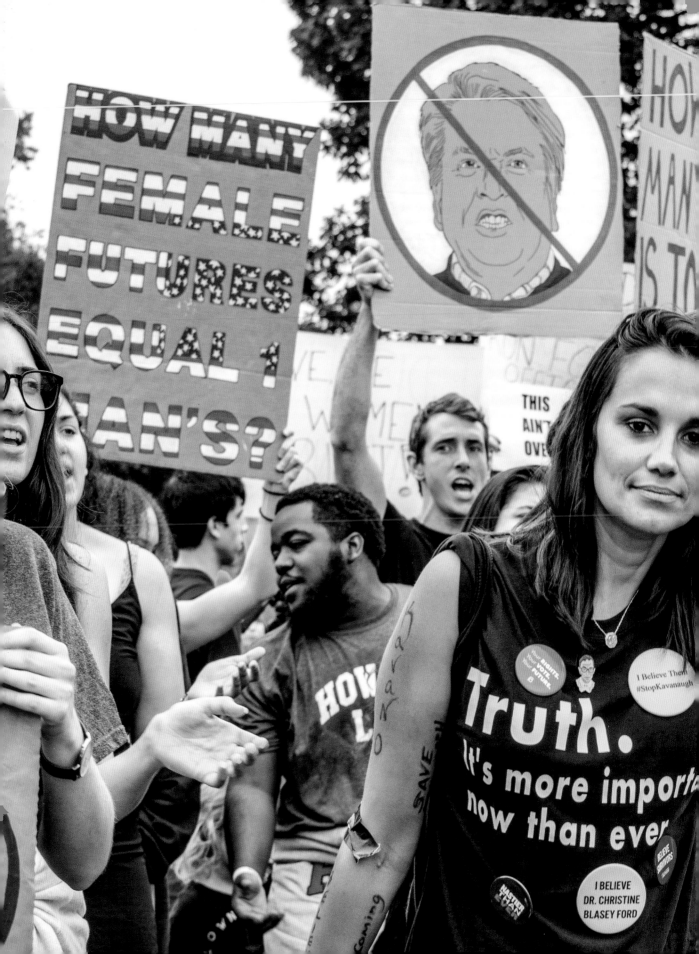

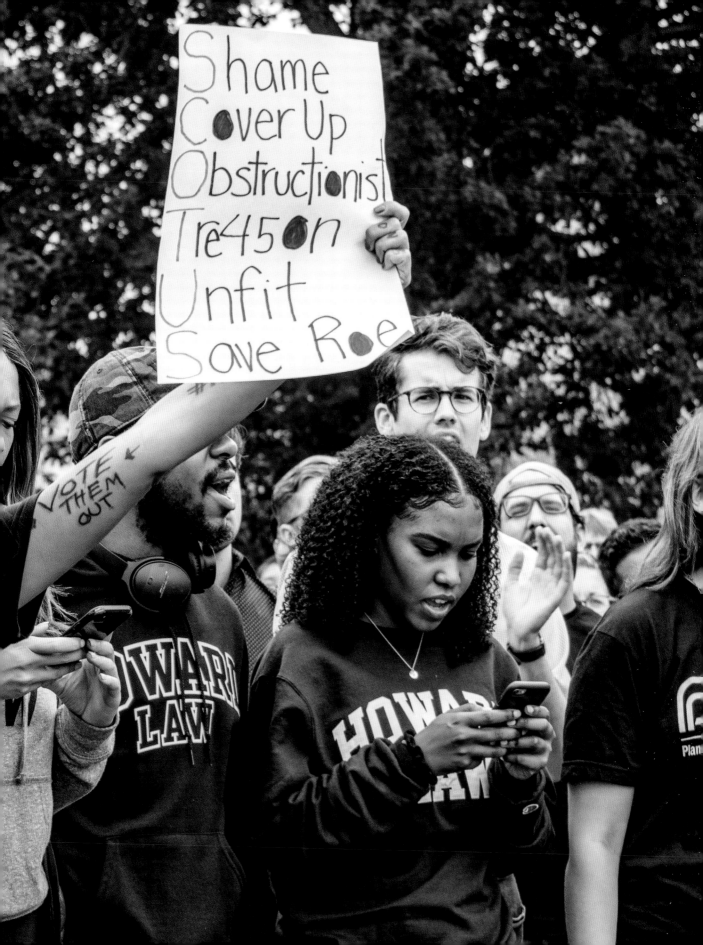

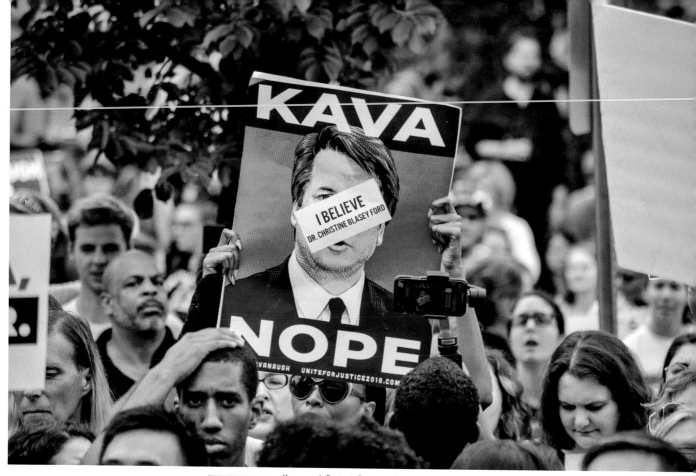

THIS & FOLLOWING SPREAD · Kavanaugh Protest, Supreme Court, Washington, DC, 2018

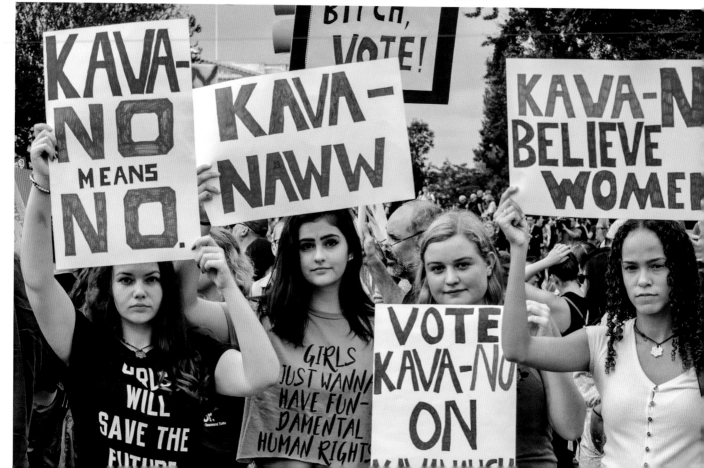

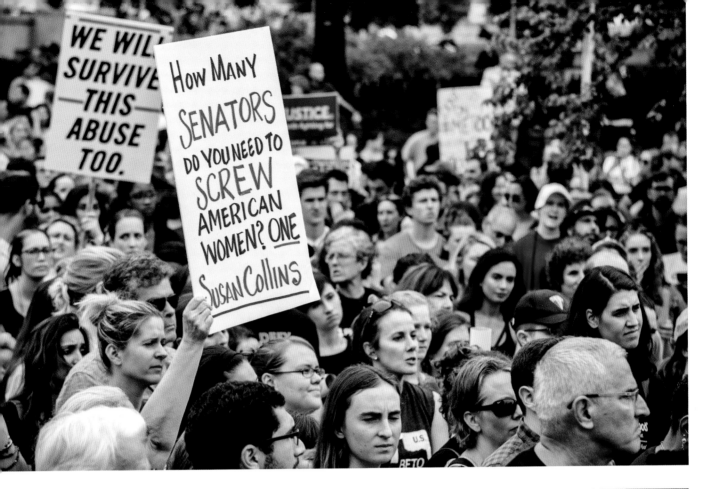

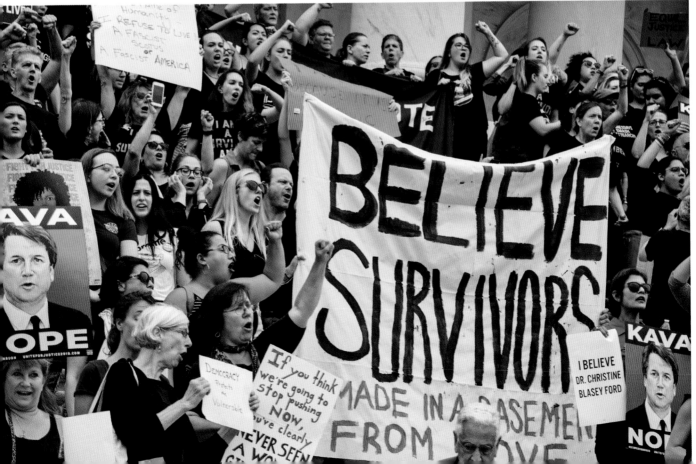

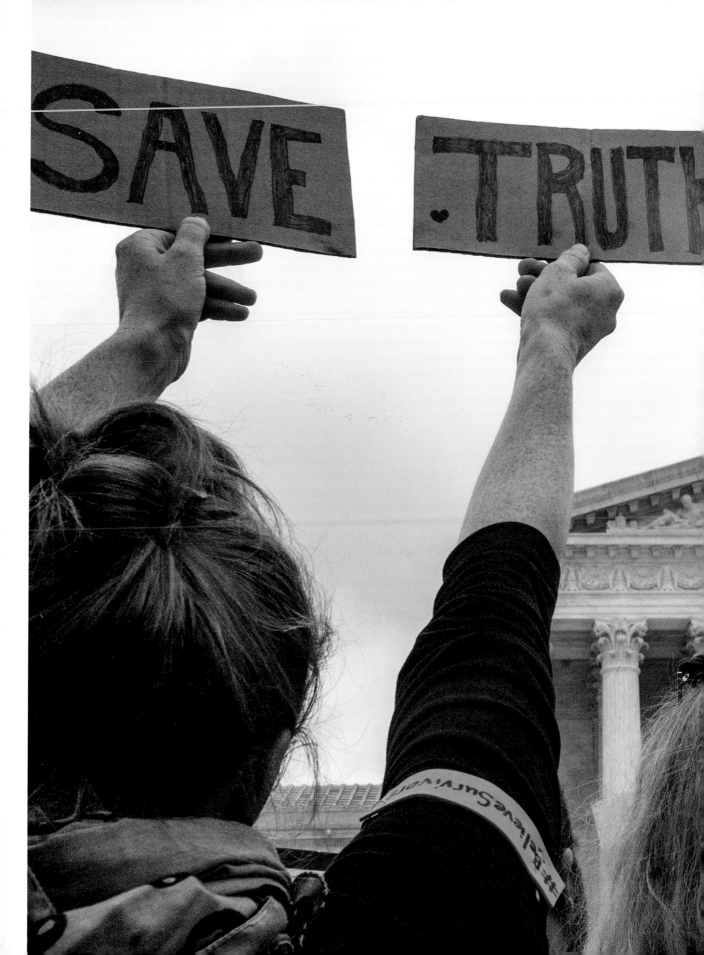

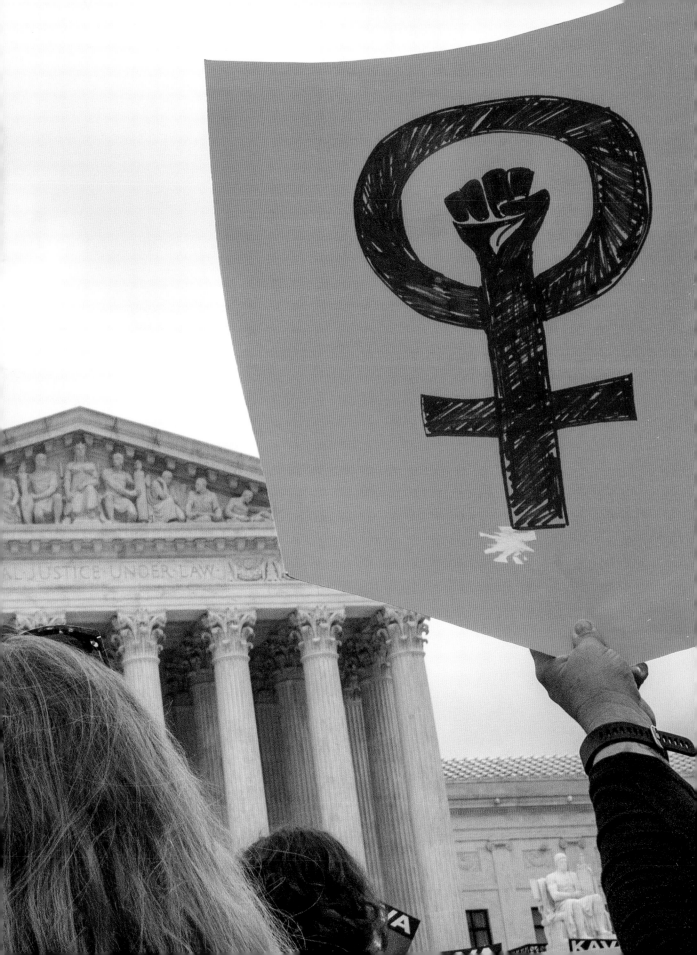

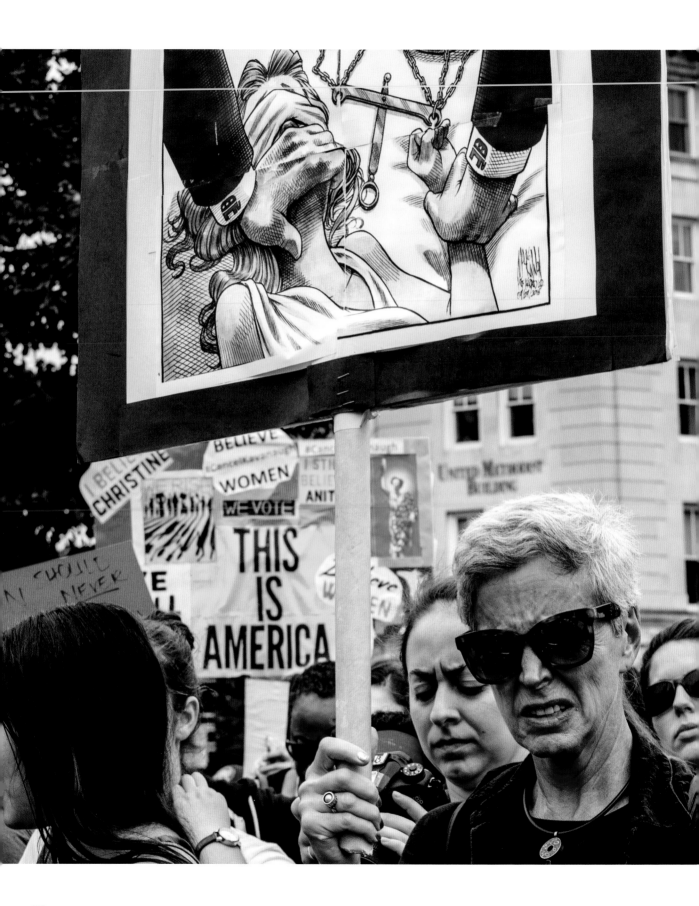

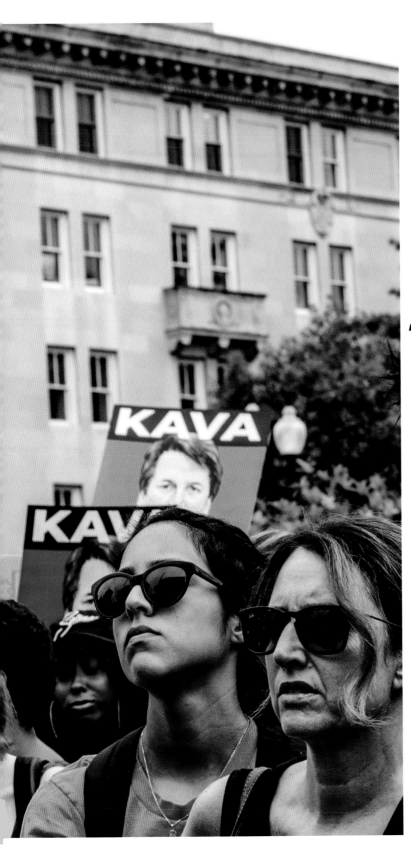

"This is the saddest and angriest time in the US Senate. The damage done today will be enduring—to the United States Supreme Court and to our country."
—RICHARD BLUMENTHAL
Senator from Connecticut, Senate Judiciary Committee

Kavanaugh Protest,
Supreme Court,
Washington, DC, 2018

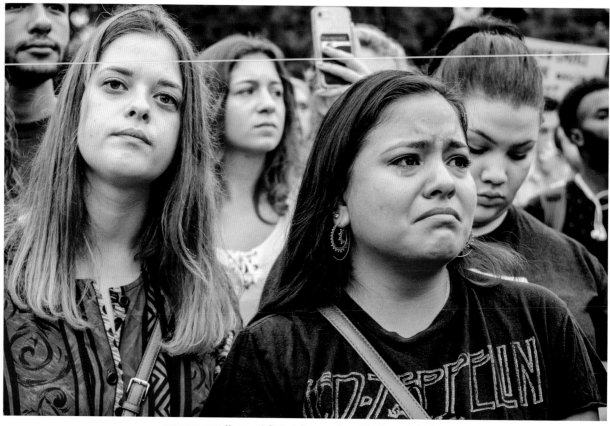

THIS & OPPOSITE PAGE · Kavanaugh Protest, Supreme Court, Washington, DC, 2018

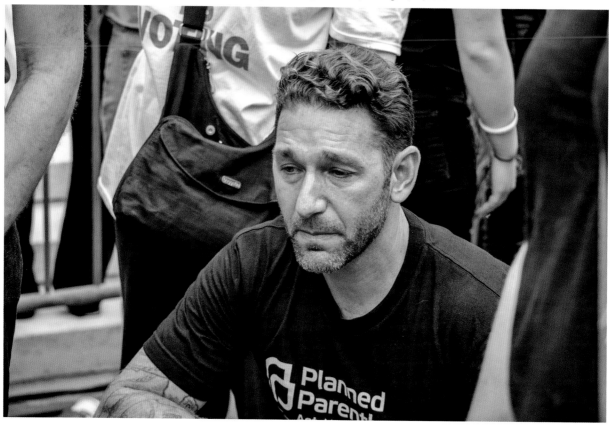

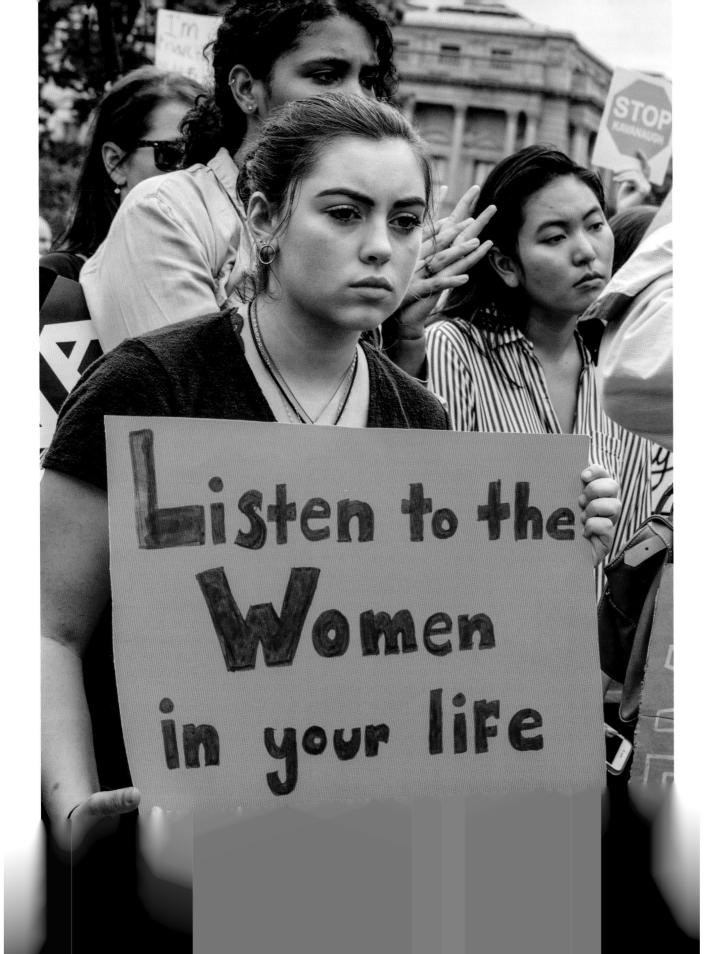

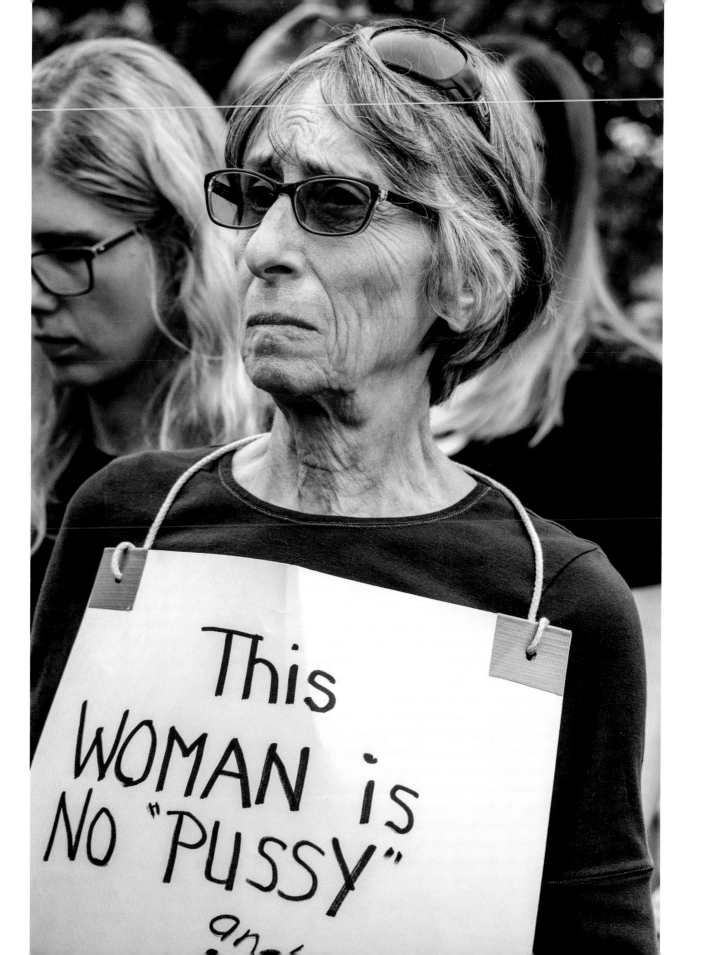

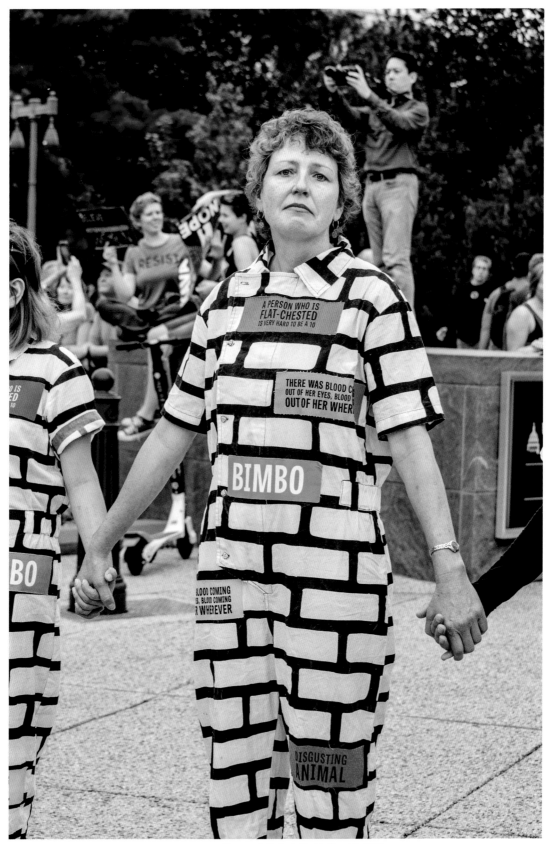

OPPOSITE & ABOVE · Kavanaugh Protest, Washington, DC, 2018

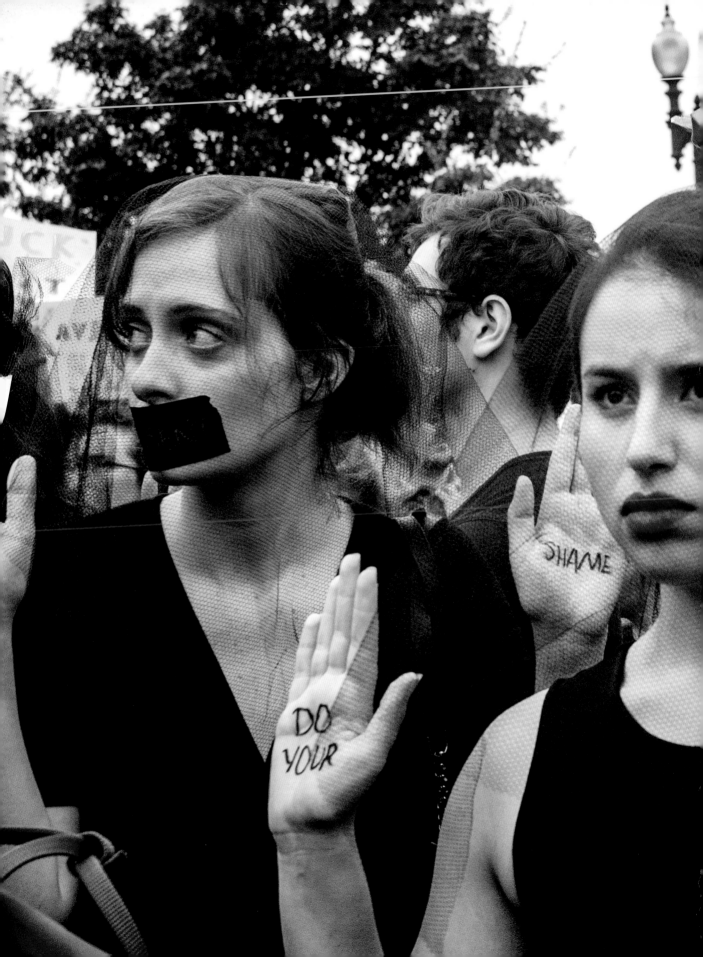

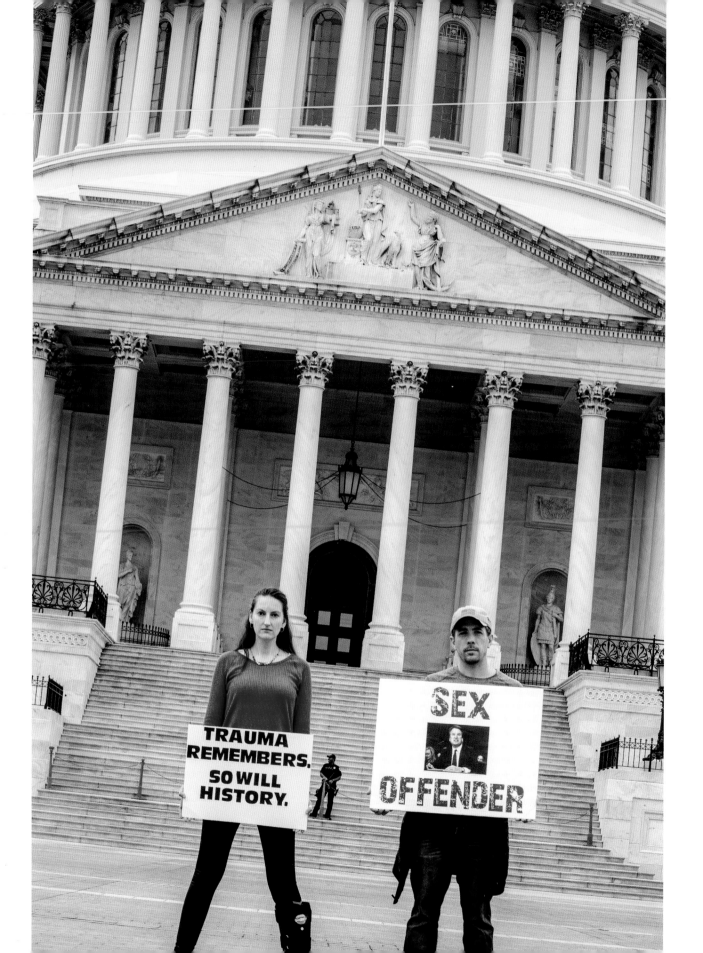

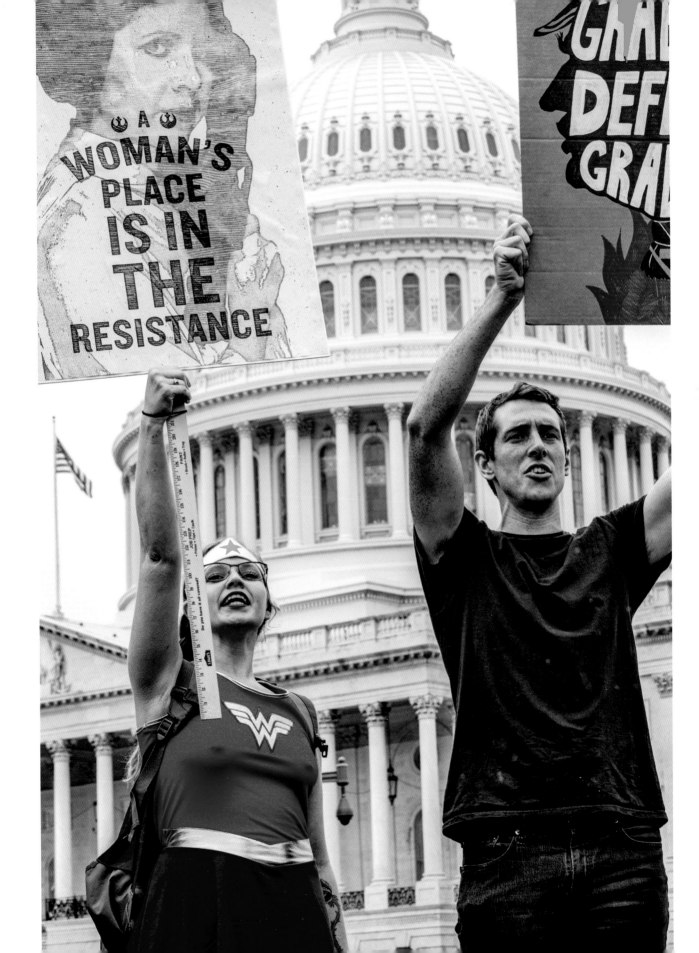

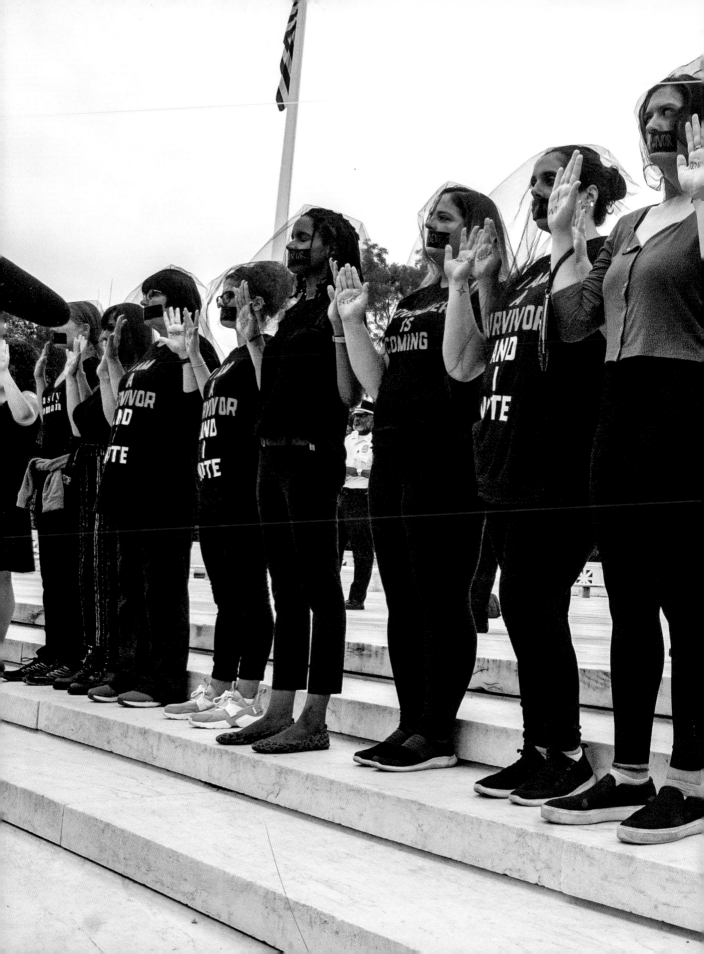

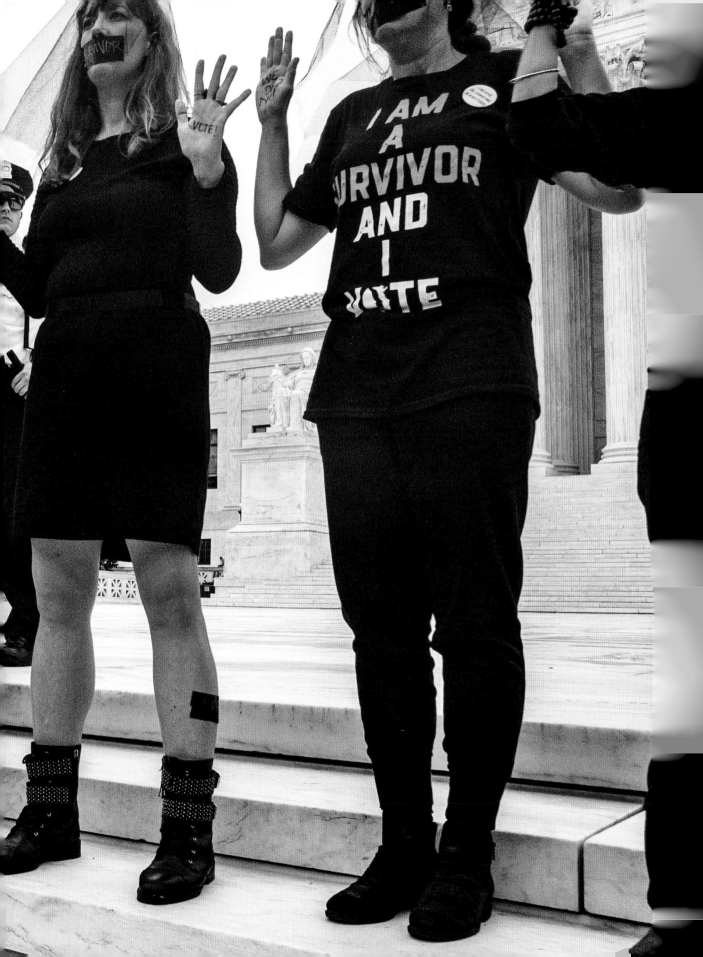

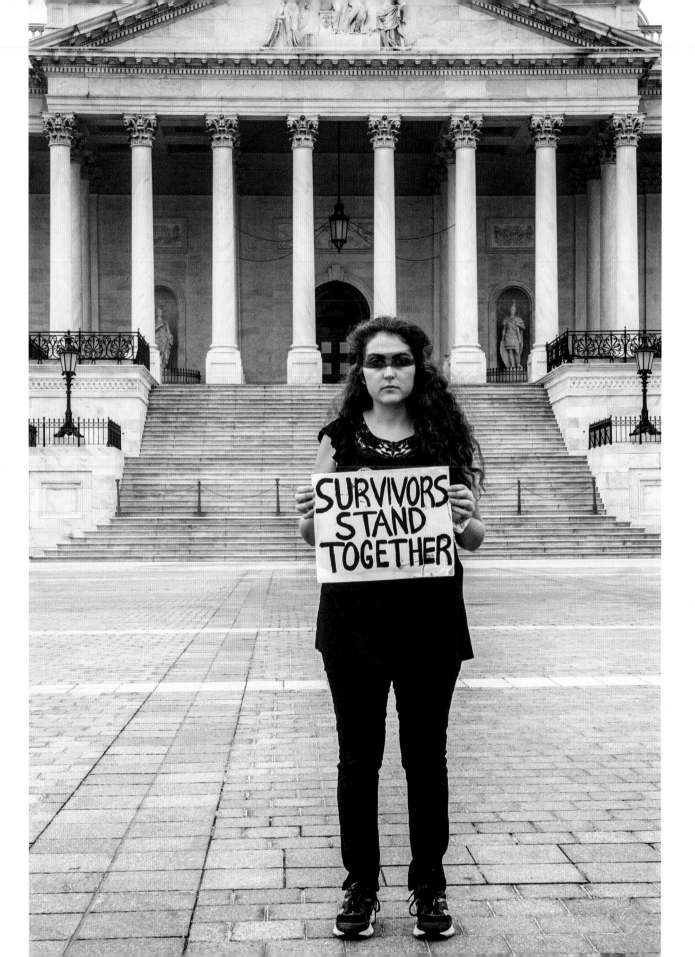

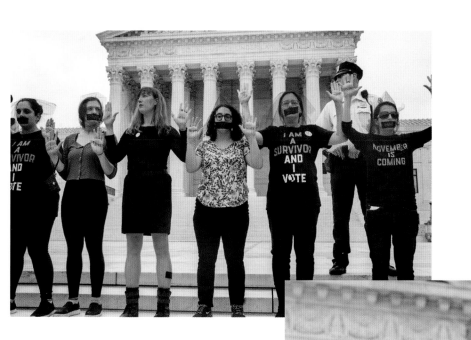

"I protested Kavanaugh because, as I heard more and more women tell their stories, I realized that the pain I carried as a survivor of sexual violence did not need to always be a source of isolation and shame. I realized I could transform my pain into solidarity, love, and political power. So I raised my voice for justice."

—ROSEMARY GESSEM

Executive Assistant, ACLU of Maryland

THIS & PREVIOUS THREE SPREADS -
Kavanaugh Protest,
Capitol Building,
Washington, DC, 2018

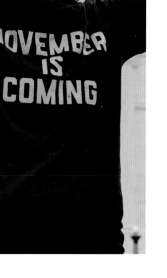

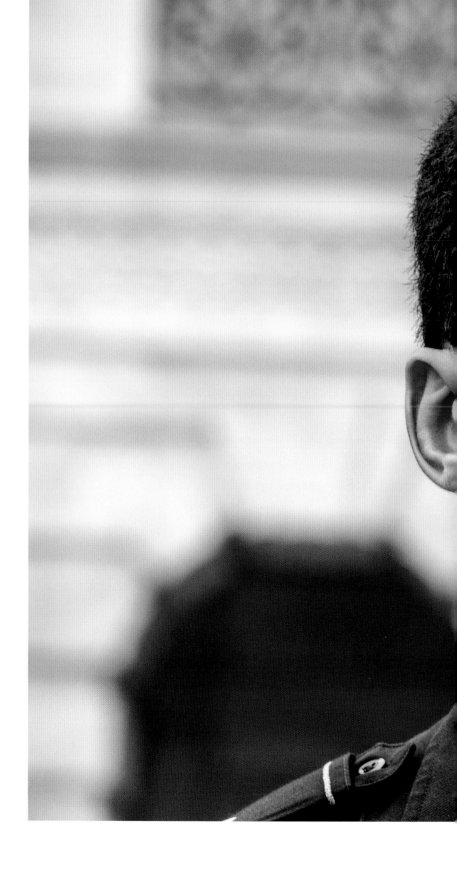

"Coming to protest gave me some sense of personal relief and agency in making my view heard. I think resetting our norms, restoring our faith in institutions, and demonstrating a caring culture are big tasks, and we have to come together to push forward on them."

—KATE DAVEY
Protester from Washington, DC

THIS & FOLLOWING SPREAD · Kavanaugh Protest, Capitol Building, Washington, DC, 2018

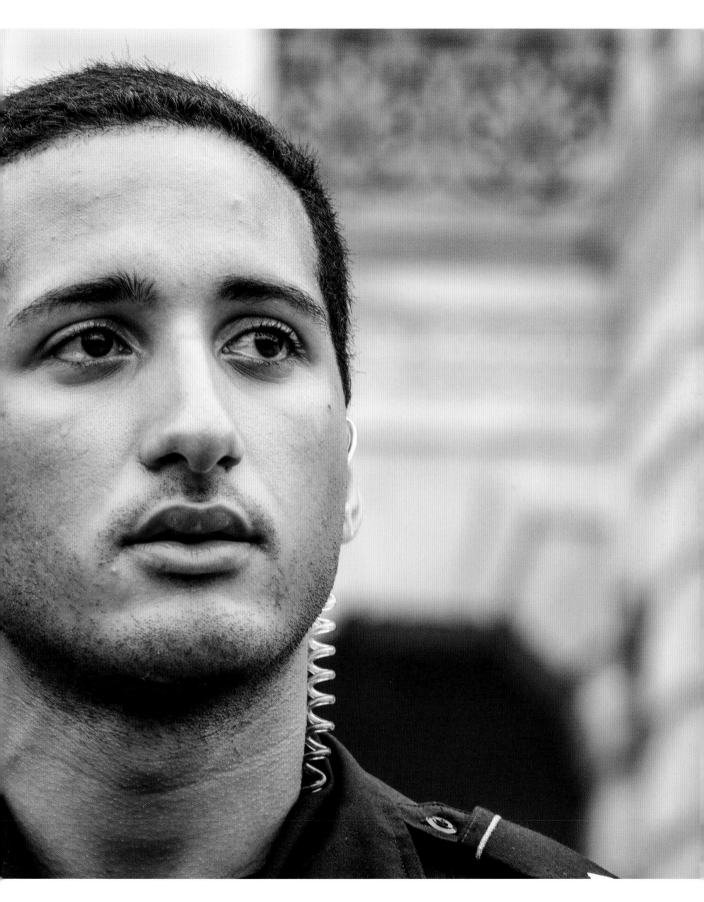

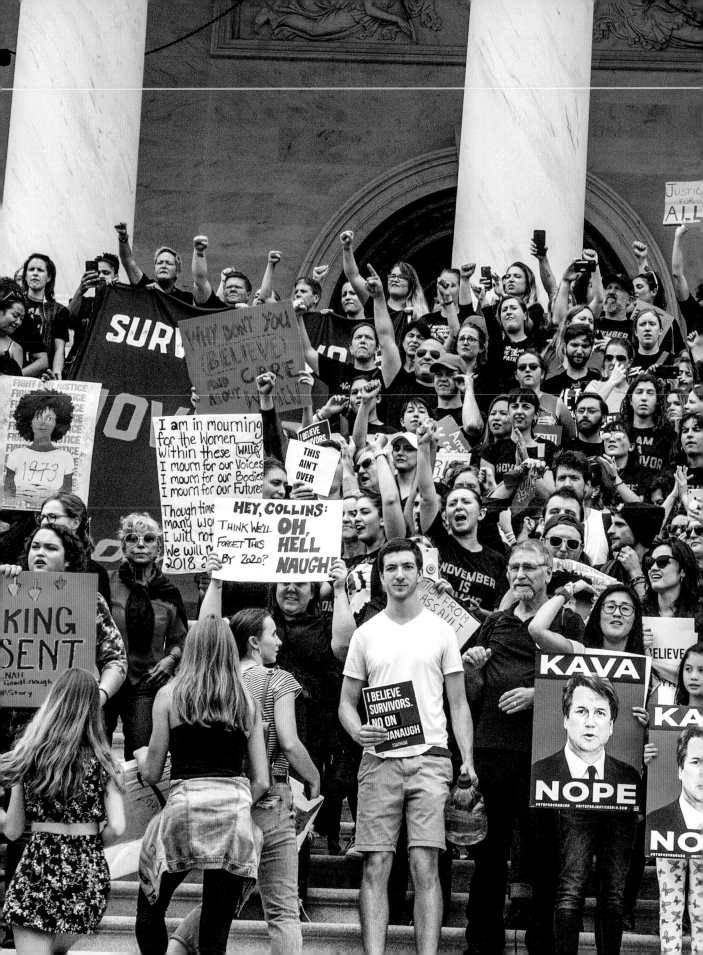

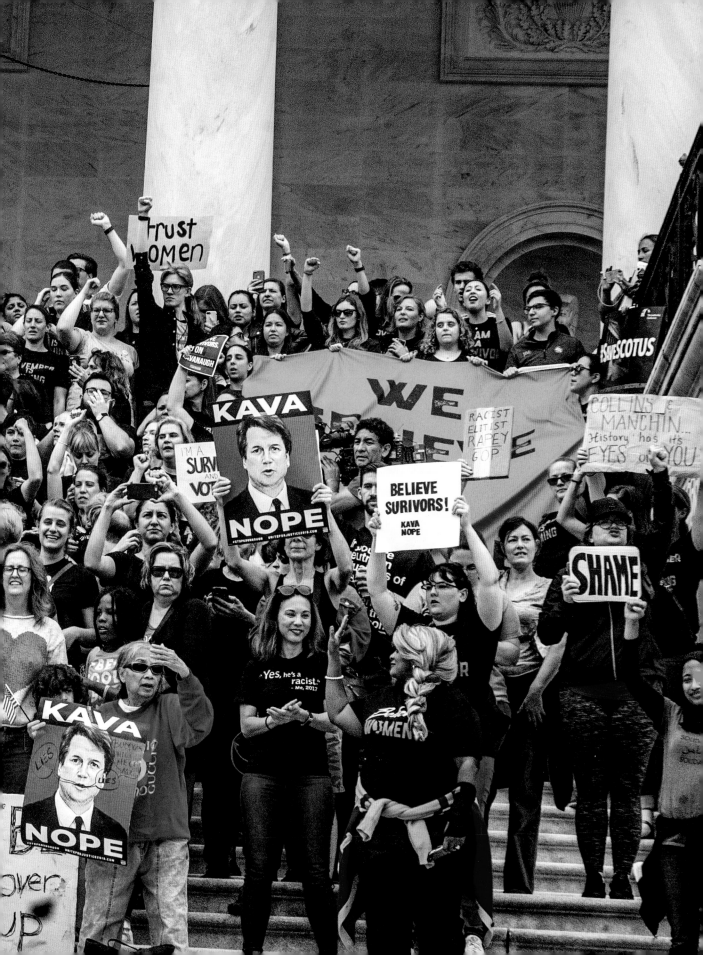

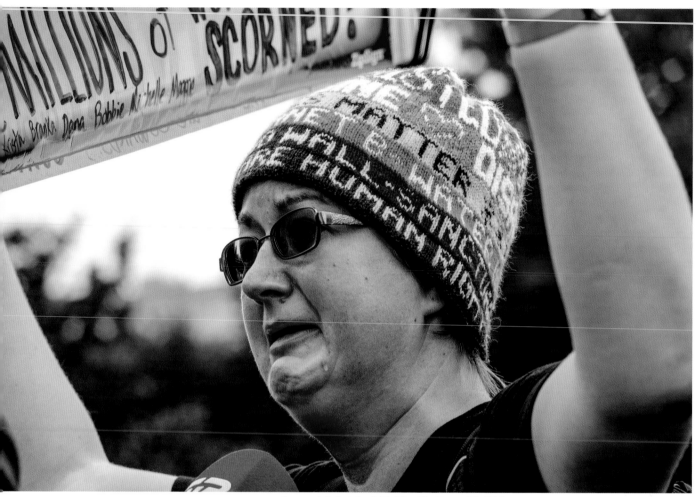

ABOVE & OPPOSITE · Kavanaugh Protest, Capitol Building, Washington, DC, 2018

"When reporters asked why I'd traveled from San Francisco, I wept. I thought of the survivors who felt further assaulted after Dr. Ford's testimony and Kavanaugh's explosive response. I cried for the women who'd be victimized should Roe v. Wade be overturned, and grieved the perversion of a rapist deciding whether or not rape victims could seek abortions. I worried that a conservative court would overturn my gay best friend's marriage that I'd witnessed just months before. Worst of all, I feared our complicit Senate was enabling Trump to destroy the checks and balances I value, and what makes our democracy unique."

—KATHERINE VELLEMAN

Protester from San Francisco

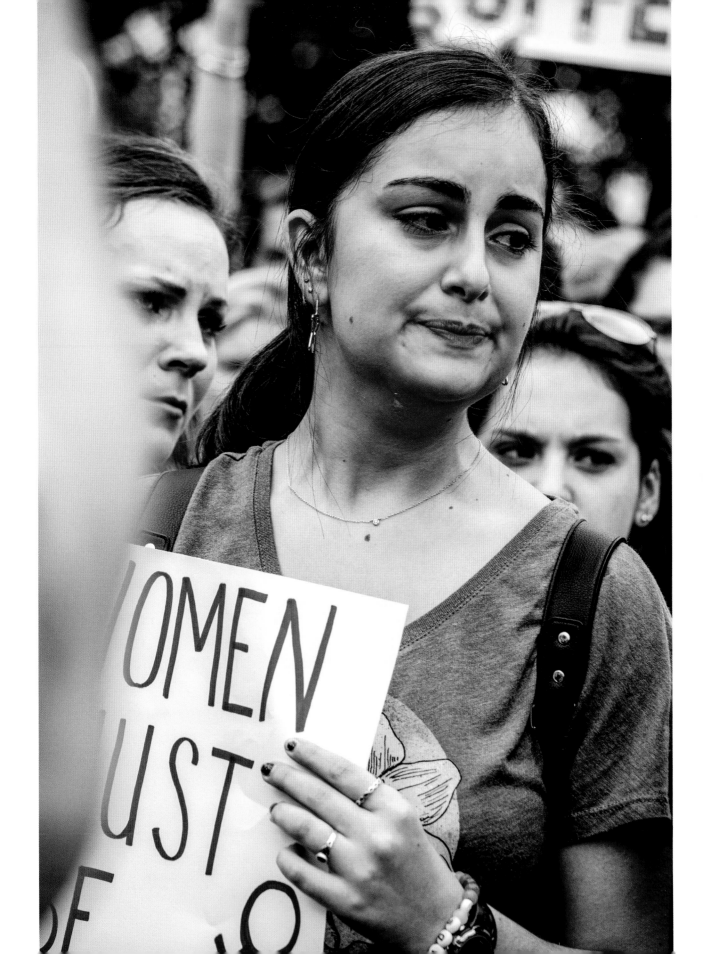

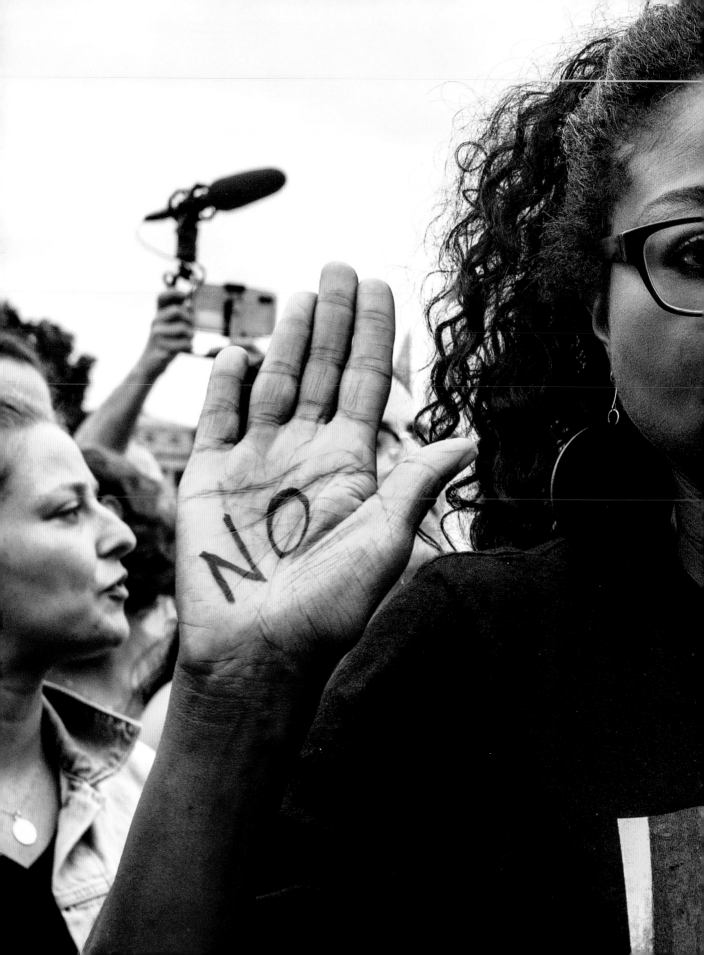

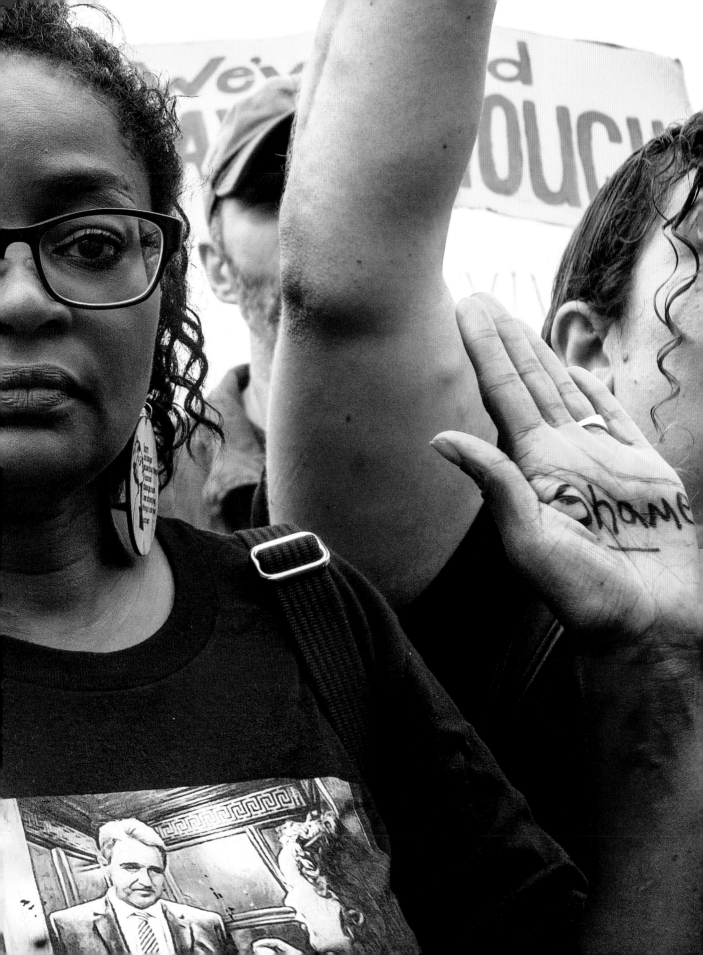

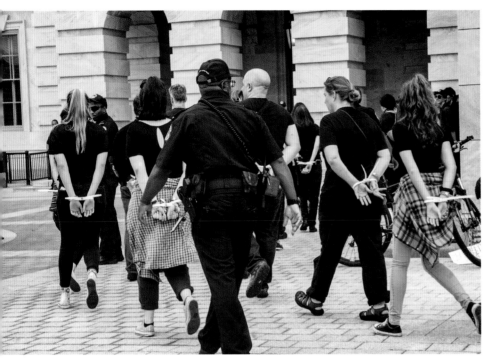

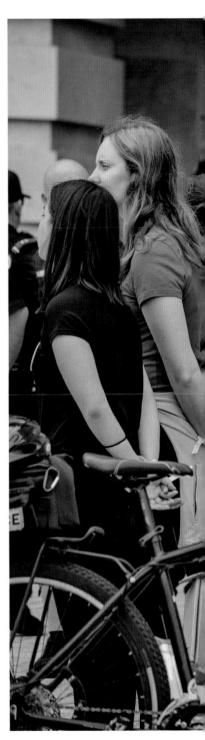

PREVIOUS & THIS SPREAD - Kavanaugh Protest, Capitol Building, Washington, DC, 2018

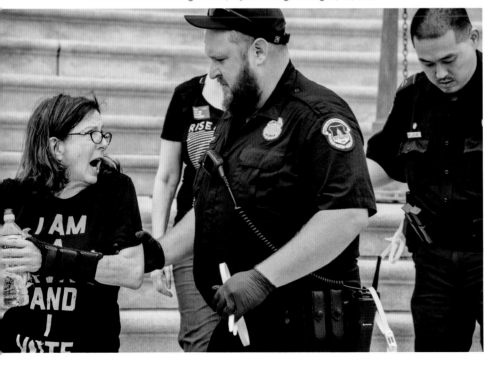

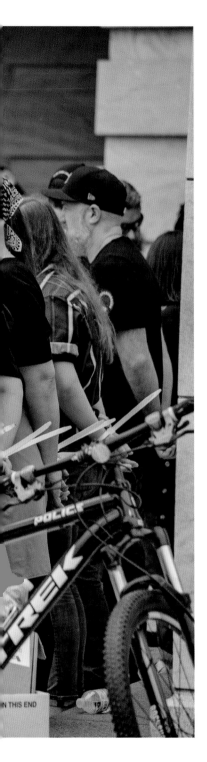

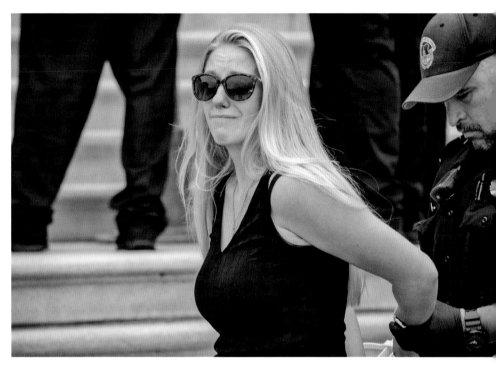

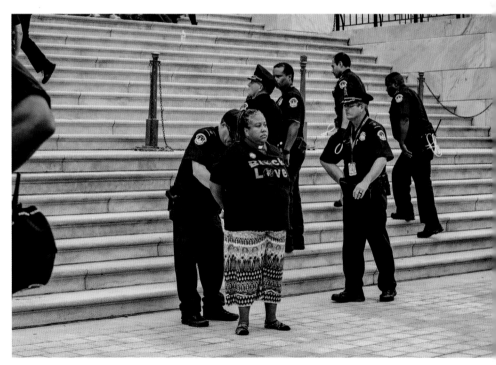

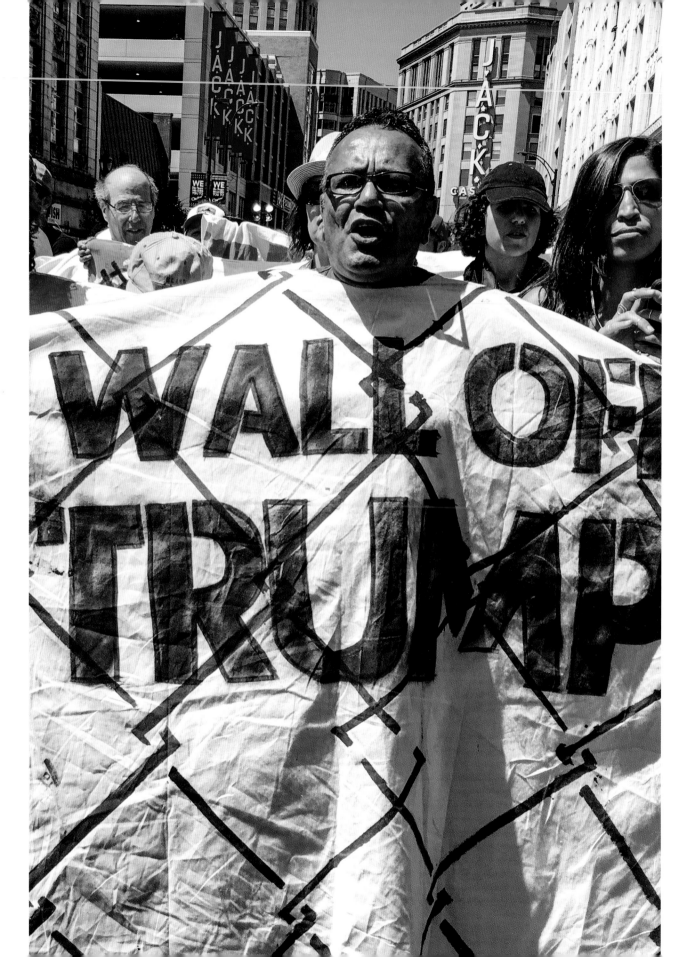

IMMIGRATION Trump's first order of business was to make good on his campaign promise to implement a travel ban on Muslims entering the United States. This executive action triggered a surge of demonstrations at airports in major cities across the U.S. Those who had relied on entry into the U.S. for lawful reasons were now targeted due to their religion.

Immigration has divided our nation for decades. The American Dream was upheld by DACA, a policy put in place by the Obama administration in 2012. This program protected immigrant youth who came to the U.S. when they were children. In 2017 President Trump rescinded DACA. The 800,000 or so youth who signed up for this program were now at risk. In one fell swoop Homeland Security targeted undocumented immigrants as well as vulnerable youth whose DACA protection had expired. There were massive arrests. The fear of deportation and the breakup of families sent shock waves rippling throughout the Latino community. The undoing of this well-liked legislation outraged most Americans of all political affiliations. "We Are Already Home" was the battle cry at rallies from coast to coast.

OPPOSITE - Republican Convention, Immigration Rally, Cleveland, Ohio, 2016

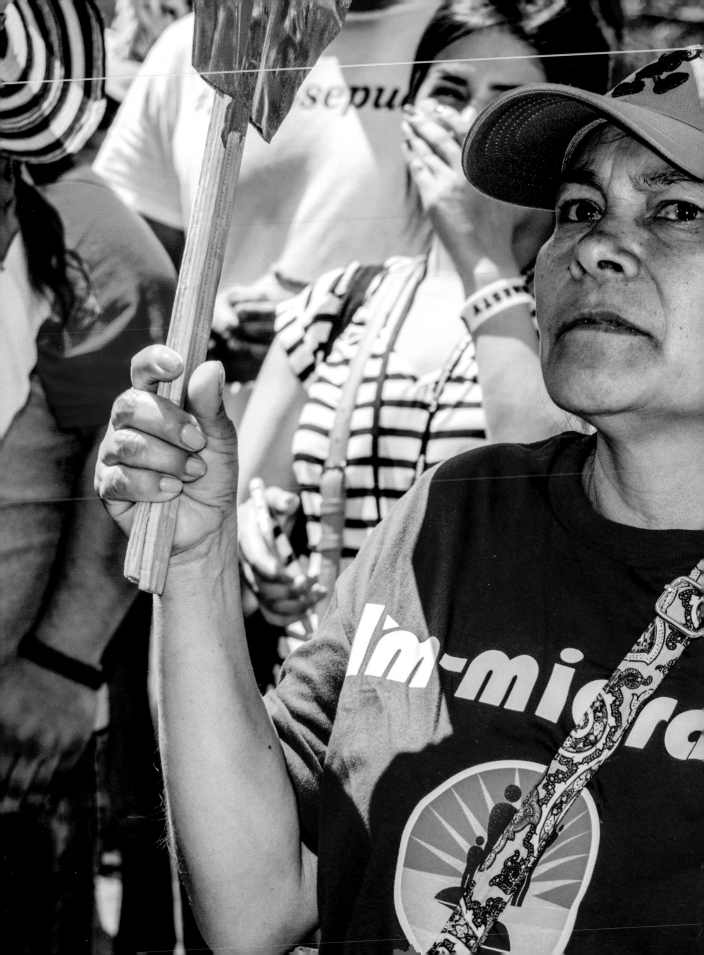

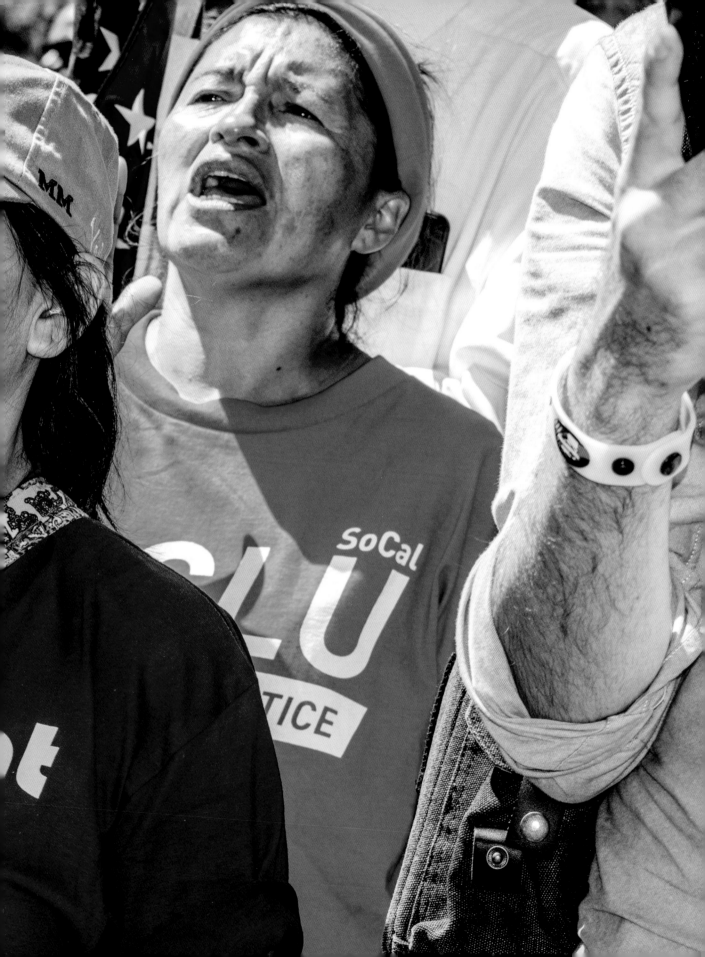

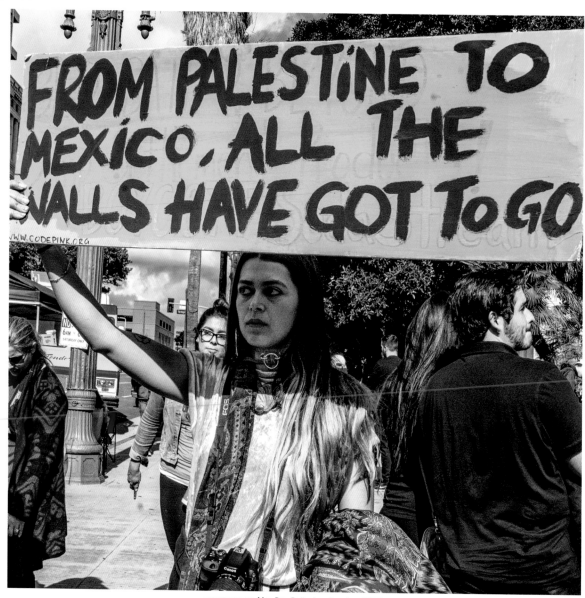

ABOVE & OPPOSITE - May Day Rally, Los Angeles, 2017
PREVIOUS SPREAD - Immigration/DACA Rally, Los Angeles, 2017

"In my ten years of advocacy in the immigrant movement, I have never seen anything like the high tension, stress, and panic that the Trump administration has imposed upon the undocumented and documented population alike."

—KARLA ESTRADA

Founder, Undocutravelers, Class of UCLA 2015

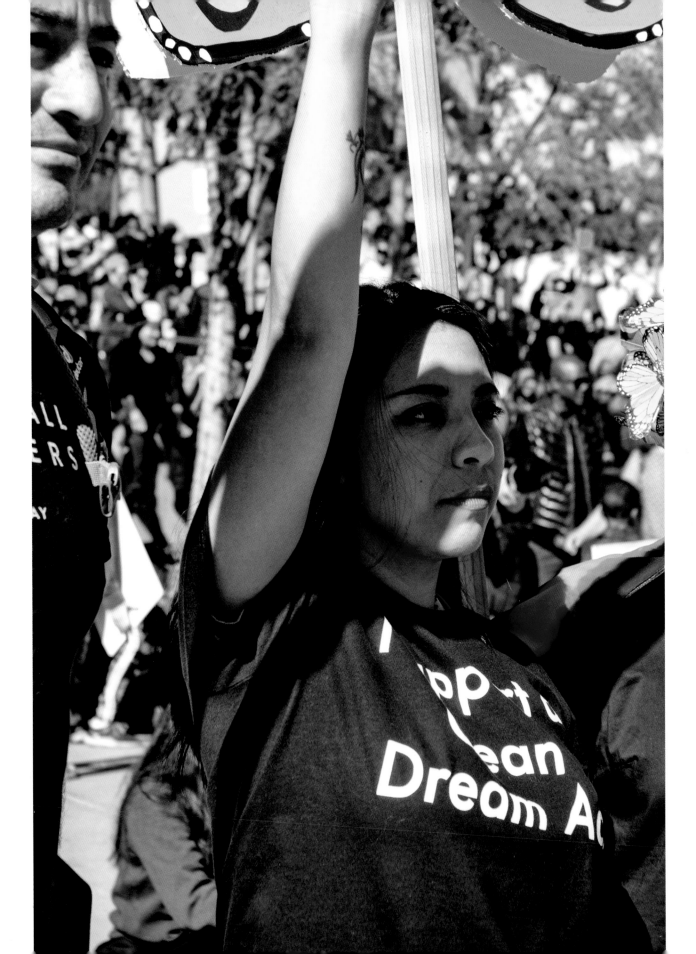

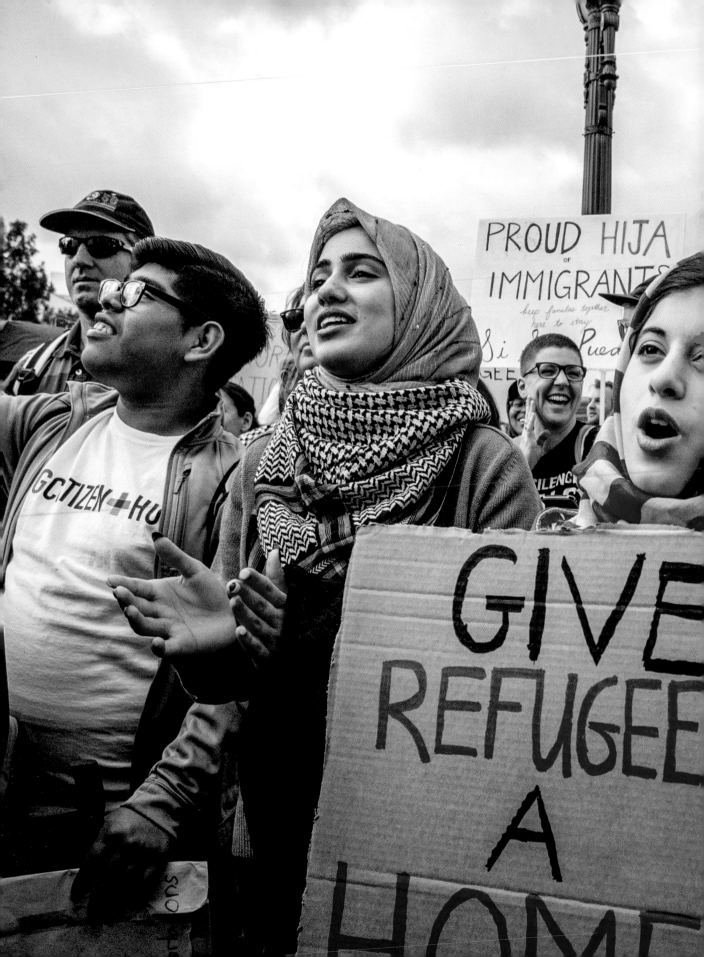

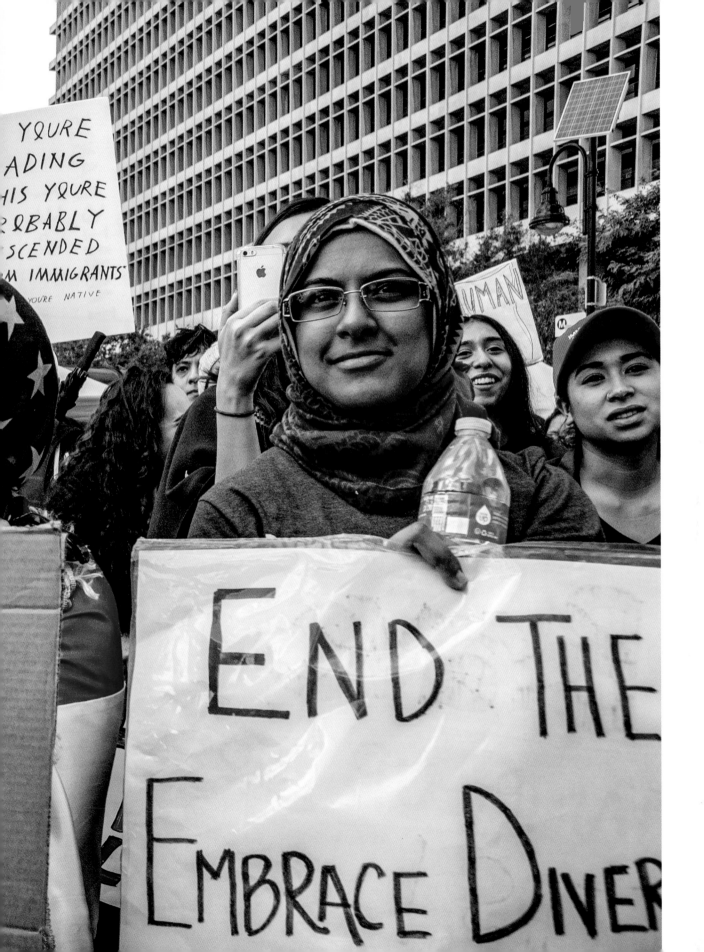

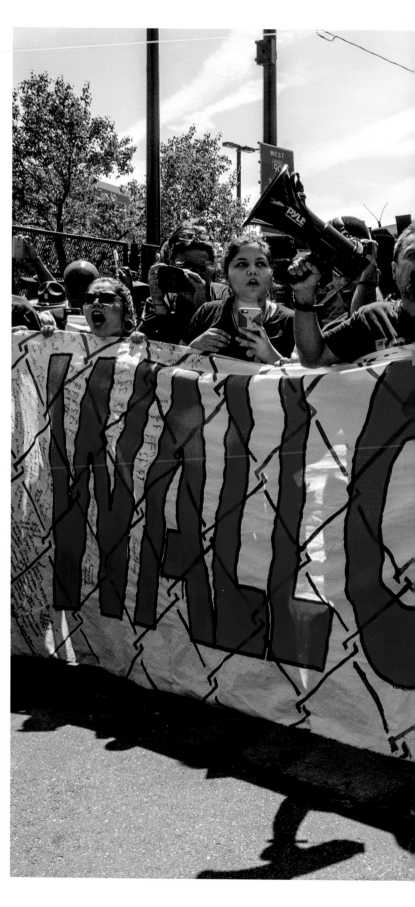

"We are controlling here, in the U.S. alone, eleven million lives. That's how severe it is. If we separate ourselves by any measure of humanity from those people, then we do not understand the situation. And if we think any differently, if we think someone else is going to solve this problem, it is not going to happen. It may take generations until there is a fair and just situation here. If we are not motivated by our humanity—and that alone —to help these people, then we have no humanity. I once heard Lyndon Johnson say that we belong to a very exclusive club and the dues are very high. It's called the United States of America. We can never pay the price of devaluing our humanity in the name of 'protecting our citizenship.'"

—MARTIN SHEEN

Actor, Activist

Republican Convention, Cleveland, Ohio, 2016
PREVIOUS SPREAD · Immigration/ DACA Rally, Los Angeles, 2017
FOLLOWING SPREAD · May Day Rally, Los Angeles, 2017

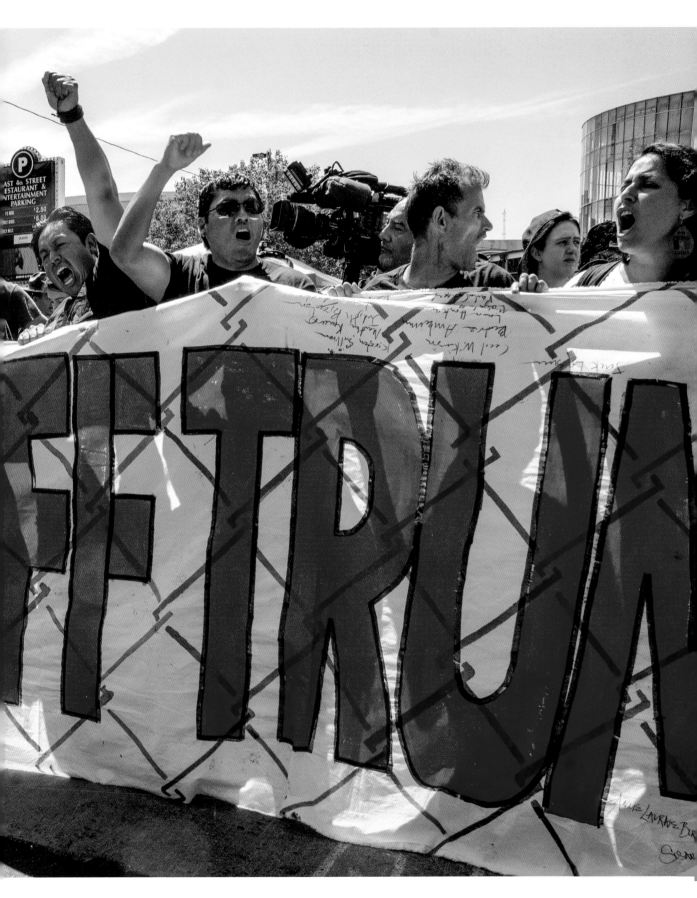

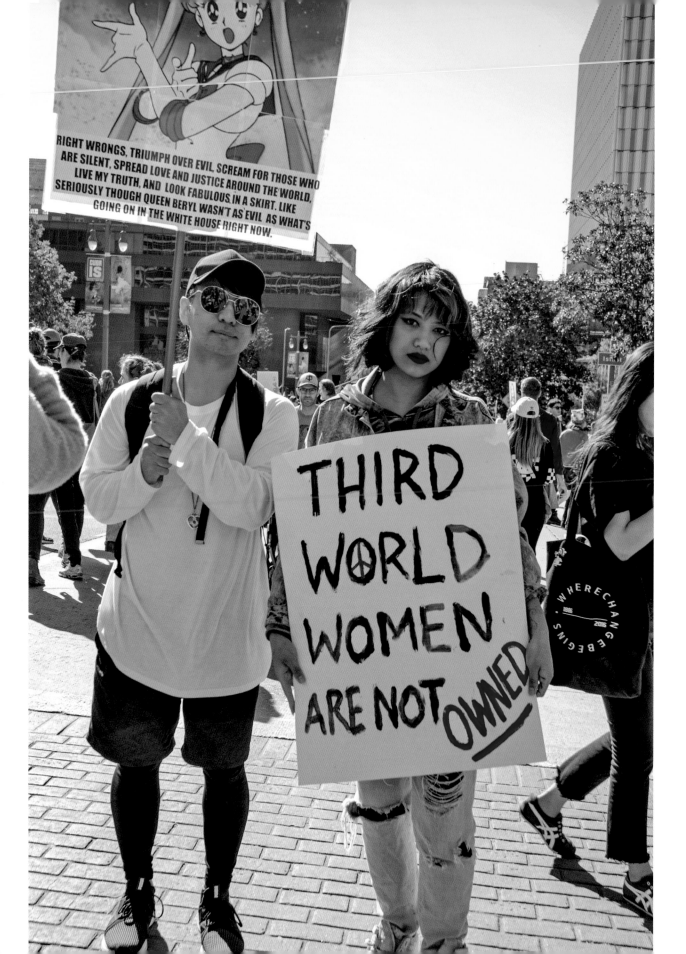

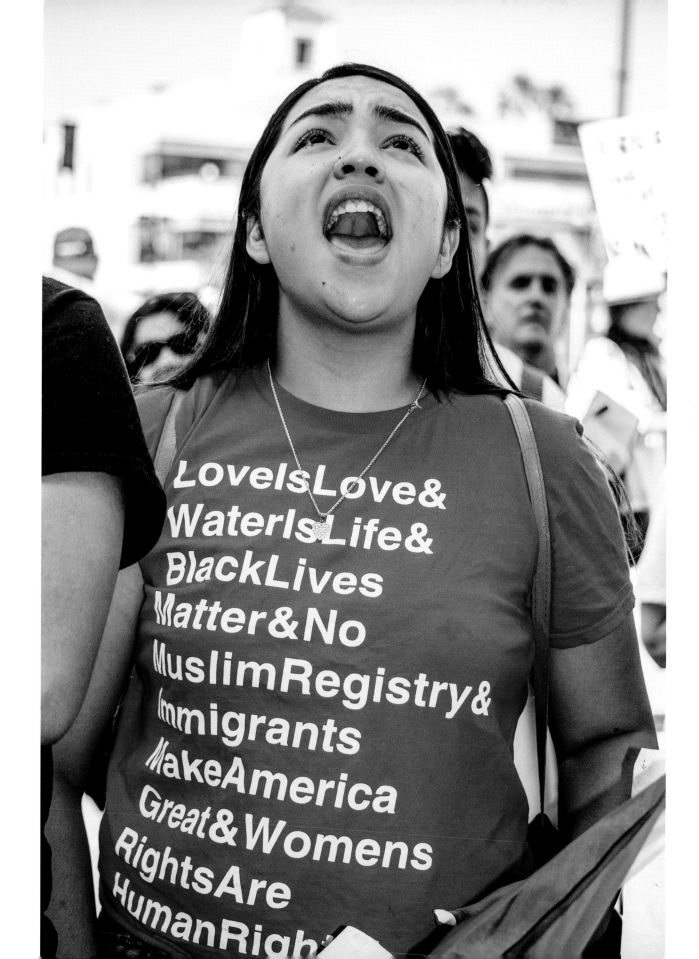

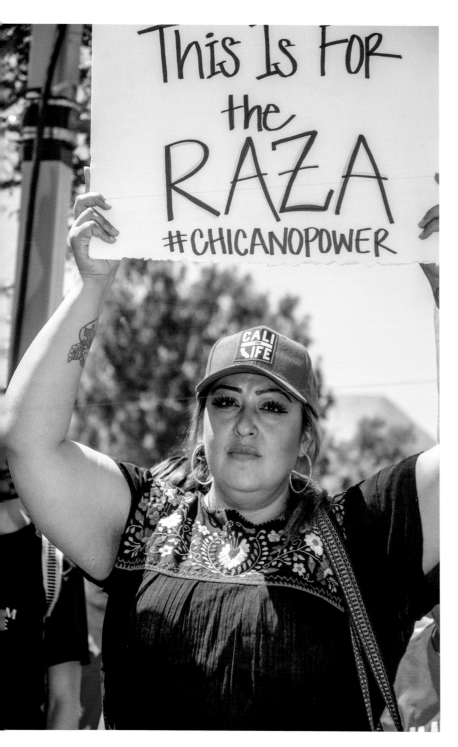
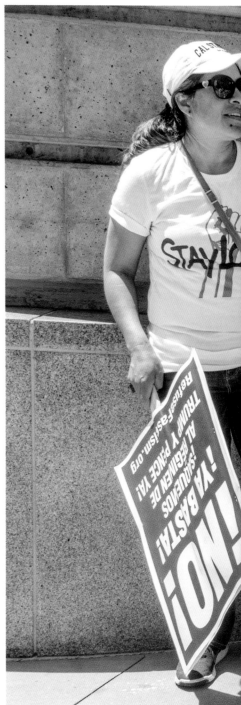

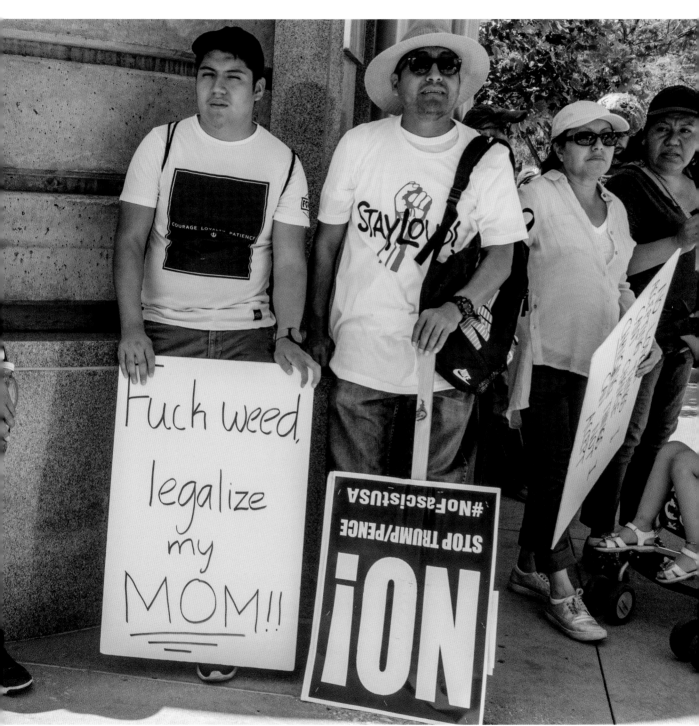

OPPOSITE & ABOVE · Immigration/DACA Rally, Los Angeles, 2017

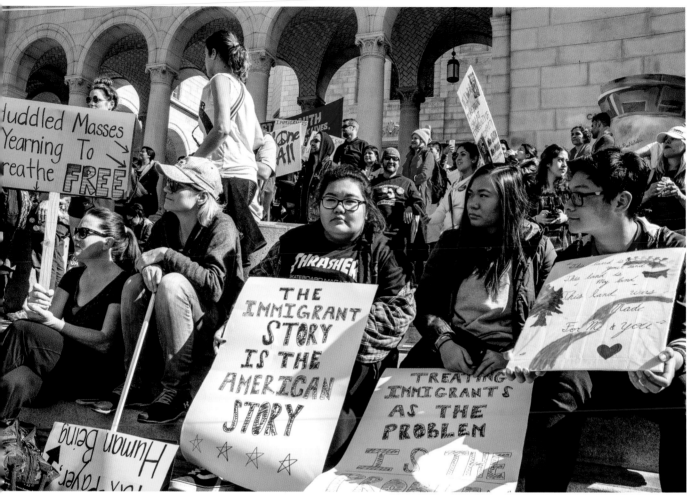

ABOVE & OPPOSITE - Immigration/DACA Rally, Los Angeles, 2017

"I am a DACA recipient, and an immigrant. I kept this to myself for many years. Whenever I faced discrimination, I felt powerless and alone. But today I can no longer be silent about the horrible things happening to families in my community.

For the longest time I felt like my voice did not matter, but now I think differently. We can't be frightened any longer. Real courage comes from acting despite being afraid, and standing up for those who cannot speak for themselves."

—JAVIER HERNANDEZ KISTTE
Documentary Filmmaker

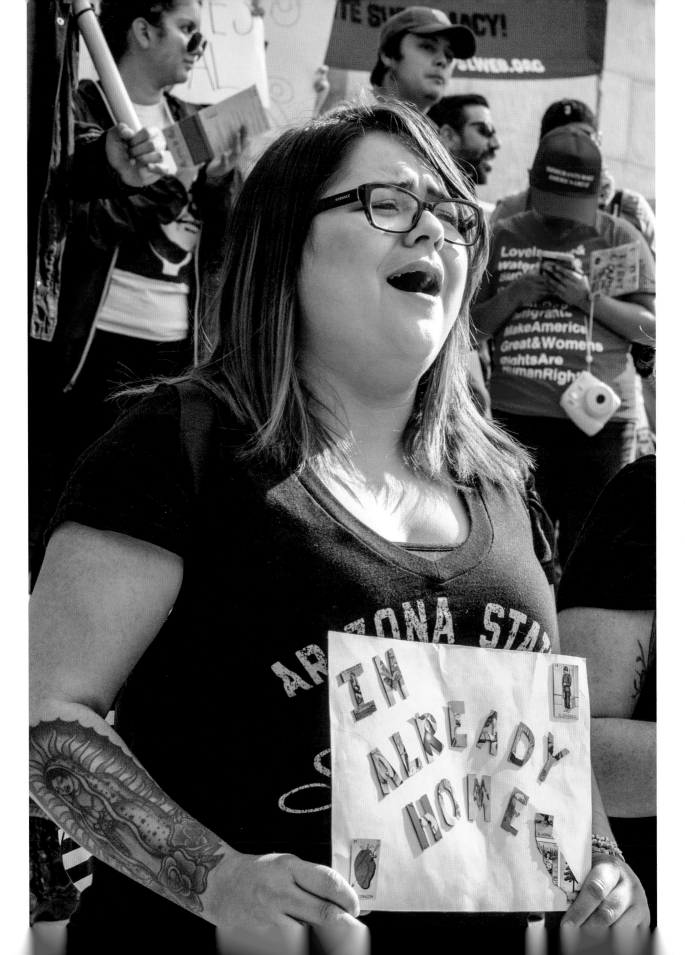

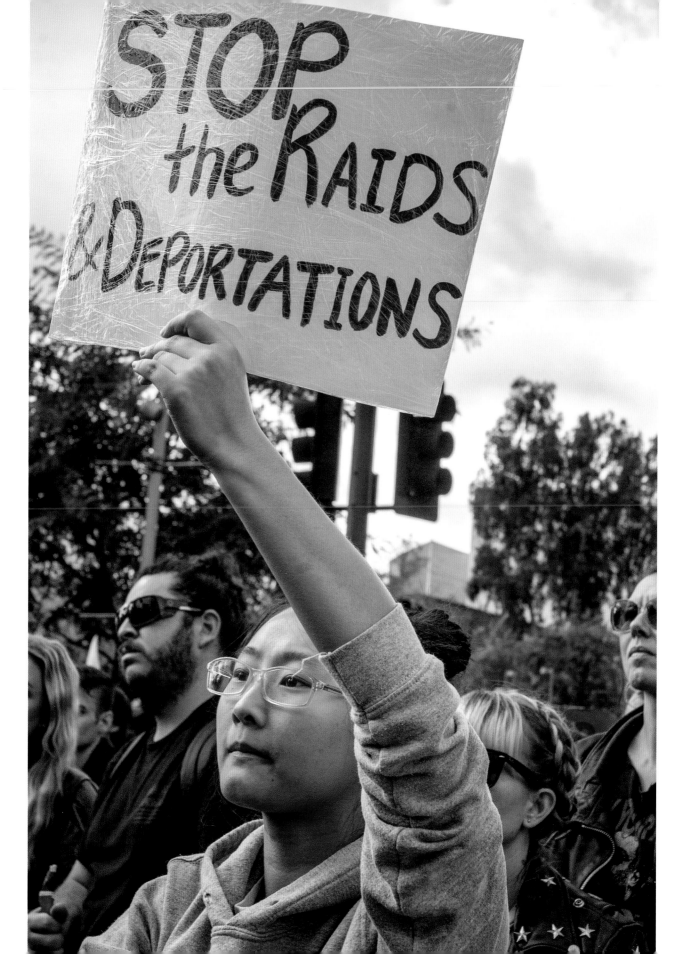

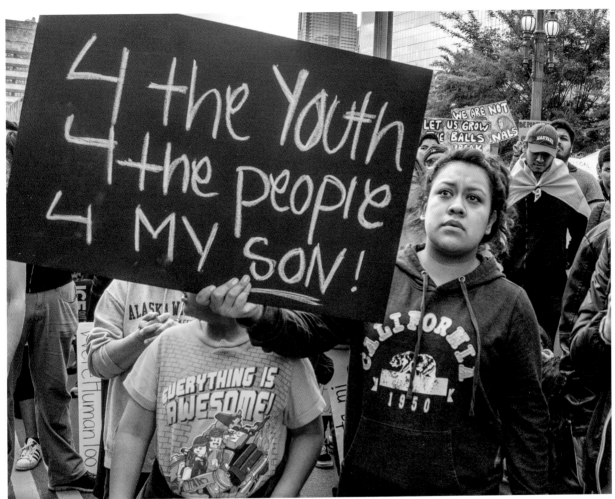

OPPOSITE, ABOVE & NEXT SPREAD · Immigration/DACA Rally, Los Angeles, 2017

"I had the honor to work alongside other undocumented youth and allies in several campaigns that ultimately pressured the Obama administration to grant DACA and led to the passage of state financial aid for undocumented and other qualified students in California. The imprisonment and separation of refugees and migrant families by the US government is immoral. This cannot continue! "

—JUSTINO MORA

Cofounder, Polibeats, Push4Reform, Text4Reform, Class of UCLA, 2015

121

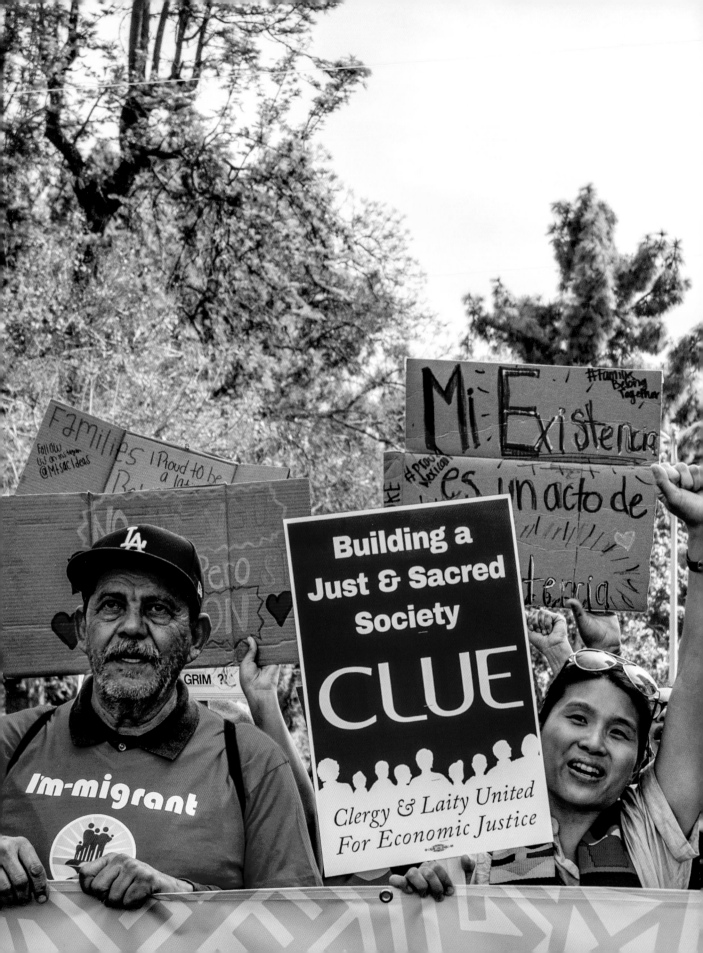

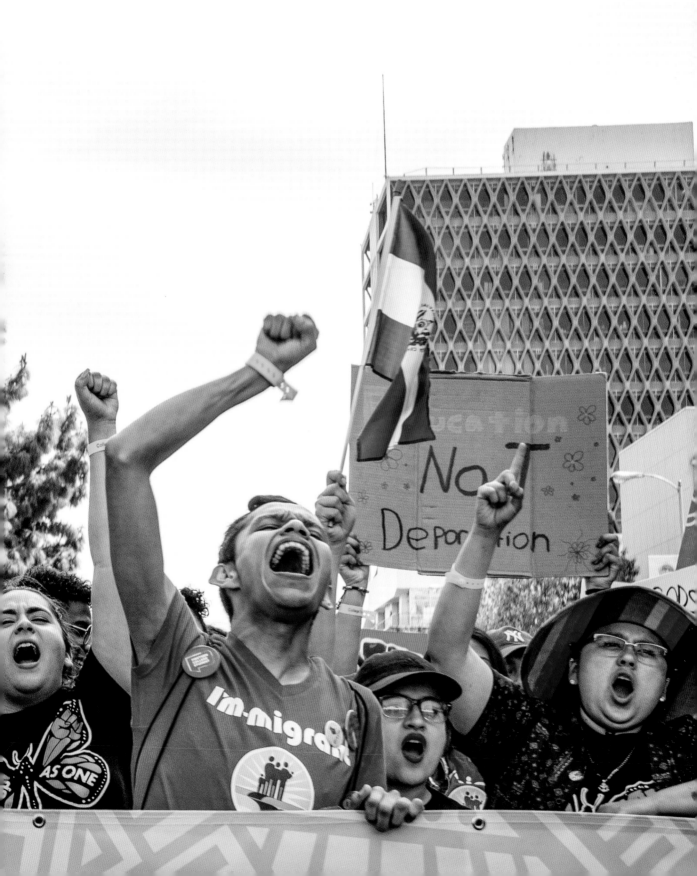

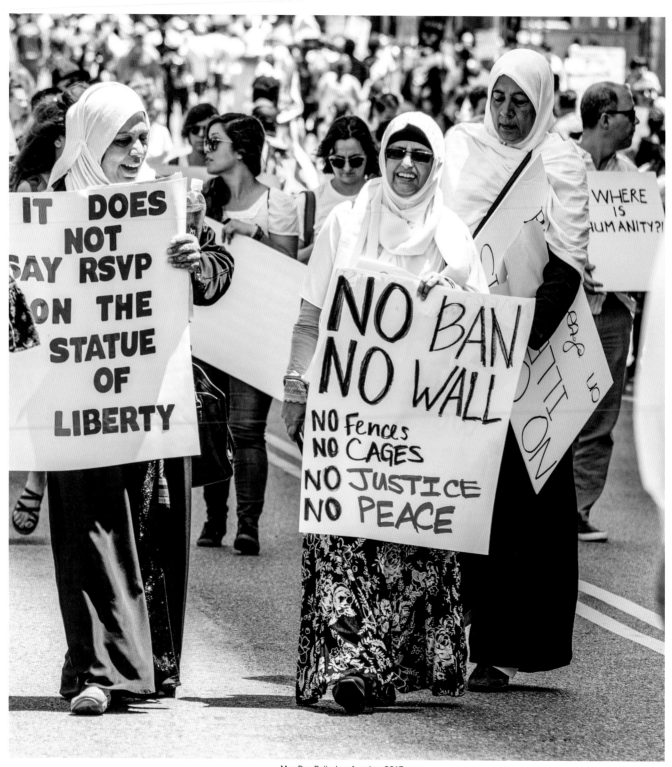

May Day Rally, Los Angeles, 2017
OPPOSITE · Protest at Pro-Trump Rally, Anaheim, California, 2018

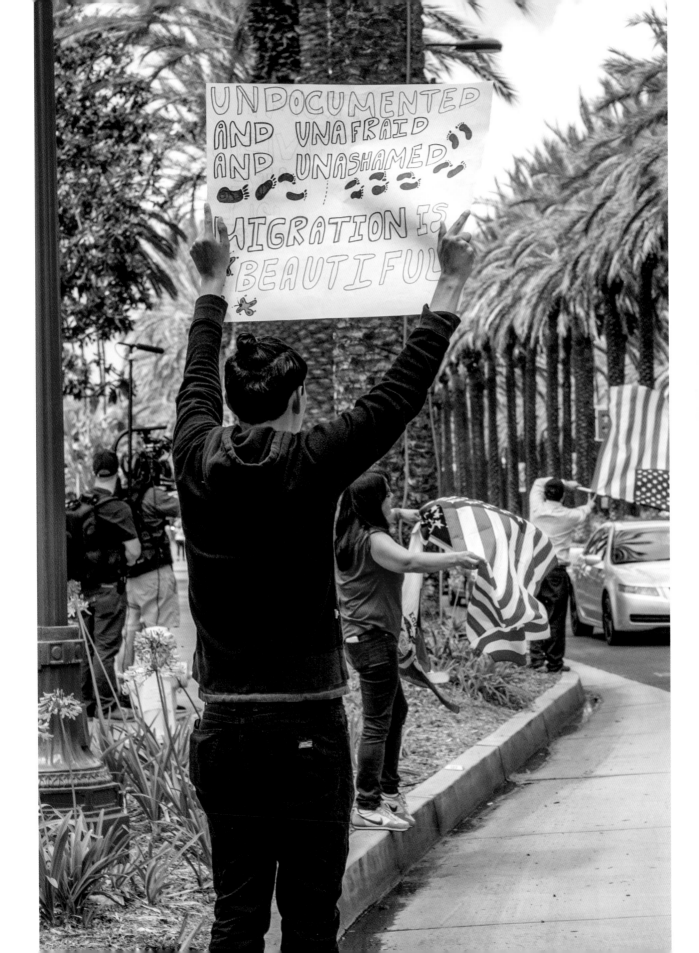

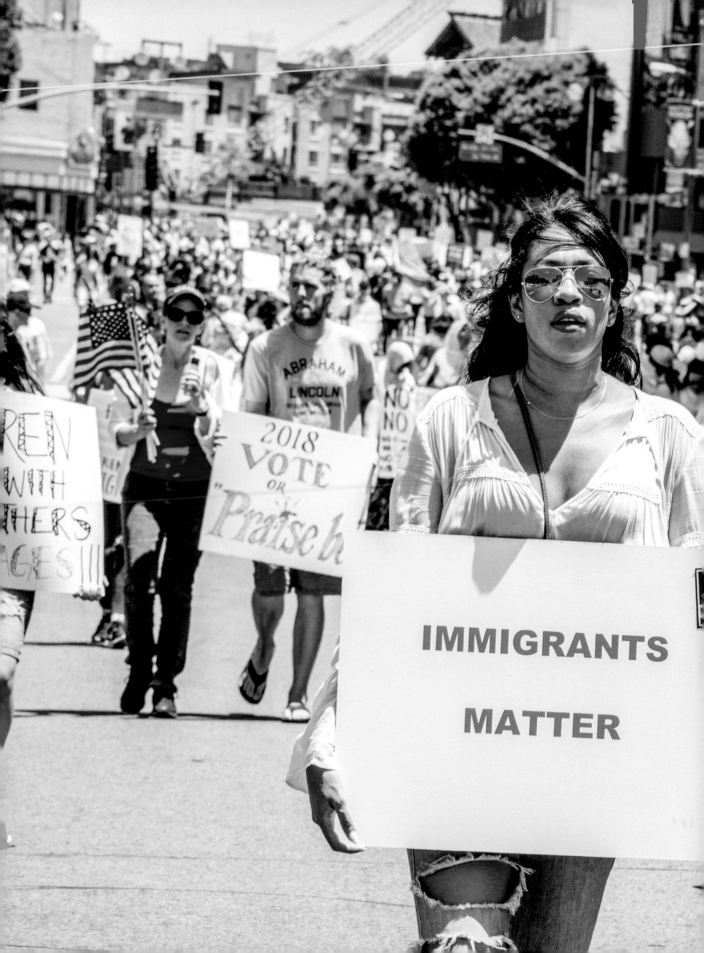

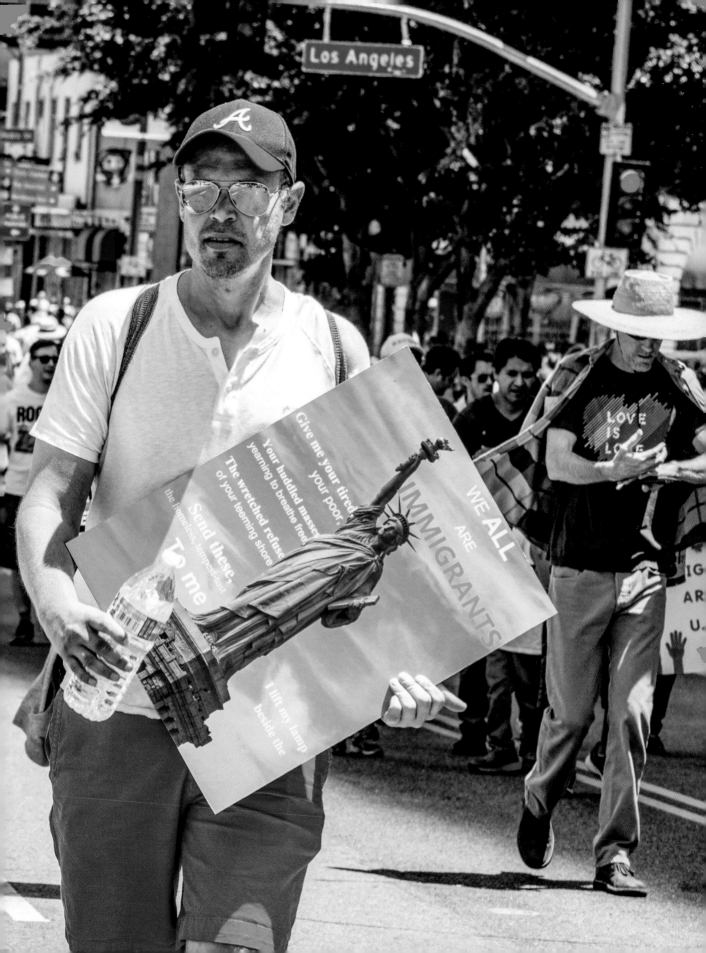

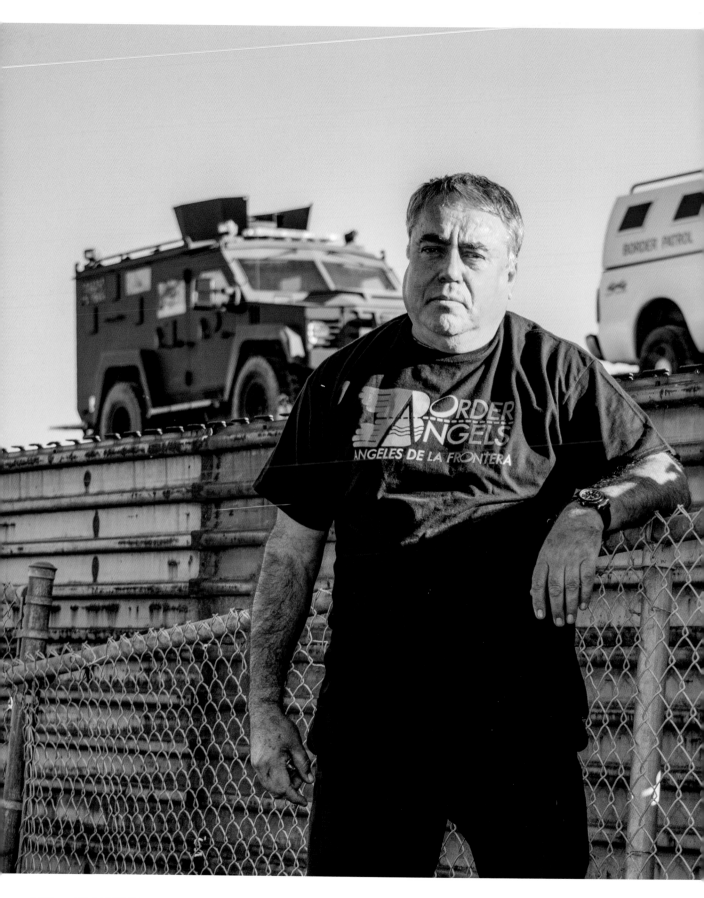

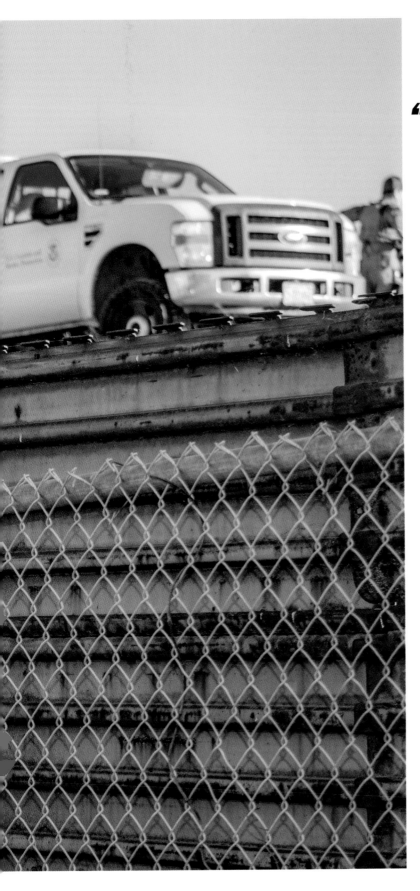

"Love is an action, not just a word. As we live in these troubling times, we should not mourn, we should organize. This country is long overdue to live up to the standards of justice and liberty for all. We need to pass a clean dream act, have humane immigration policies, and stop interfering in the policies of other countries. This country should be leading the world in welcoming migrants instead of espousing hateful and divisive rhetoric from the White House. The US should not be at a distant twenty-first (per capita) internationally in welcoming migrants. Love has no borders."

—ENRIQUE MORONES

Executive Director and Founder, Border Angels

Enrique Morones, Border Wall,
San Diego County, 2018
PREVIOUS SPREAD · May Day Rally,
Los Angeles, 2017

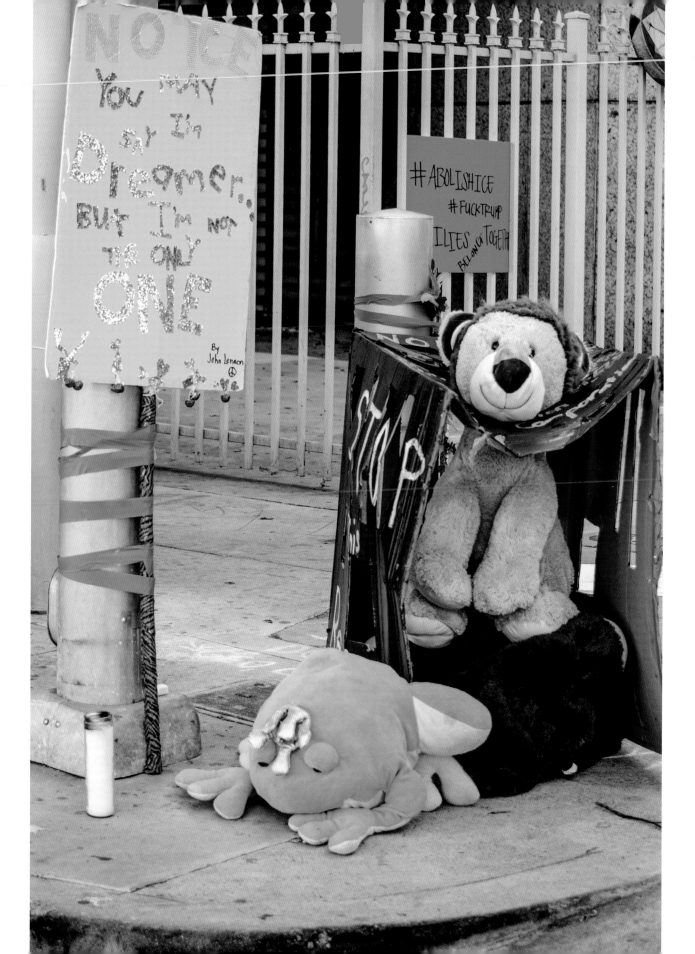

FAMILY SEPARATION

The Trump administration mandated a zero tolerance policy on April 6, 2018, calling for the criminal prosecution of migrants caught entering the United States illegally. Children traveling with them were detained and placed in holding cells. The separation of families tore at the fabric of who we are as Americans, scorching our basic decency and harkening back to the most egregious images of the previous century. Haven't we learned?

Americans believe in the symbol of the Statue of Liberty as the "Mother of Exiles."

Politicians and celebrities led supersized crowds marching down main streets USA, chanting in unison, "children don't belong in cages" and "let the children go."

Due to public pressure, the separation of families was halted by executive action on June 20, 2018. Yet the separation never really stopped. The damage to the children, their mothers and fathers, and these families continues and is irrevocable. Many families will never be reunited. This is not who we are as a nation. We can do better. We must do better.

OPPOSITE · Family Separation Rally, Metropolitan Detention Center, Los Angeles, 2018
FOLLOWING SPREAD · Family Separation Rally, Los Angeles, 2018

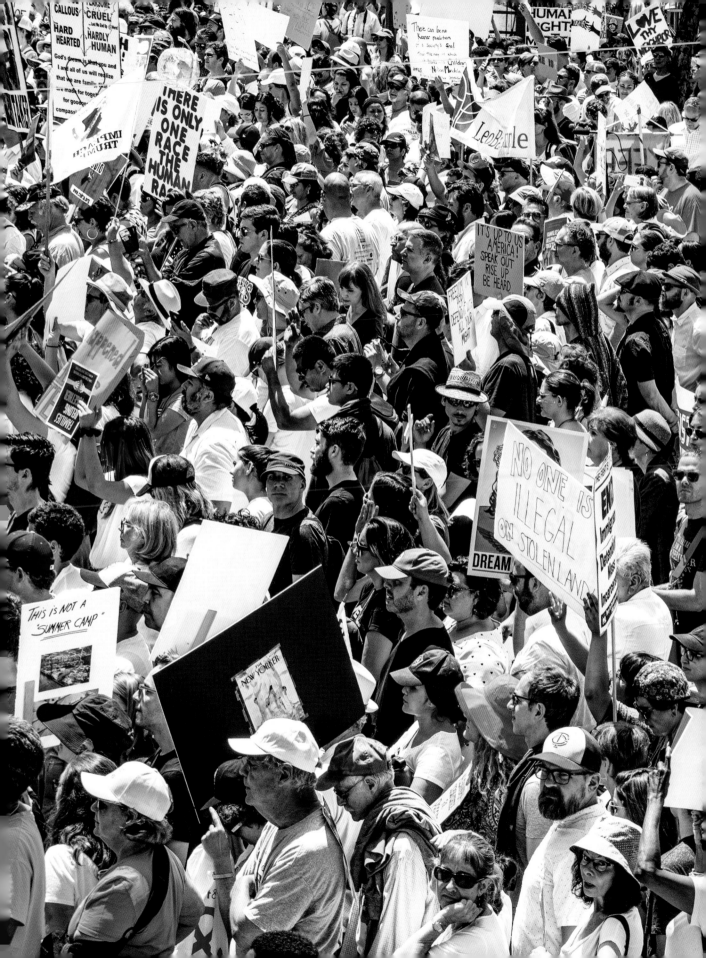

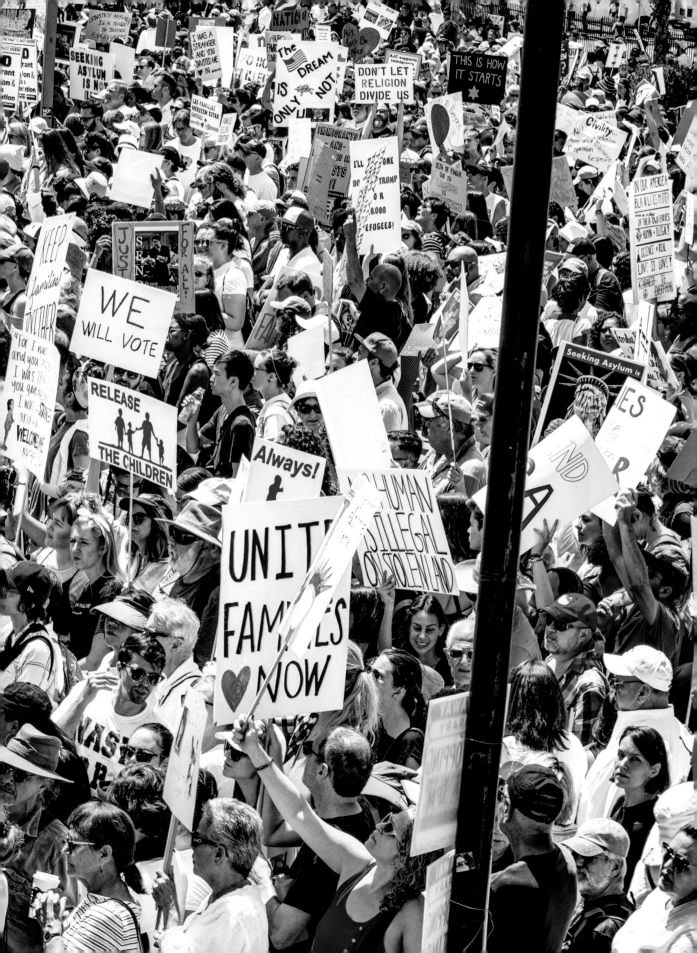

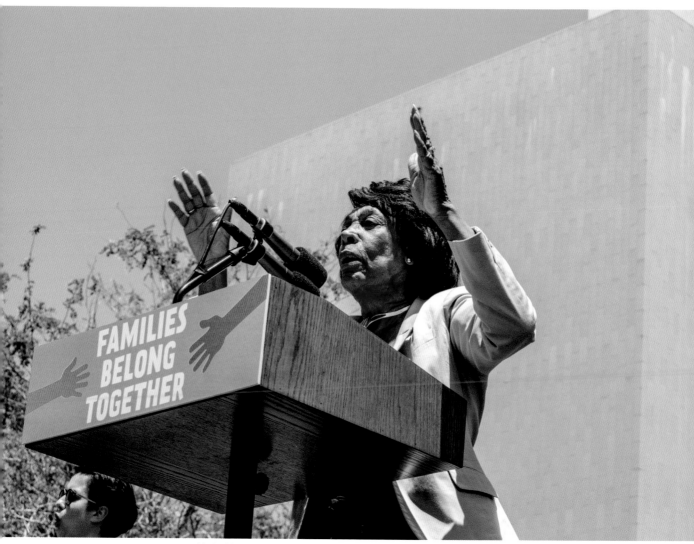

ABOVE · Maxine Waters, **TOP OPPOSITE** · Kamala Harris **& BOTTOM OPPOSITE** · Jaime Gomez of the Black Eyed Peas,
Family Separation Rally, Los Angeles, 2018

"How dare you take the babies from mothers' arms? How dare you take the children and send them all across the country into so-called detention centers? You are putting them in cages, you are putting them in jails, and you think we're going to let you get away with that? I don't think so."

—MAXINE WATERS

Congresswoman from California

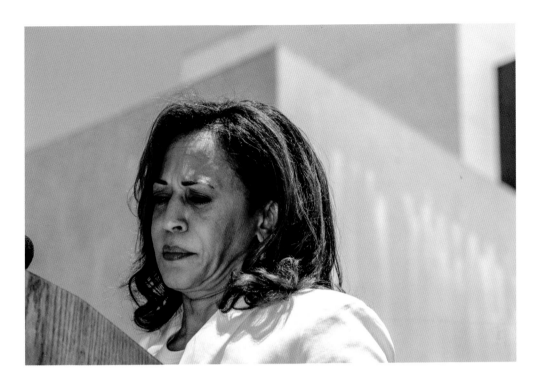

"Years from now our children and our grandchildren are going look at us and they are going to ask us the question: Where were you at that reflection moment? I know our answer is not simply going to be how we felt. Our answer is going to be what we did. We will fight. We will speak truth to power. We will act on our word. We will vote. We will not relent. We will not cower. And we will not stop fighting because we are better than this."

—**KAMALA HARRIS**
Senator from California

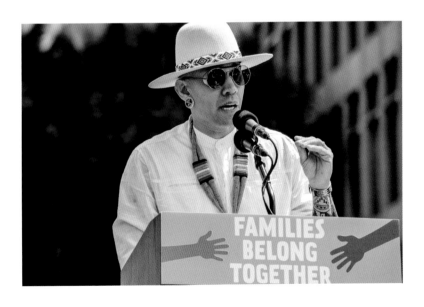

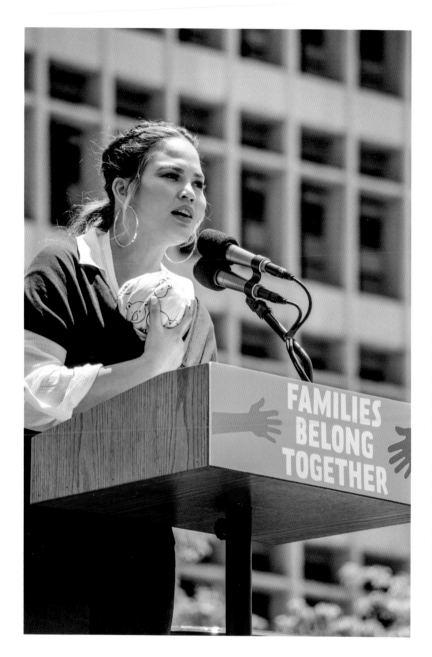

" What makes California great is at our best, we don't tolerate diversity, we celebrate that diversity. A universal state, California, a state of refuge. A state that has brought in, in the last twelve years, over 112,000 refugees.

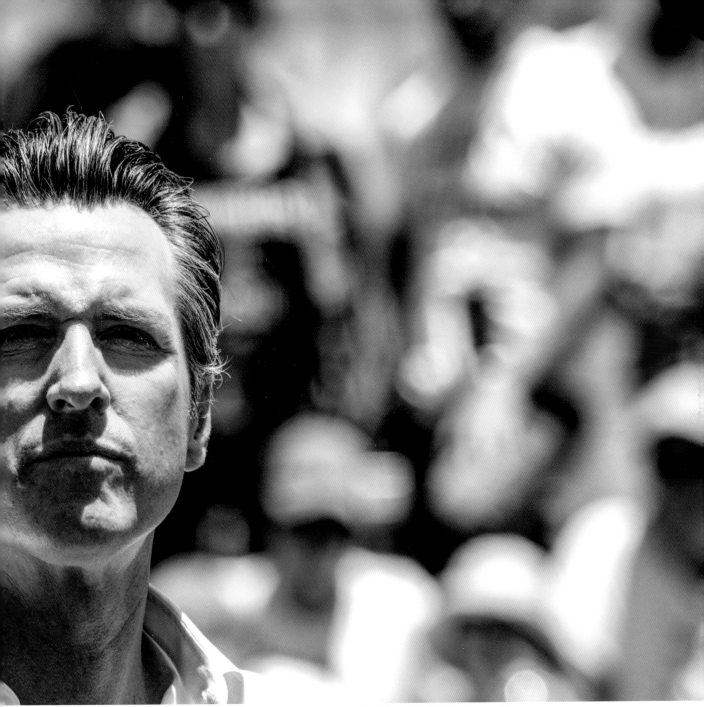

OPPOSITE · Chrissy Teigen, actress, ABOVE · Gavin Newsom & FOLLOWING SPREAD · Family Separation Rally, Los Angeles, 2018

A state that in the last year has brought in 1,454 refugees, more than any other state, because at the end of the day, the future is not just something to experience, it is something to manifest."

—GAVIN NEWSOM

Governor of California

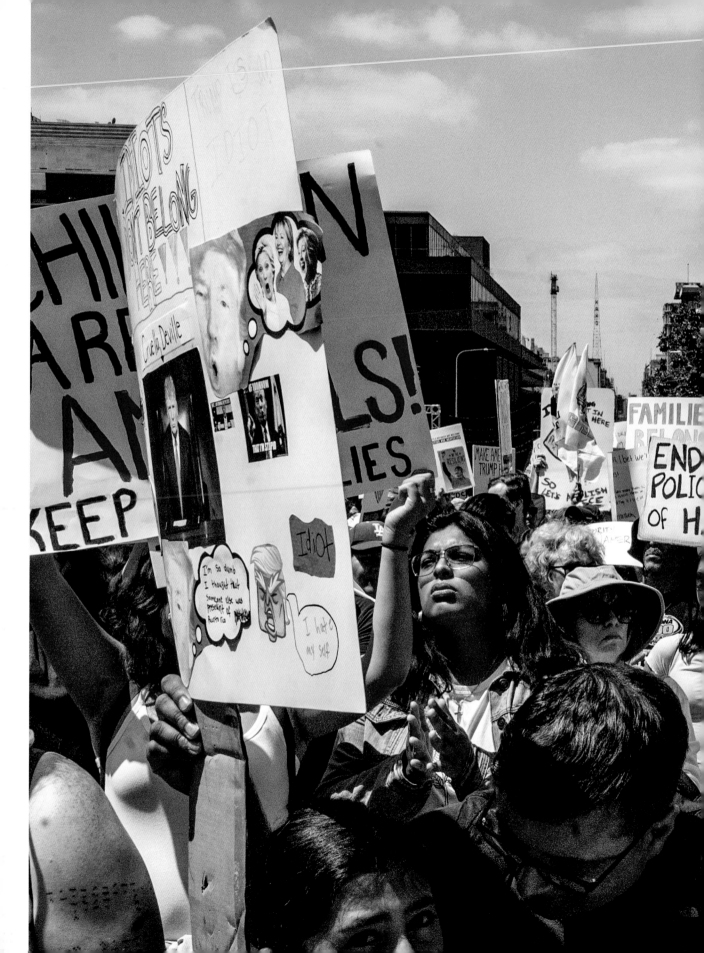

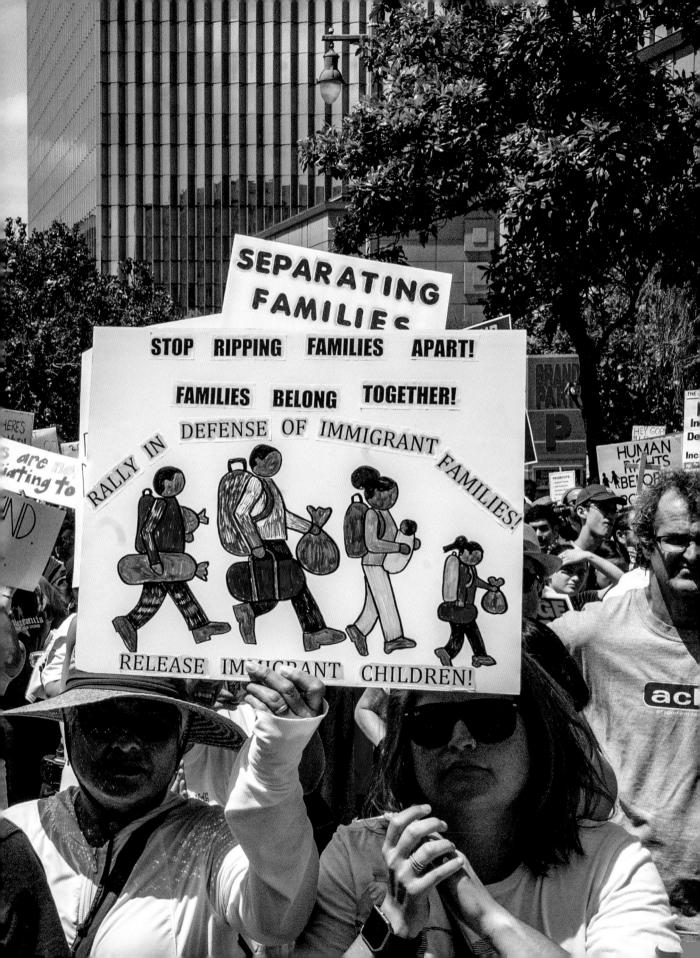

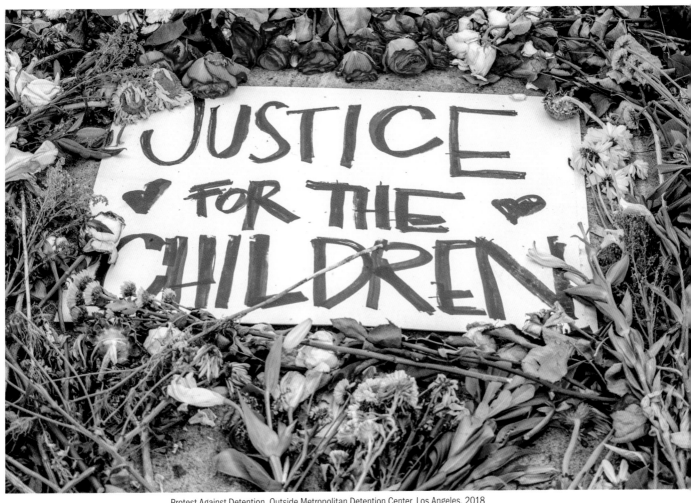

Protest Against Detention, Outside Metropolitan Detention Center, Los Angeles, 2018
OPPOSITE - John Legend **& FOLLOWING SPREAD** - Coalition for Humane Immigrant Rights of Los Angeles (CHIRLA) youth,
Family Separation Rally, Los Angeles, 2018

" We are here today as an act of love for mankind. The world is a big place. There are seven billion people out there. Seven billion strangers. We know how important family is. Every one of us deserves the right of life, liberty, and the pursuit of happiness. "

—JOHN LEGEND

Musician, Songwriter, Philanthropist

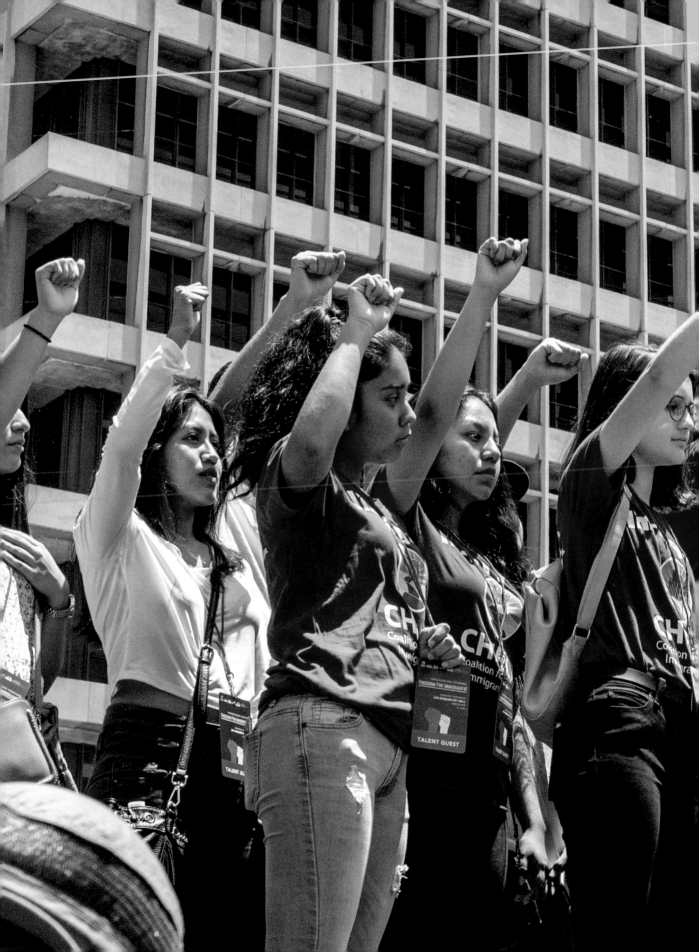

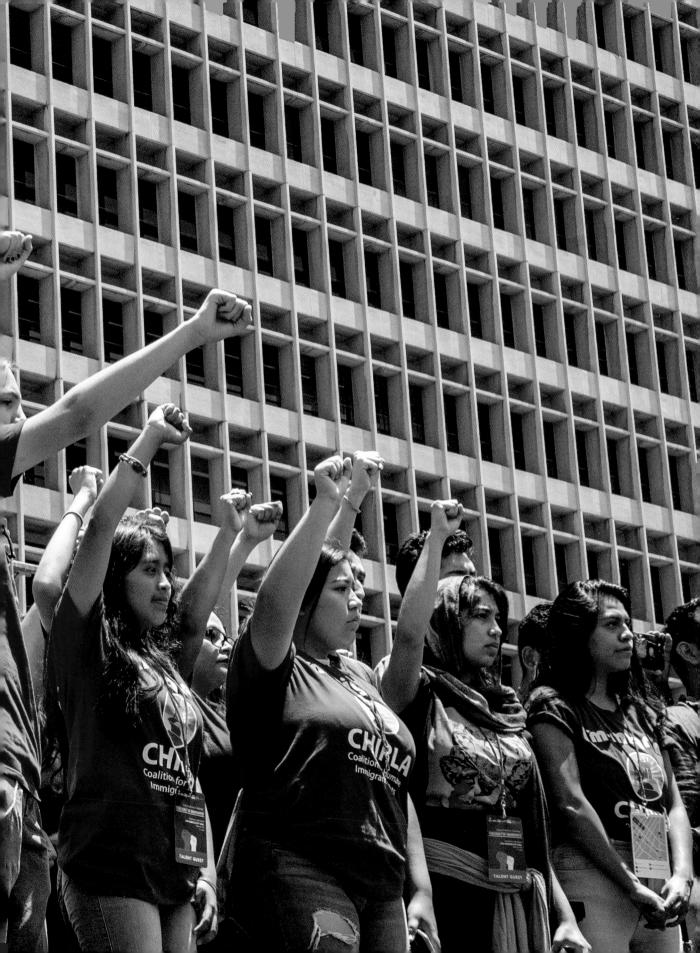

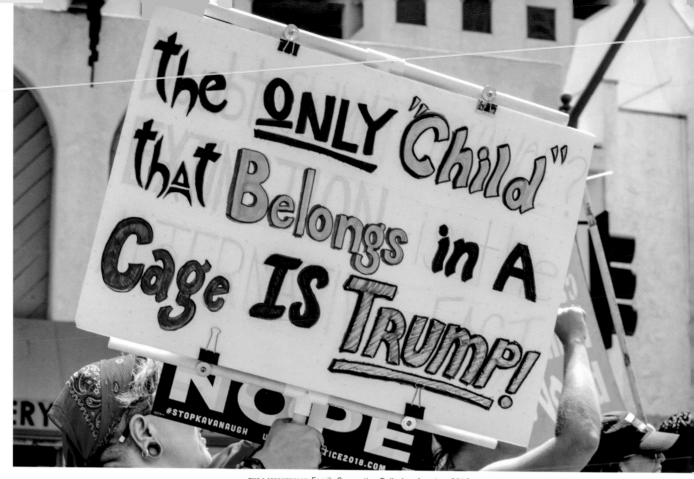

THIS & OPPOSITE PAGE - Family Separation Rally, Los Angeles, 2018

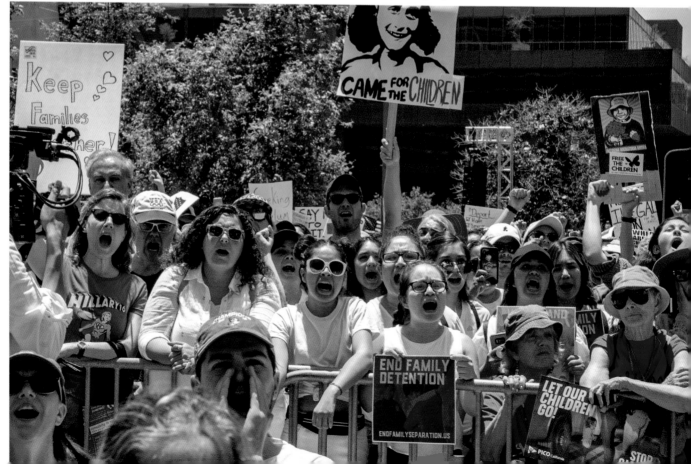

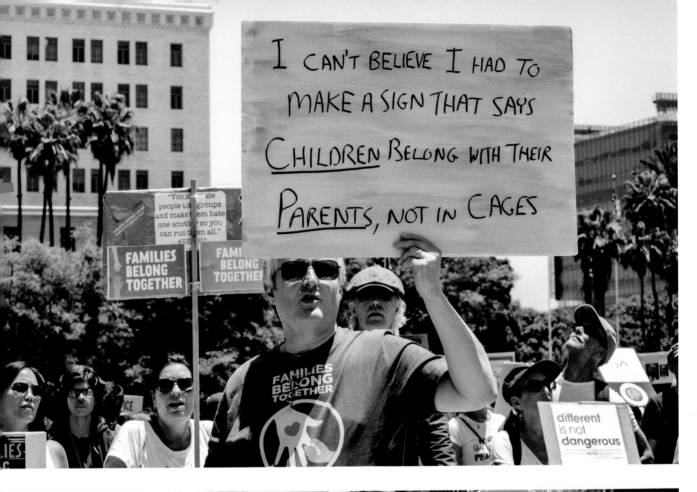

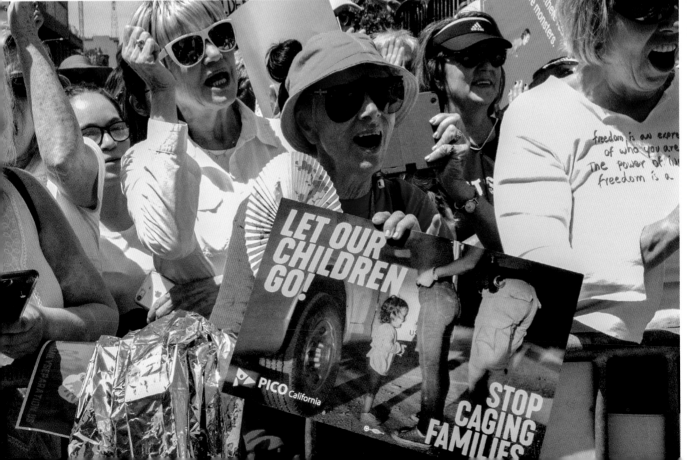

ABOVE · Protest Against Detention, Inmates in Metropolitan Detention Center, Los Angeles, 2018
OPPOSITE · Family Separation Rally, Metropolitan Detention Center, Los Angeles, 2018

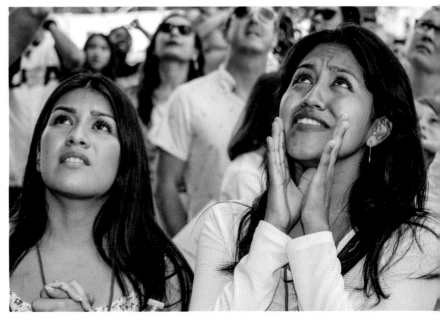

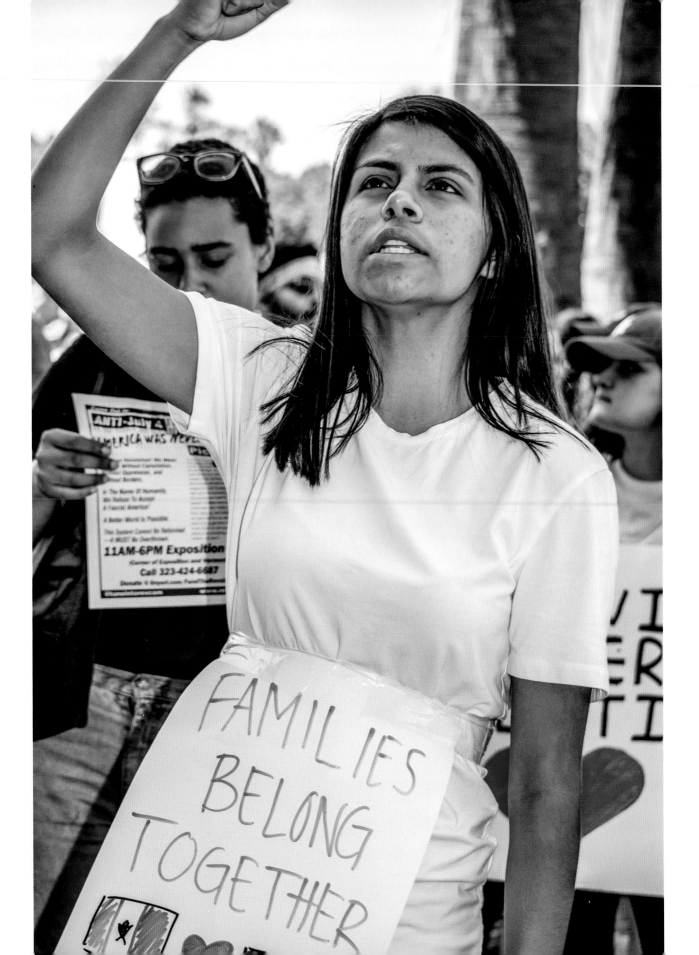

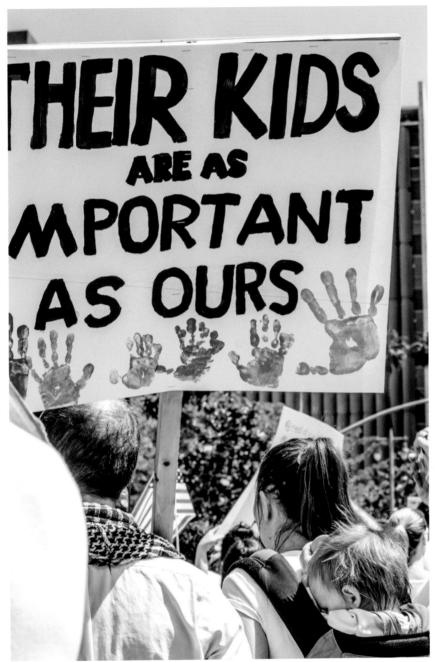

OPPOSITE & ABOVE · Family Separation Rally, Los Angeles, 2018
FOLLOWING SPREAD · Protest Against Detention, Outside Metropolitan Detention Center, Los Angeles, 2018

"We must decriminalize migration. Contrary to the public policy issue here, nothing will be solved as long as we continue to insist that the people who need our help are criminals and that these people have to be punished."

—ALLEGRA LOVE

Immigration Attorney and Cofounder, Sante Fe Dreamers Project

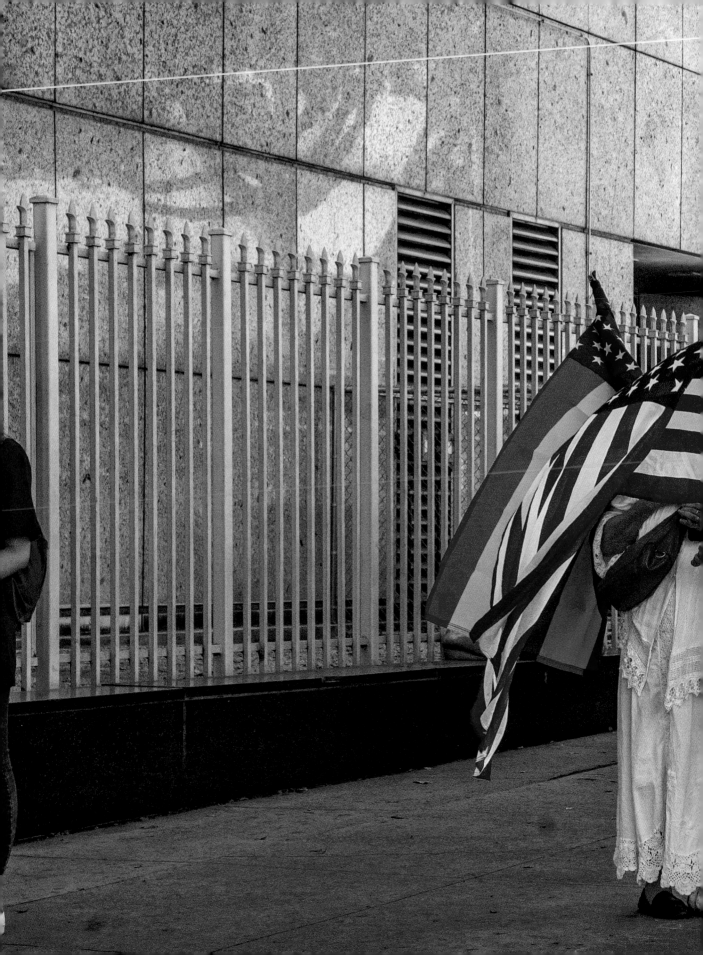

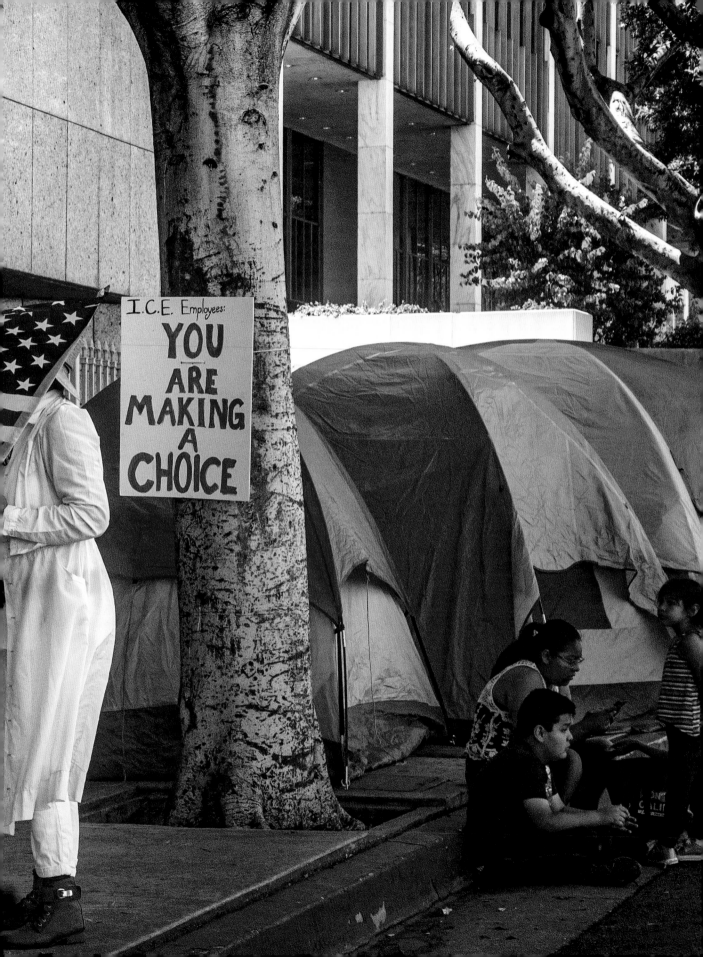

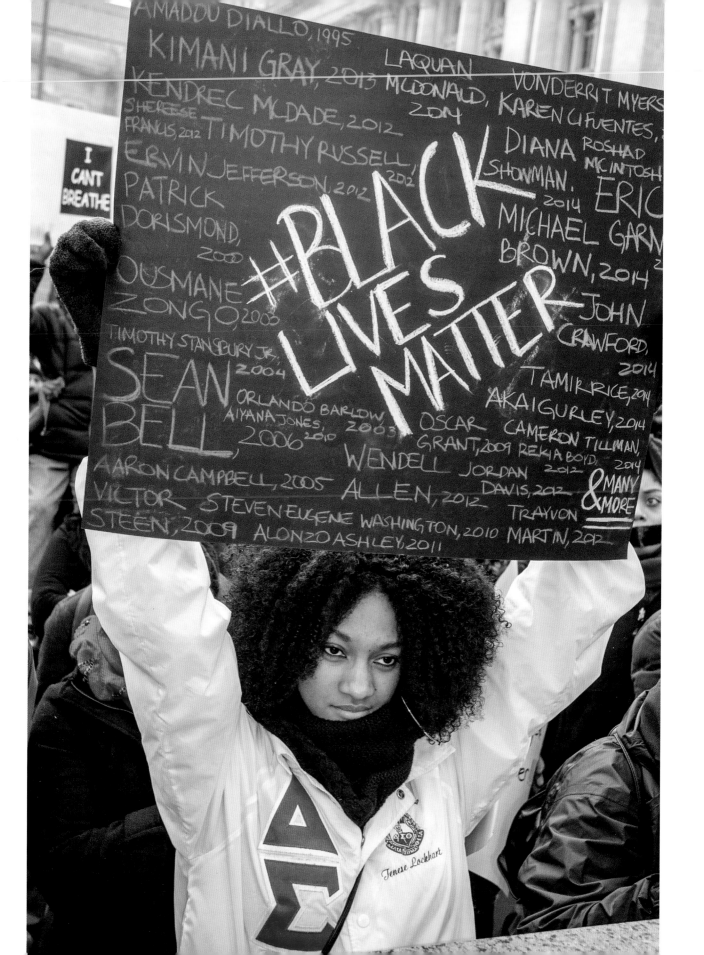

CIVIL RIGHTS Heroes from the civil rights era ended institutionalized segregation with historic nonviolent protests and action. The struggle for equality continues today with efforts against police brutality and racial profiling. Acclaimed filmmaker Ava DuVernay tweeted on March 1, 2019: "Our young people of color are blamed, judged, and accused on sight." Black Lives Matter and Don't Shoot are social protest movements born out of the heartache of systematic racial violence perpetrated by law enforcement. Its ranks are filled with youth activists who have joined with civil rights leaders calling for criminal justice reform. Their individual voices are amplified by social media to post alerts and live-stream protests as they break out. With almost daily posts, these protestors are in solidarity with fellow activists who oppose the rising tide of white nationalism emboldened by Donald Trump. Merging with other like-minded social justice platforms creates a larger global movement to take action against hate crimes whenever and wherever they emerge.

OPPOSITE · National Action Network (NAN) Rally, Washington, DC, 2014
FOLLOWING SPREAD · Rally against Police Brutality, Los Angeles, 2016

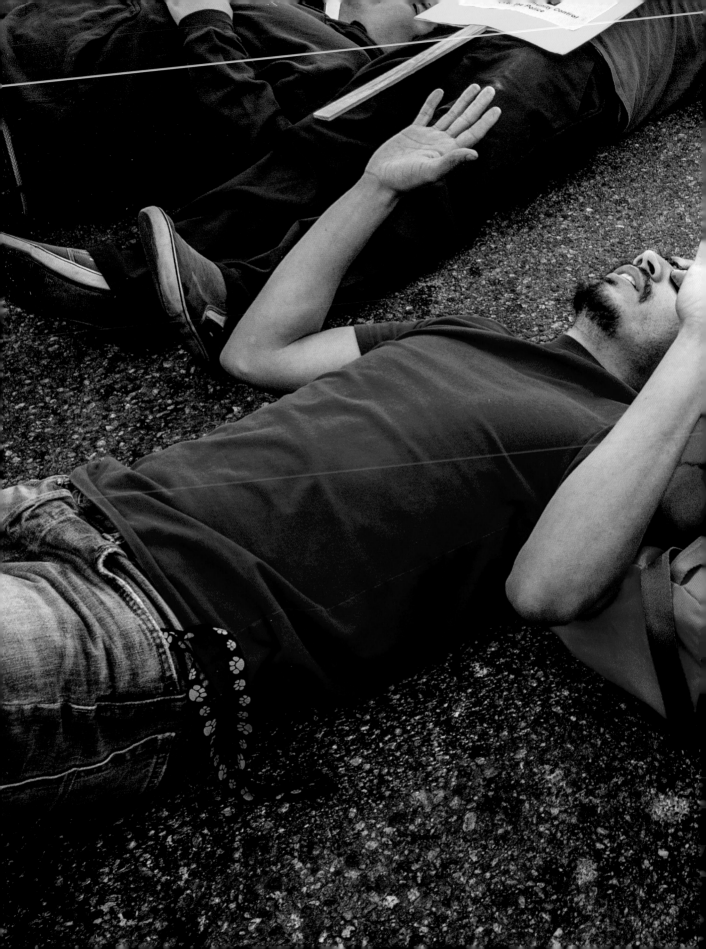

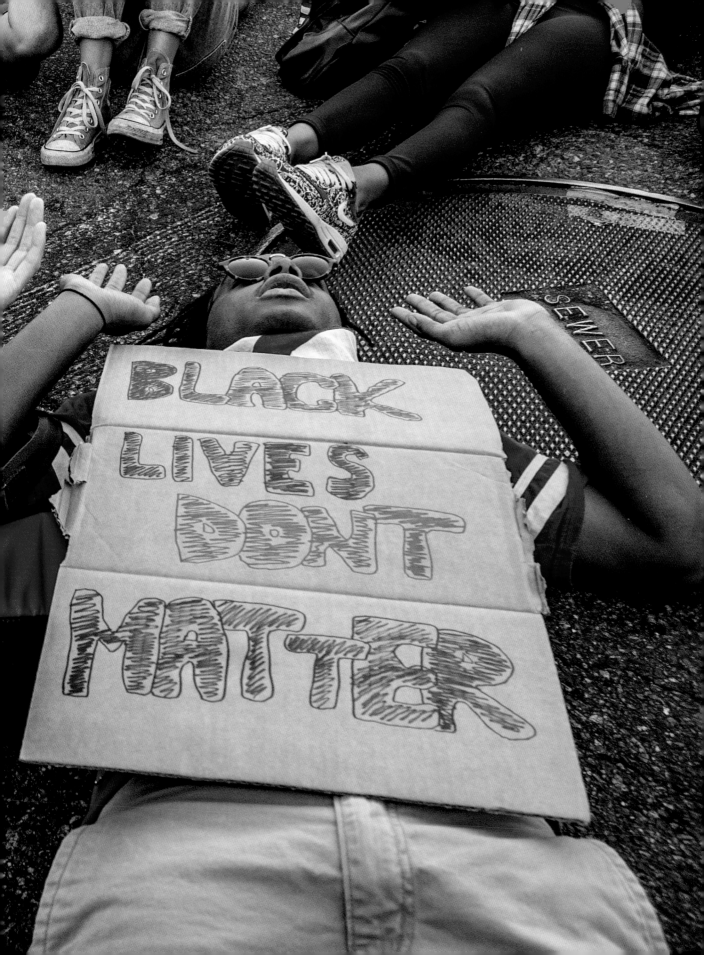

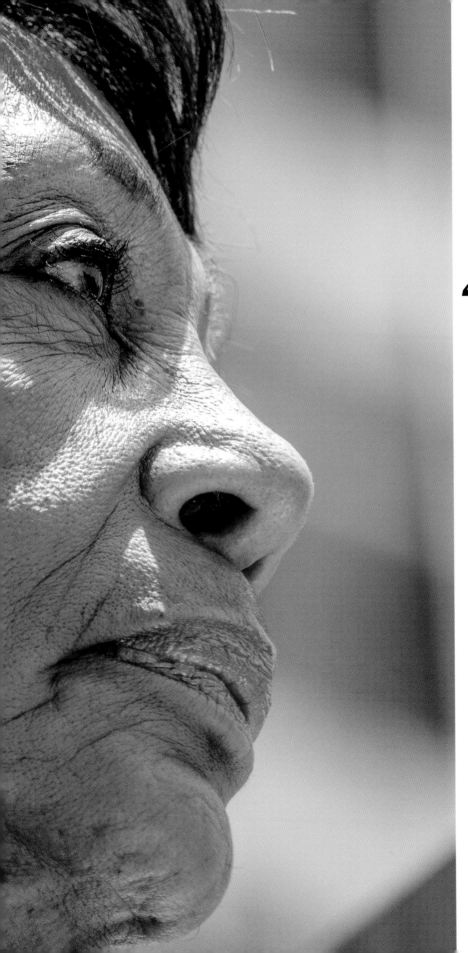

"We moan and groan all the time about a lack of involvement of young people. But they have taught me a lot about what moves them. It seems like all they are looking for is some honesty and some truth and somebody that they can believe in."

—MAXINE WATERS

Congresswoman from California

Maxine Waters,
Rally for Families,
Los Angeles, 2017

"Racism is a plague this country holds on to dearly. From my brown complexion to my outspokenness, I've walked in life with this target on my back. From this I know to protect myself from anyone who means to do me harm. That alertness has never left me and now I believe it is a tool. A tool that helps me wear that target without fear.

A tool to encourage others to do the same. I believe if we do not voice our frustrations towards injustice, if we do not stand tall against tyranny, we will fall and we will fall hard! In this stain of a presidency we have a duty to protect each other for that reason. Watch each other closely, raise each other up high, and call out the acts of violence. Silence is not an option!"

—OSCAR BAUTISTA
Freelance Journalist and Community Organizer

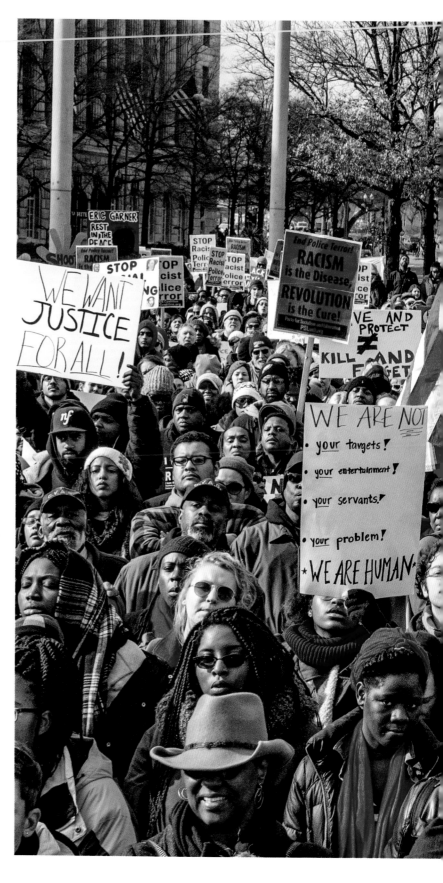

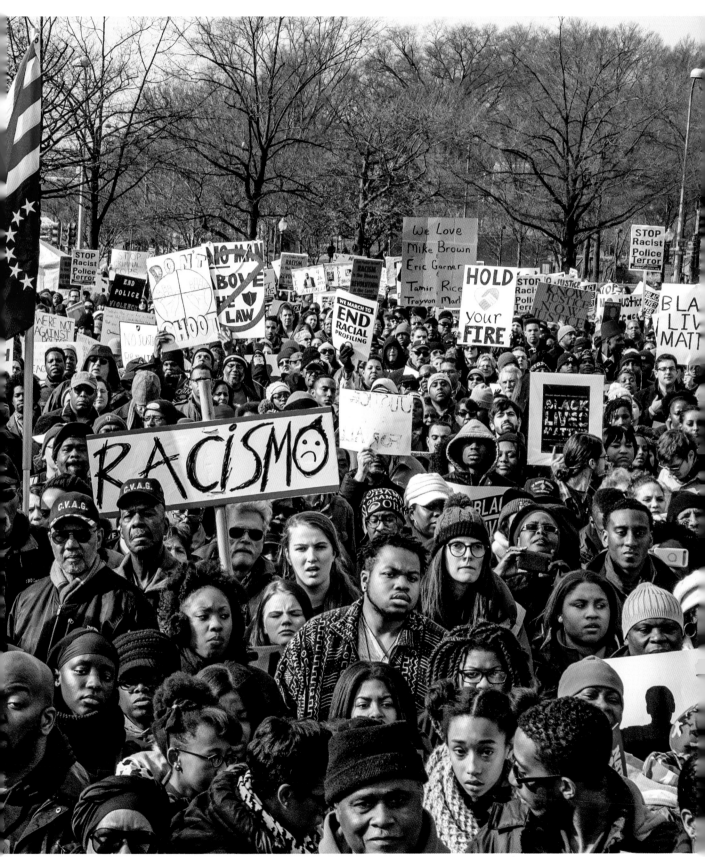

THIS & FOLLOWING SPREAD · National Action Network (NAN) Rally, Washington, DC, 2014

159

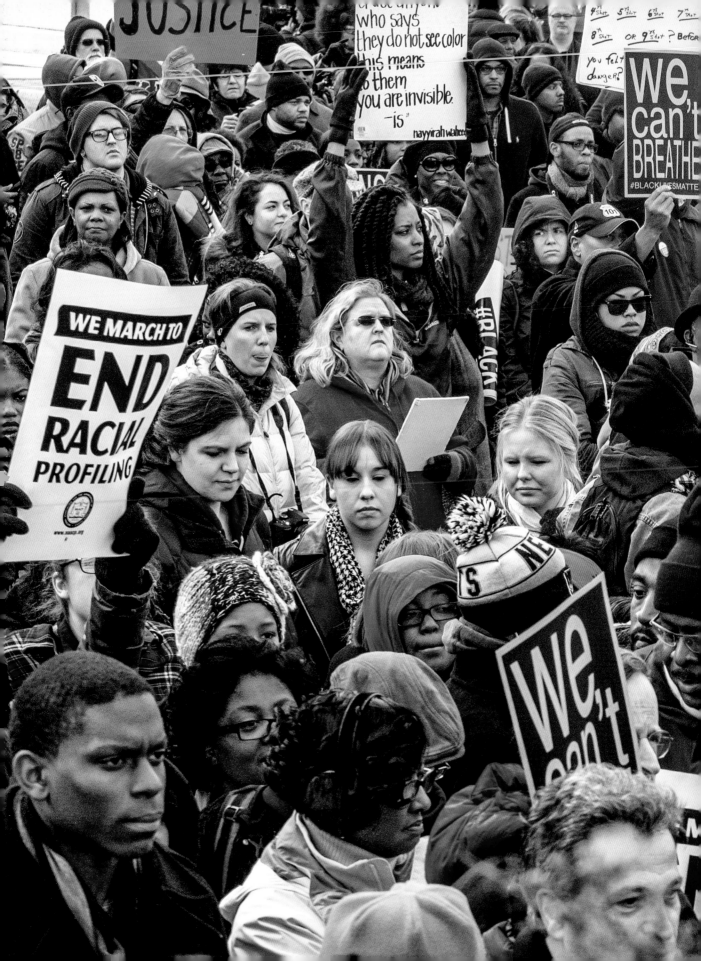

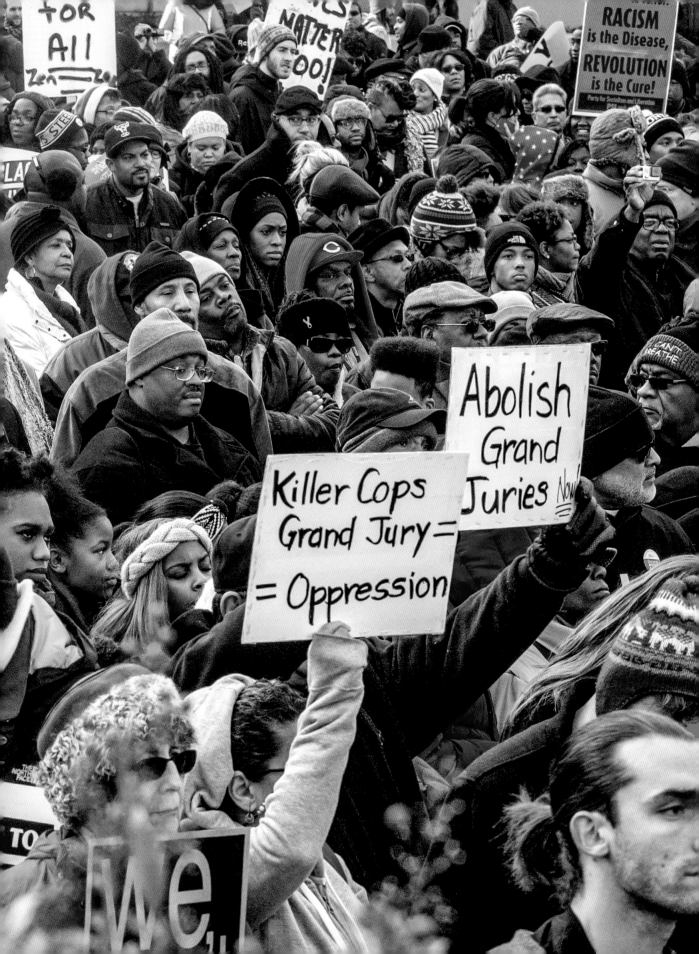

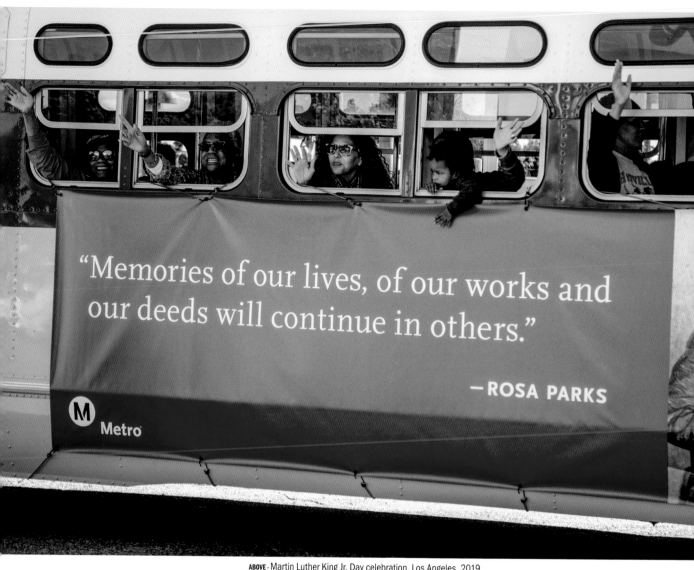

> "Memories of our lives, of our works and our deeds will continue in others."
>
> —ROSA PARKS

M Metro

ABOVE · Martin Luther King Jr. Day celebration, Los Angeles, 2019
OPPOSITE · John Lewis, Martin Luther King Jr. "I Have a Dream" Speech Fiftieth Anniversary, Washington, DC, 2013

**"We have turned a deaf ear to the blood of innocents.
We are blind to a crisis. Where is our courage?
We have lost hundreds and thousands of innocent
people to gun violence."**

—JOHN LEWIS
Representative from Georgia

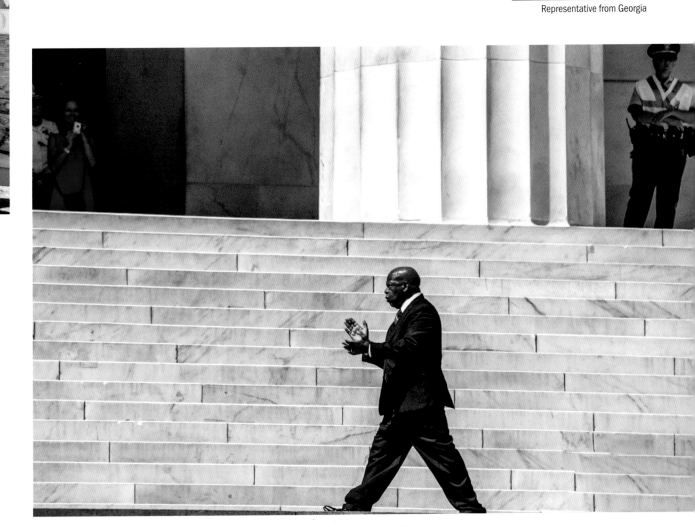

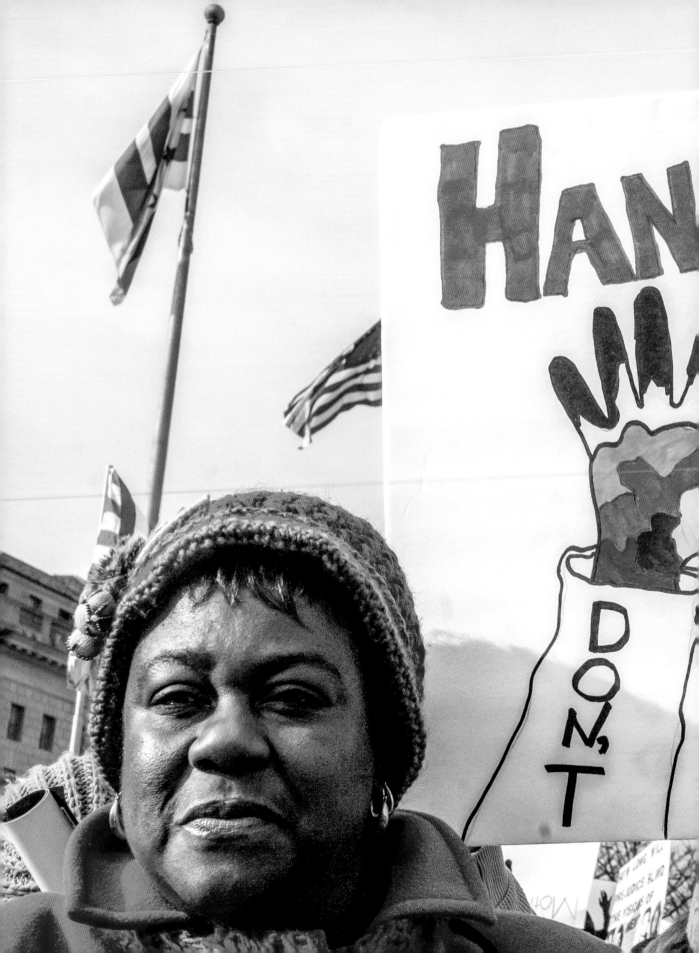

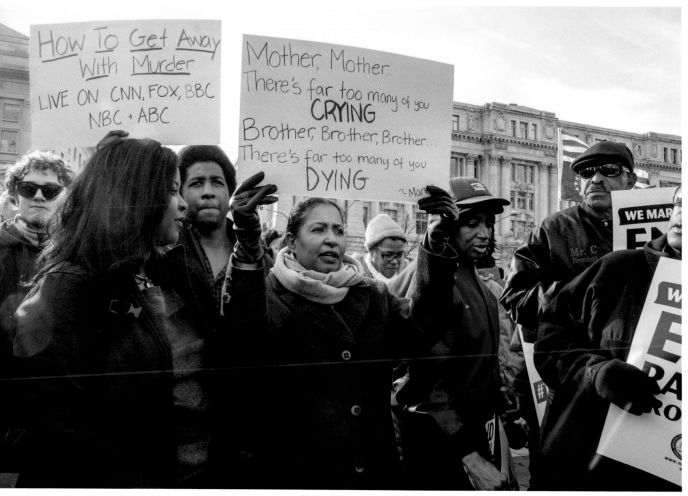

PREVIOUS SPREAD, ABOVE & OPPOSITE - National Action Network (NAN) Rally, Washington, DC, 2014

"The first step to reconciliation is listening. We have to look at the culture our law enforcement officers are going into, and the culture they are from. It all comes down to selection, training, and discipline. As I said, the first step is listening. We are not there yet but we can get there. If we meet in the middle, we can find a place of collaboration without sacrificing one's integrity and dignity. This is the sweet spot of societal sustainability, and the foundation for reconciliation."

—M. QUENTIN WILLIAMS

Law Enforcement Mediator, Training Consultant to the FBI, Attorney

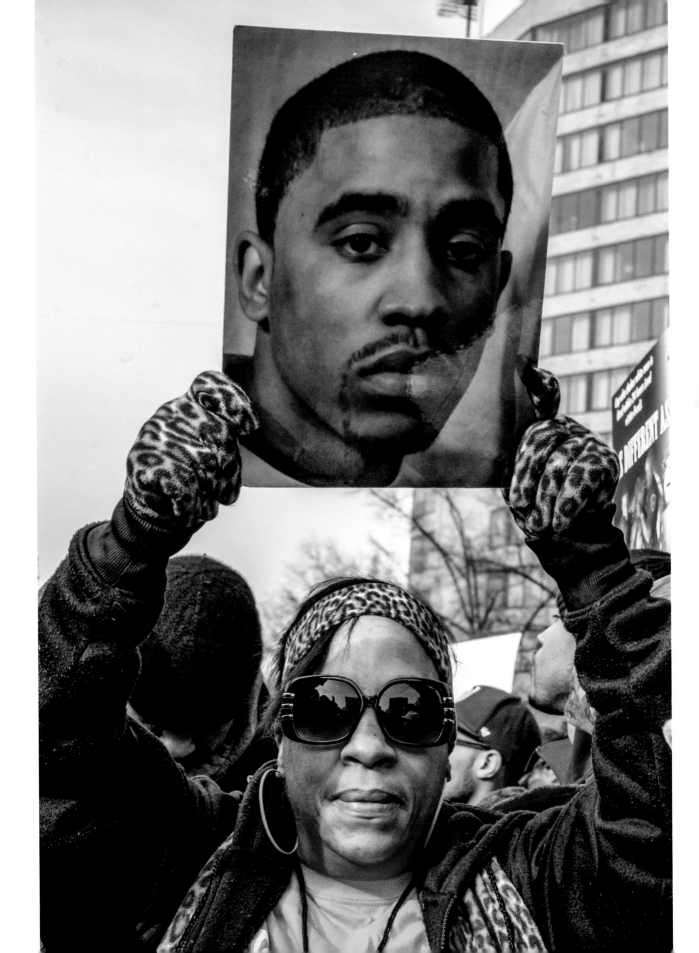

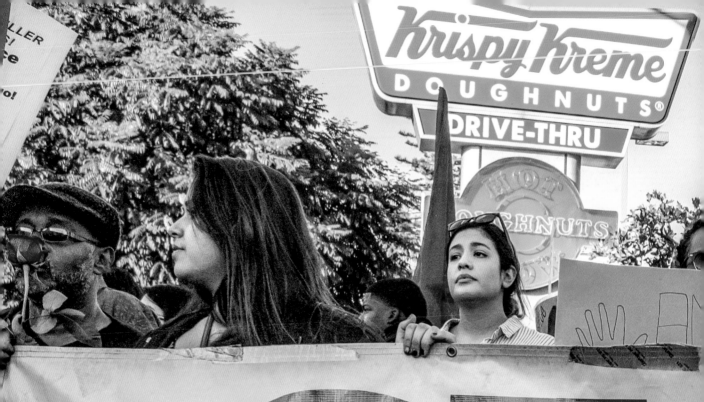

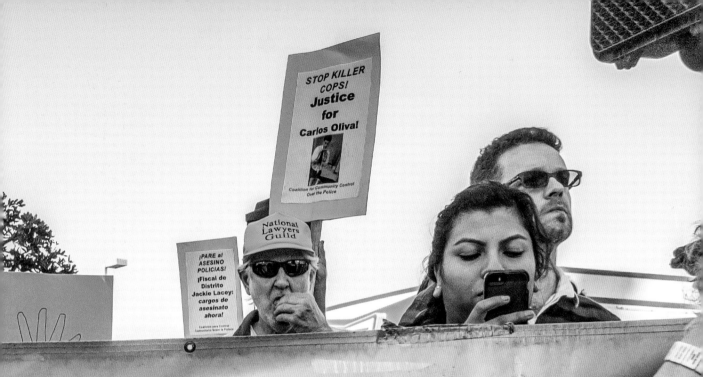

STOP KILLER
COPS!
Justice
for
Carlos Olival

Coalition for Community Control
Over the Police

National
Lawyers
Guild

¡PARE al
ASESINO
POLICIAS!

¡Fiscal de
Distrito
Jackie Lacey:
cargos de
asesinato
ahora!

Coalición para Control
Comunitario Sobre la Policía

OP

COPS!

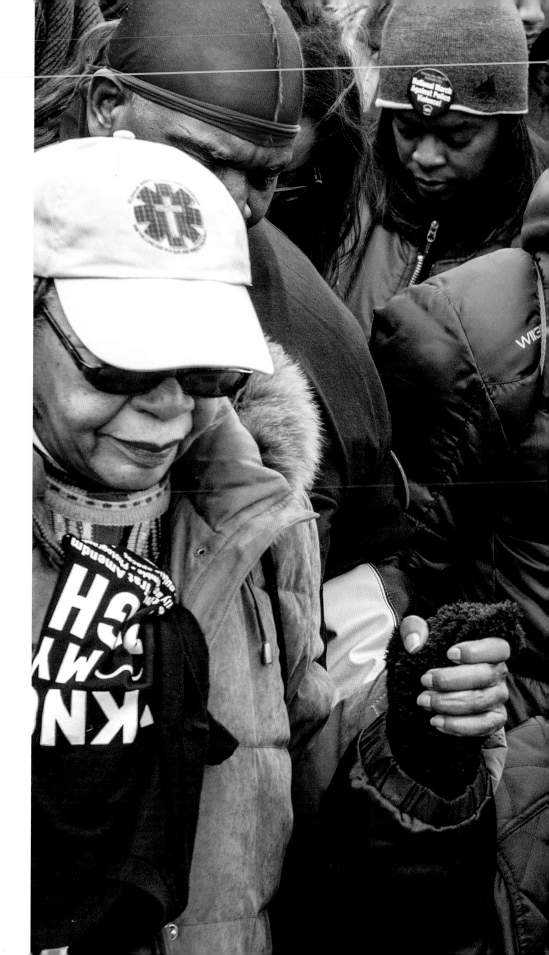

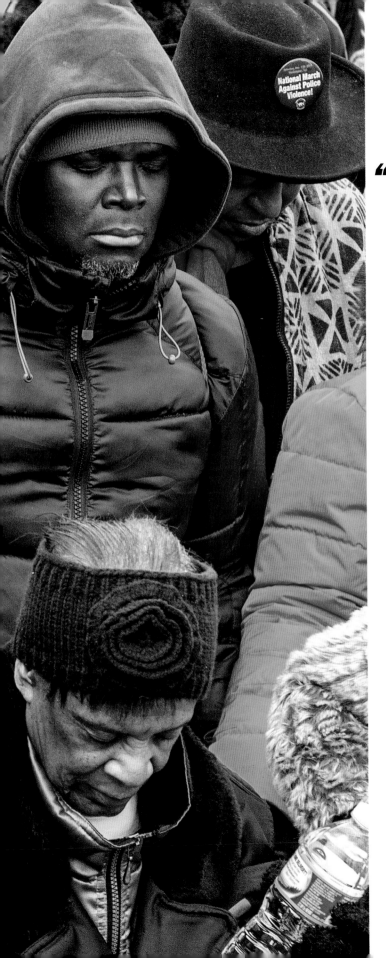

"There has to be a great awakening where we build up our community while at the same time fortify our politics. Black people need concrete legislative solutions. Our elected officials offer great speeches but they are giving us lip service. They are not giving us productivity. We need to improve our status financially by teaching literacy, by teaching our community how to eat better. The number one killer for black people is what we put in our bodies. We have to respect ourselves. Black people have to do away with old systems. Right now when we talk about black politics, it's about optics. It's not about results. We will need to be oriented on productivity and real change."

—HAWK NEWSOME

President, Black Lives Matter of Greater New York

National Action Network (NAN) Rally, Washington, DC, 2014
PREVIOUS SPREAD · Rally Against Police Brutality, Los Angeles, 2016

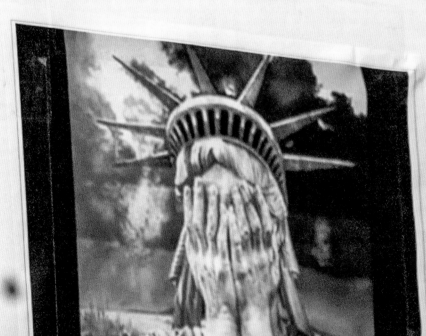
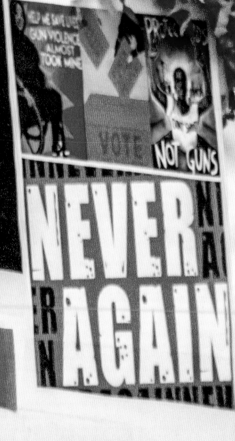

GUN CONTROL When shots were fired at Stoneman Douglas High School in Parkland, Florida, on February 14, 2018, the tragic deaths of fourteen students and three adults sparked groundbreaking engagement of students across the United States to take an uncompromising stand for gun reform. The widespread infrastructure put in place from the Women's March enabled Parkland survivors to give birth to the March for Our Lives movement. They mobilized in historic crowd sizes. Not since the Vietnam War and the 1970 Kent State shootings have we seen our young citizens come together in this magnitude. For generations the adults shoved gun control under the carpet. To that young people called B.S.: they're now the adults in the room and are not afraid to take on the National Rifle Association's lobbying.

In major cities students staged walkouts to pay tribute to the tragedy. They walked out, they spoke out. They shouted "Never again!" and "Not one more life." Their outpouring of sympathy and commemoration became a national chorus of new, young activist voices.

OPPOSITE · March for Our Lives Rally, Los Angeles, 2018
FOLLOWING SPREAD · School Walkout for Gun Reform, Los Angeles, 2018

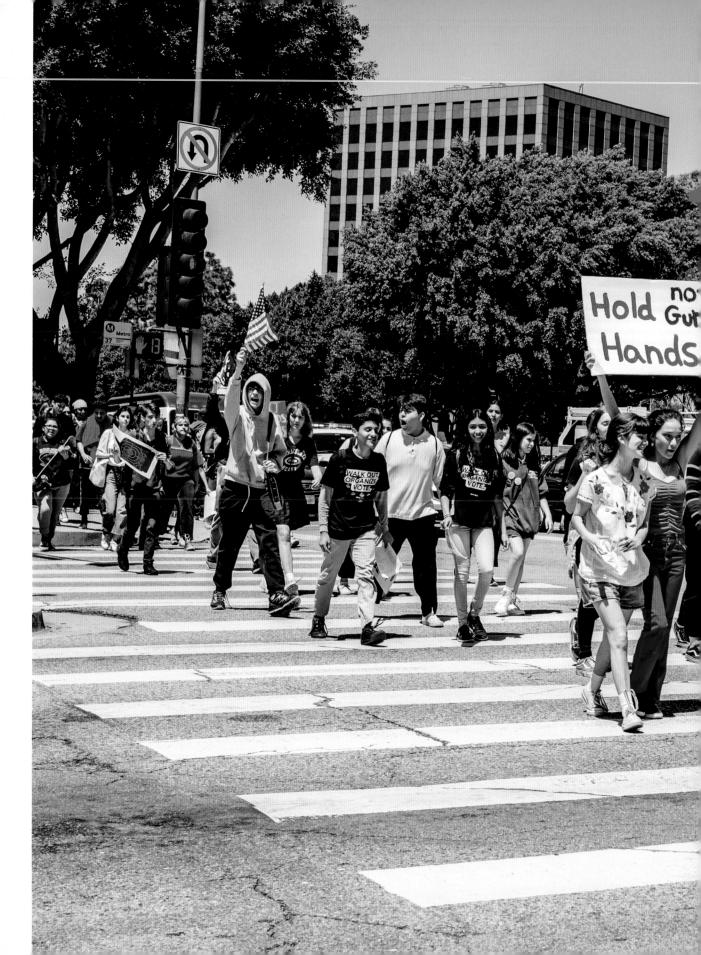

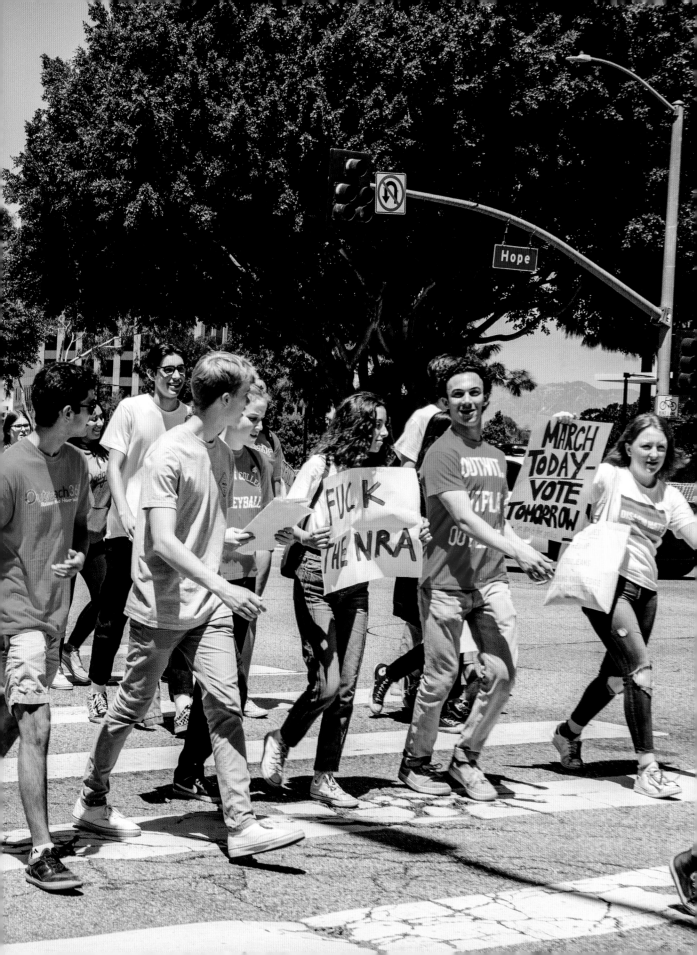

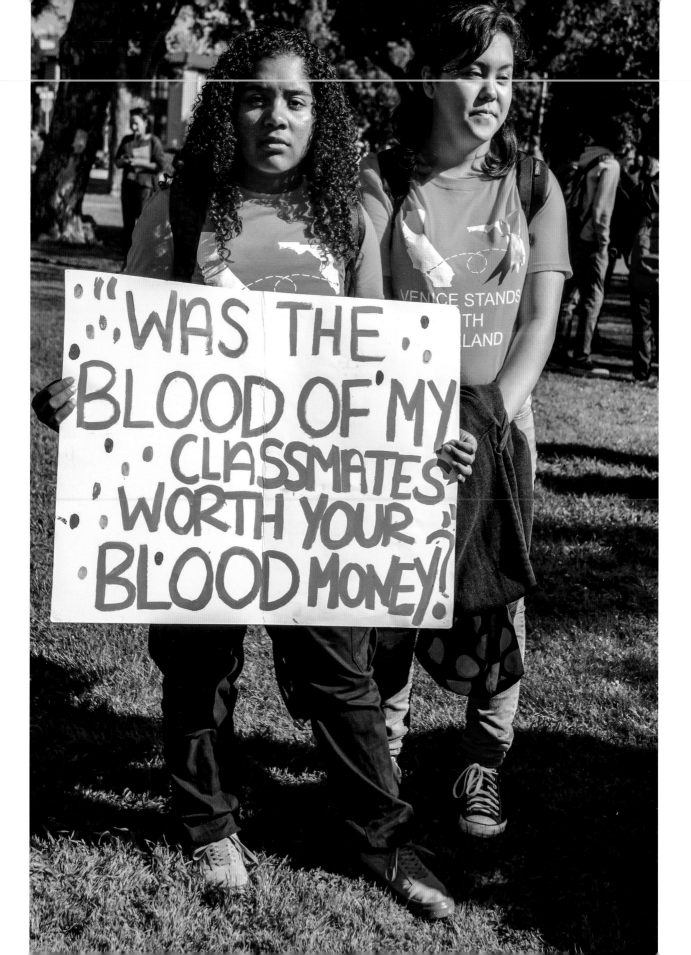

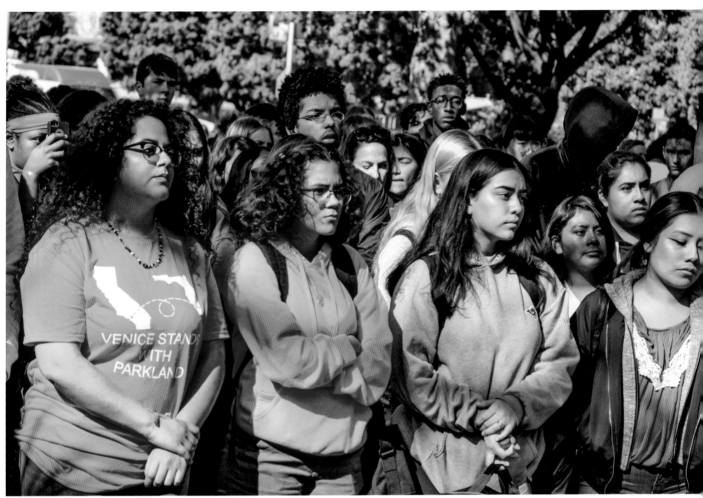

OPPOSITE & ABOVE · Commemoration of Parkland students, Venice High School, Venice, California, 2018
FOLLOWING SPREAD · Student Protests at Santa Monica City Hall, Anniversary of Columbine Shooting, Santa Monica, California, 2018

"In the most recent years, the United States has seen an increase in the number of mass shootings in public spaces—places where we would go for fun recreational activities. Teenagers like us must now be cautious every day, fearing that we may never come home from school one day. By expressing our voices across the nation, I believe that we can make a great impact and remind our leaders of who they are really serving—we, the future citizens of this very nation."

—MANA NAKANO
Student Protester at Venice High School

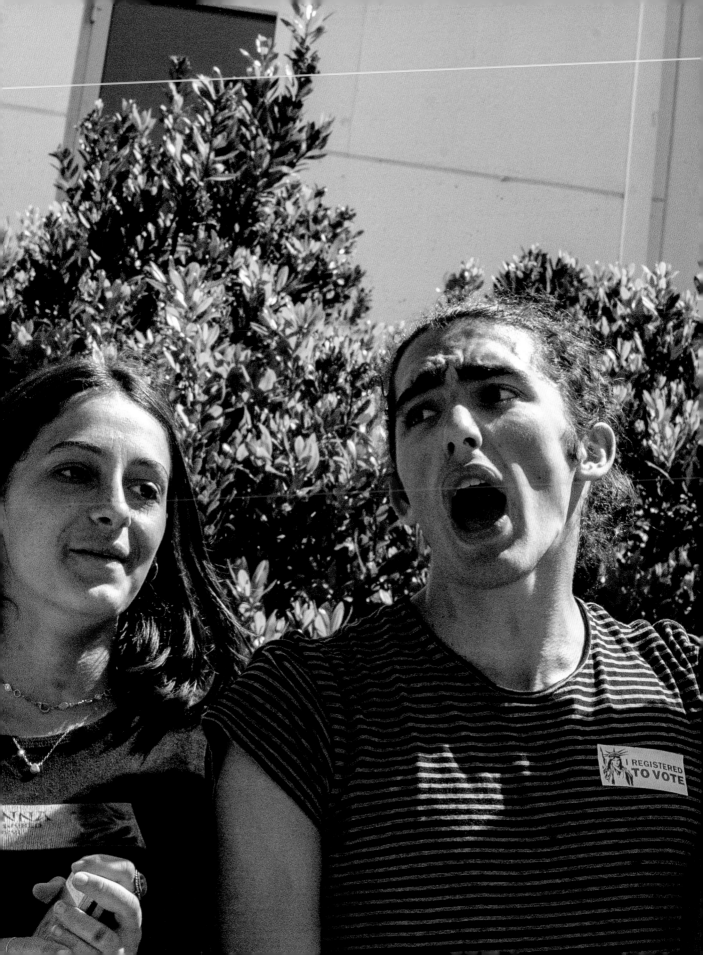

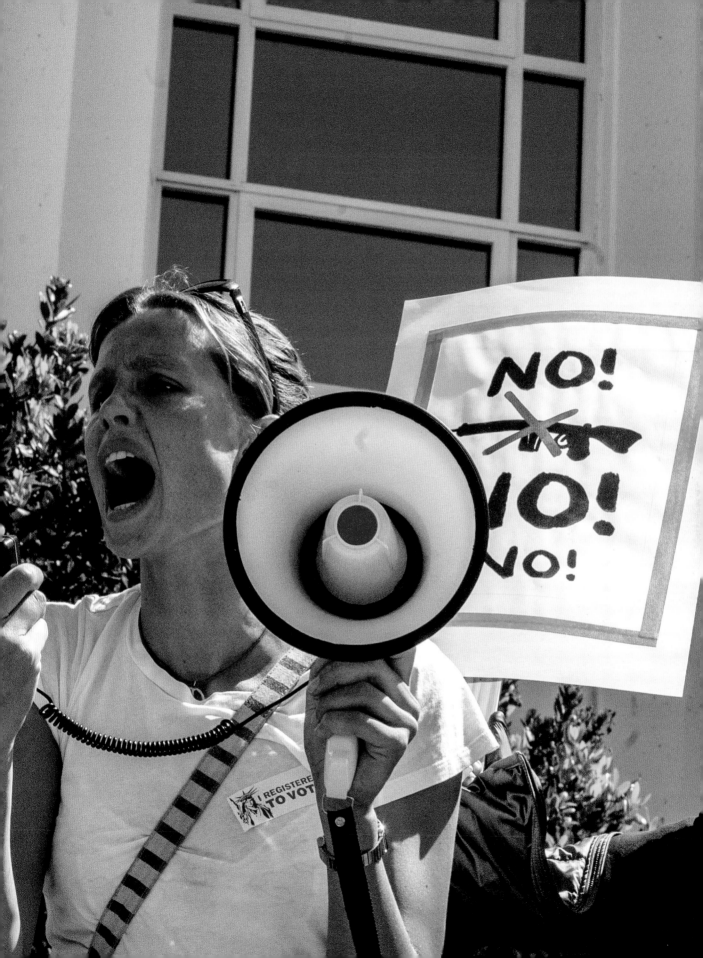

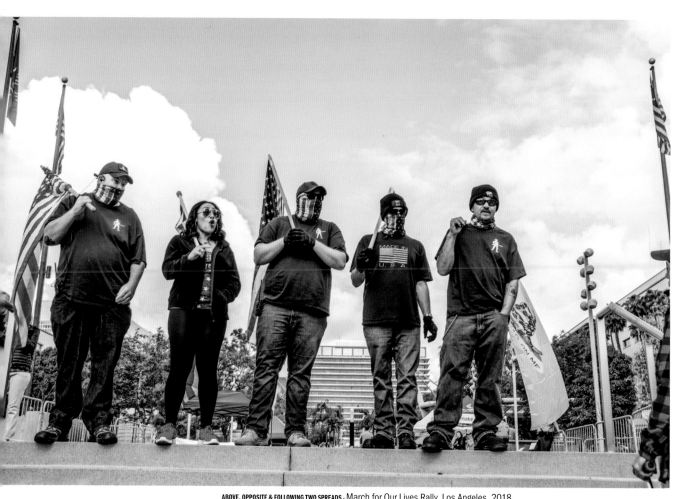

ABOVE, OPPOSITE & FOLLOWING TWO SPREADS · March for Our Lives Rally, Los Angeles, 2018

" I have witnessed the American pro-gun lobby trample over the sanctity of human life for far too long. Fortunately, a new moral force has come along promising to change the politics of guns in America forever. Imagine if this vital spirit of activism, moral authority, and political muscle were also extended to help stop irresponsible international gun transfers. The gun violence prevention movement currently sweeping America with youthful and electoral fervor, may one day help reduce the number of dangerous people acquiring guns and curtail gun rampages around the globe. **"**

—KATHI LYNN AUSTIN
Executive Director, Conflict Awareness Project

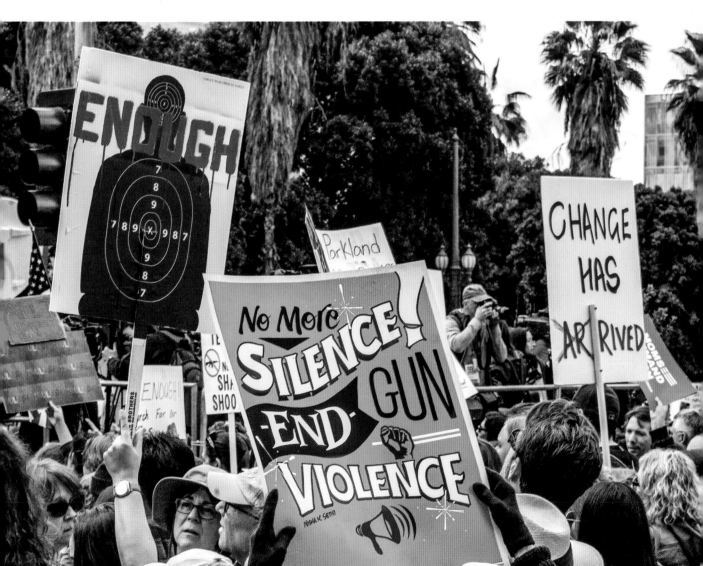

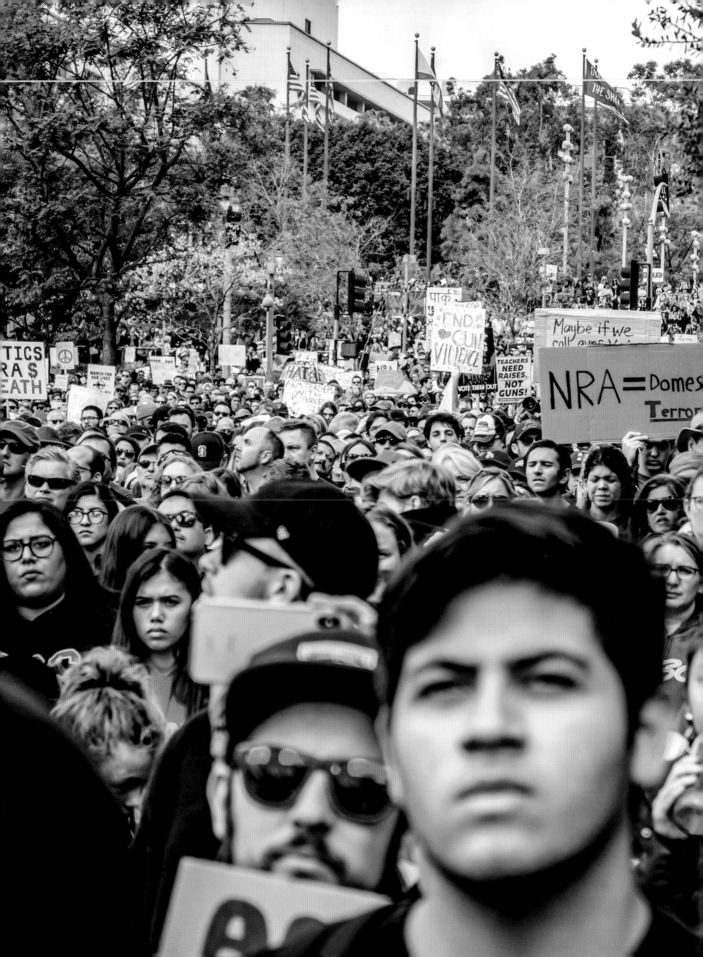

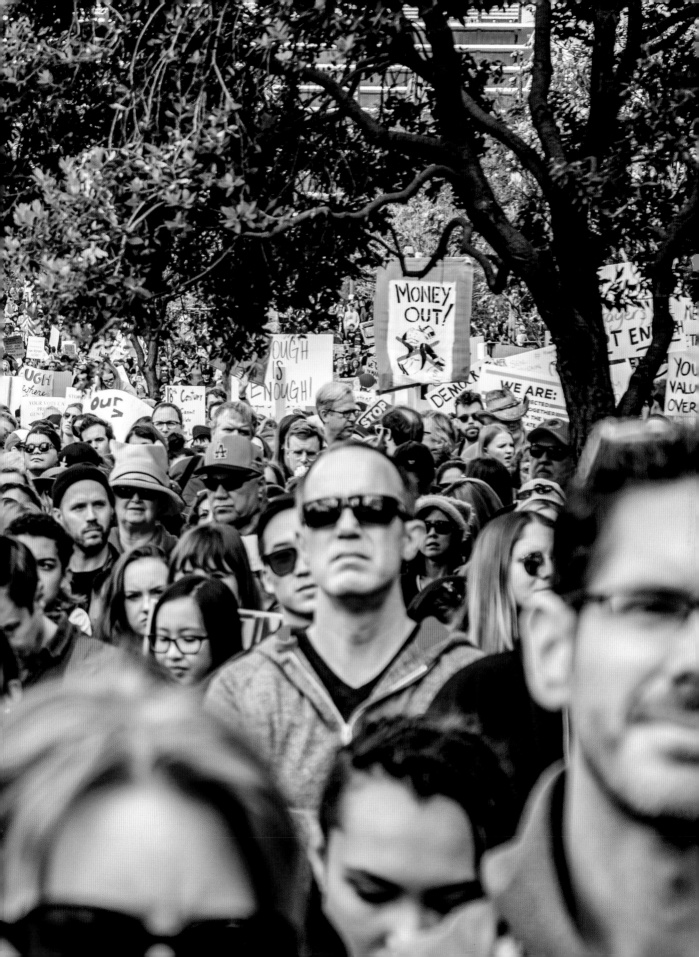

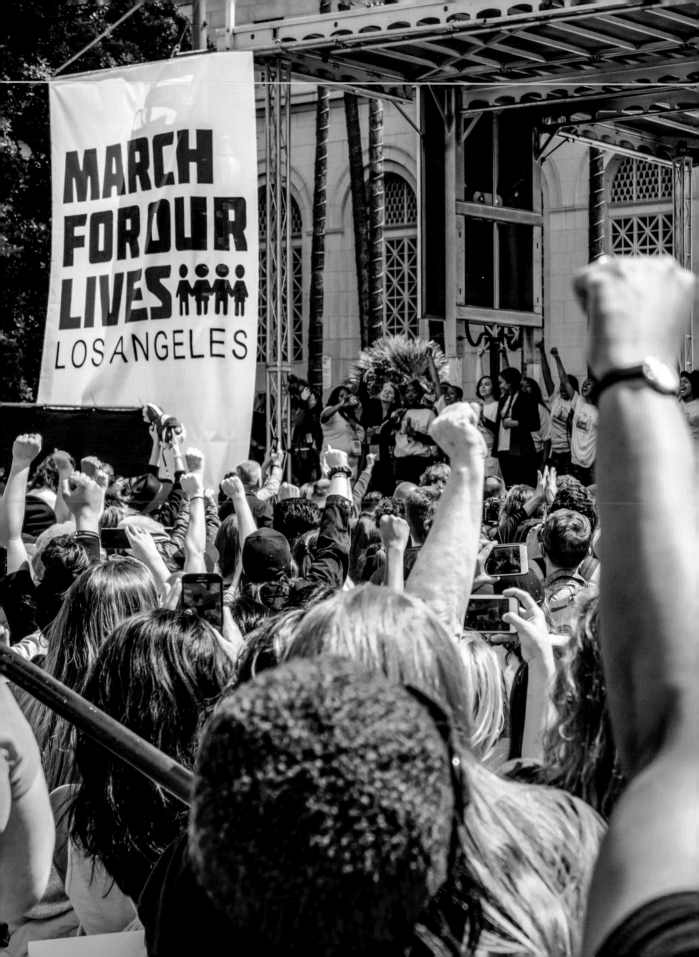

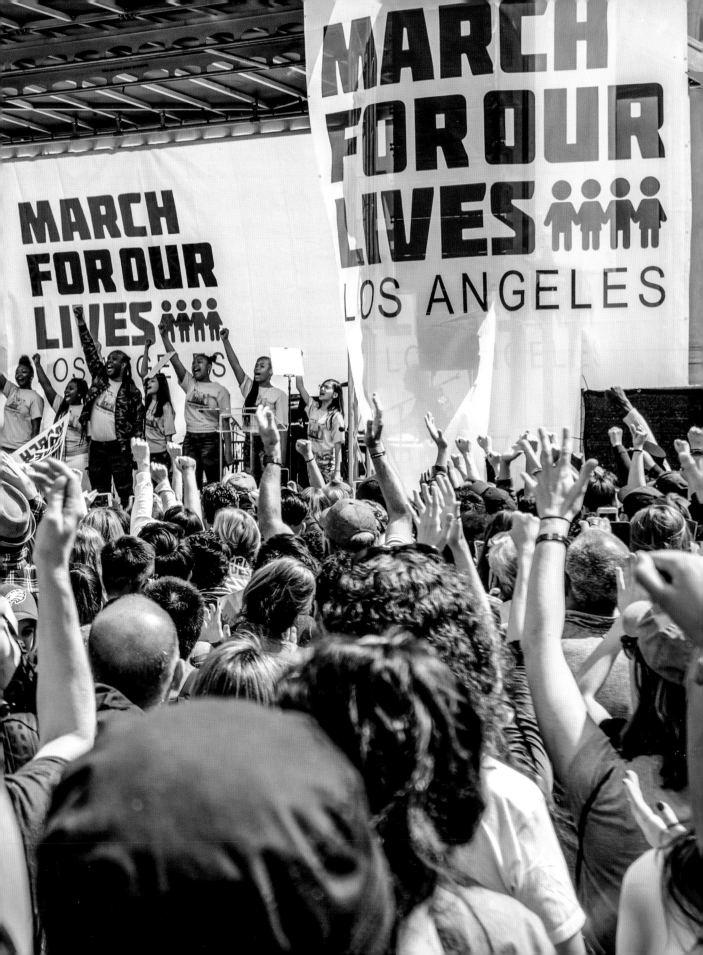

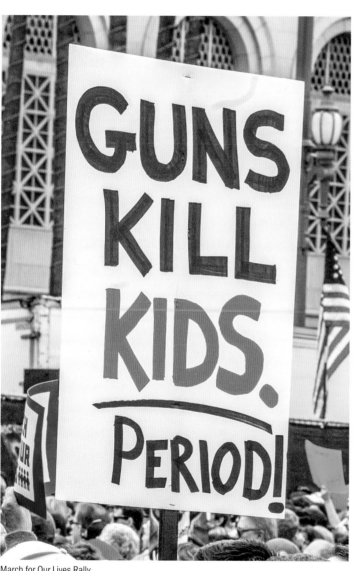

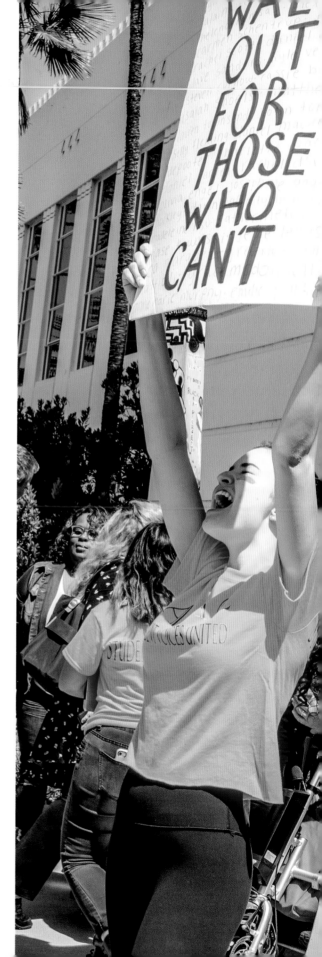

March for Our Lives Rally,
Los Angeles, 2018
OPPOSITE · Student Protests at
Santa Monica City Hall,
Anniversary of Columbine
Shooting, Santa Monica,
California, 2018

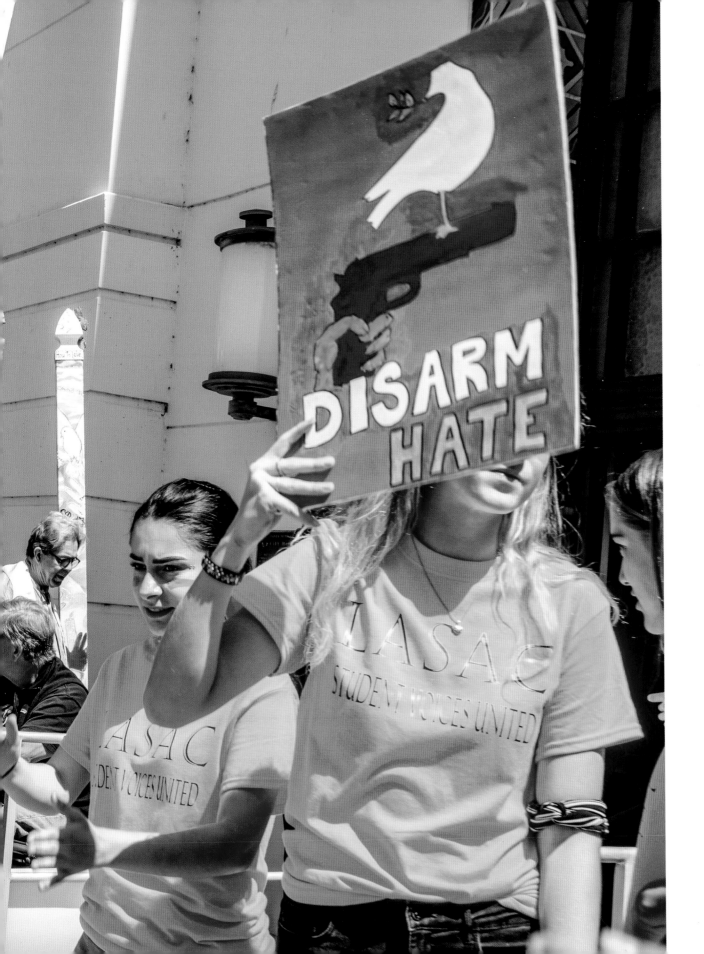

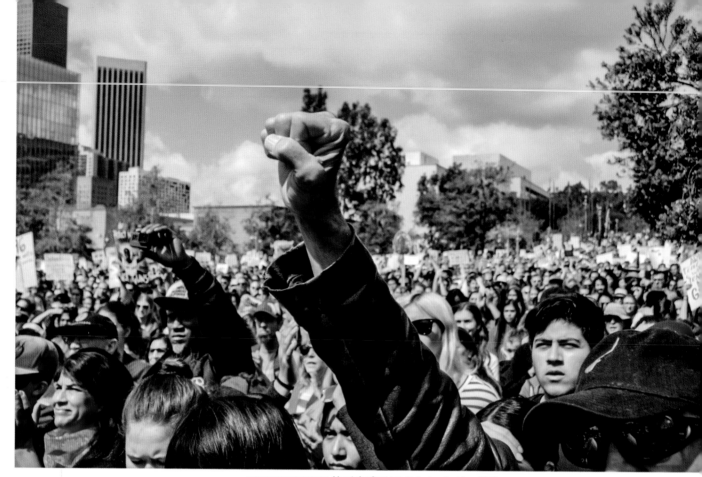

ABOVE, BELOW & TOP OPPOSITE · March for Our Lives Rally, Los Angeles, 2018

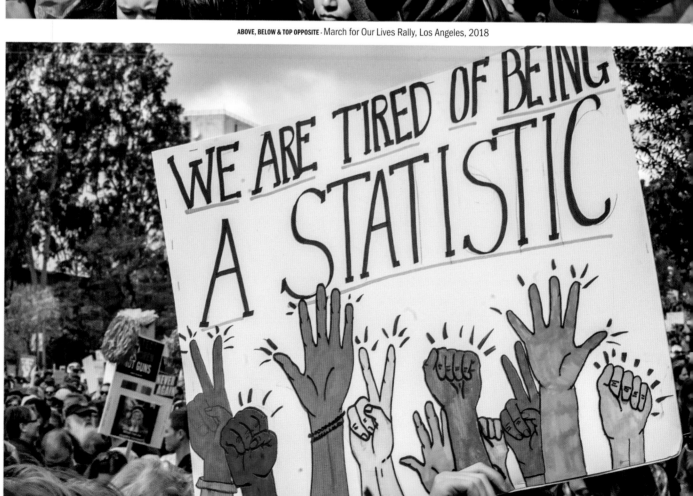

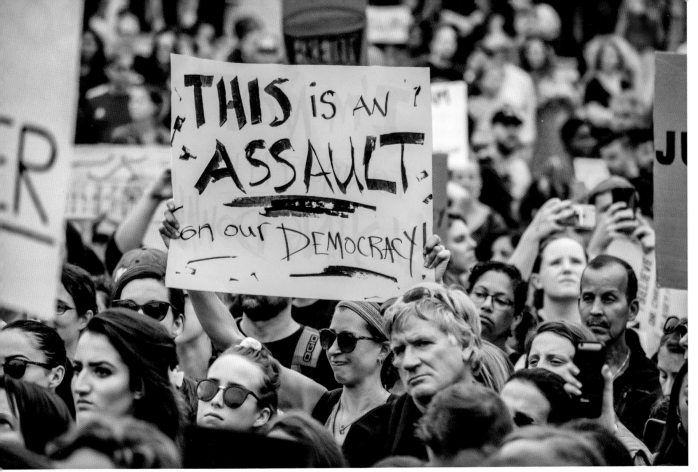

BELOW · School Walkout for Gun Reform, Los Angeles, 2018

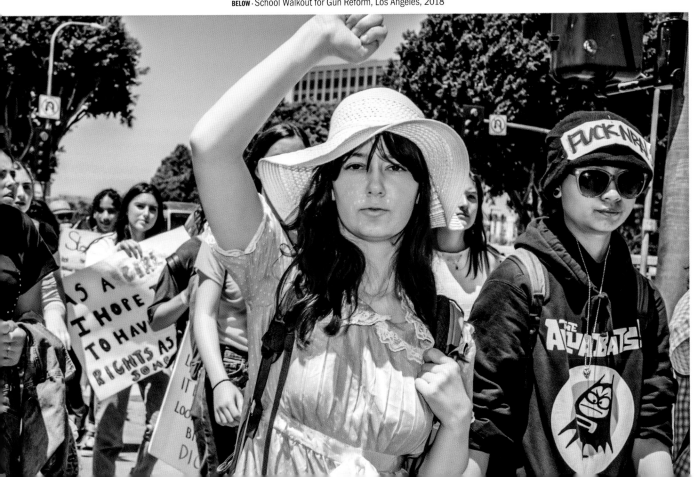

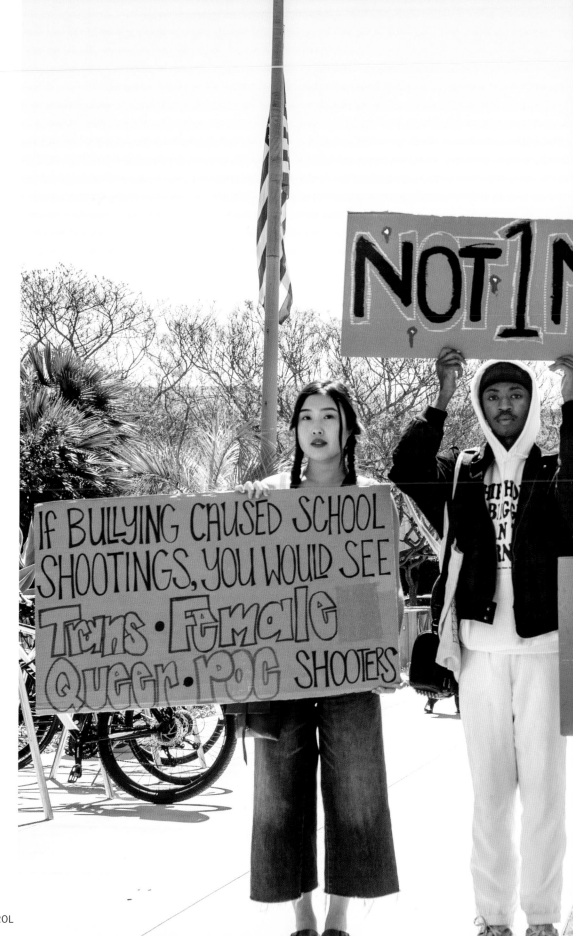

Student Protests at
Santa Monica City Hall,
Anniversary of Columbine
Shooting, Santa Monica,
California, 2018

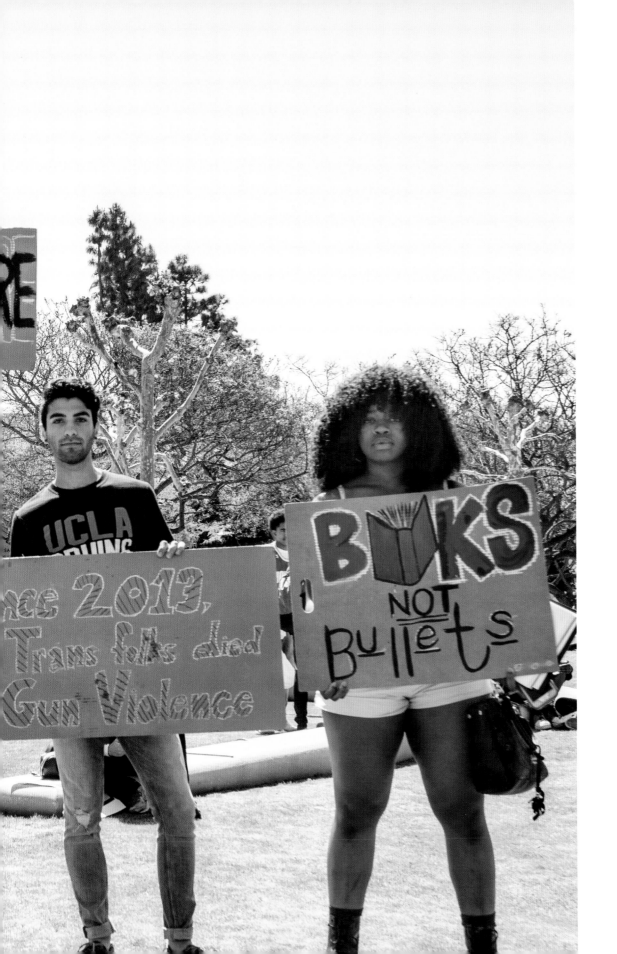

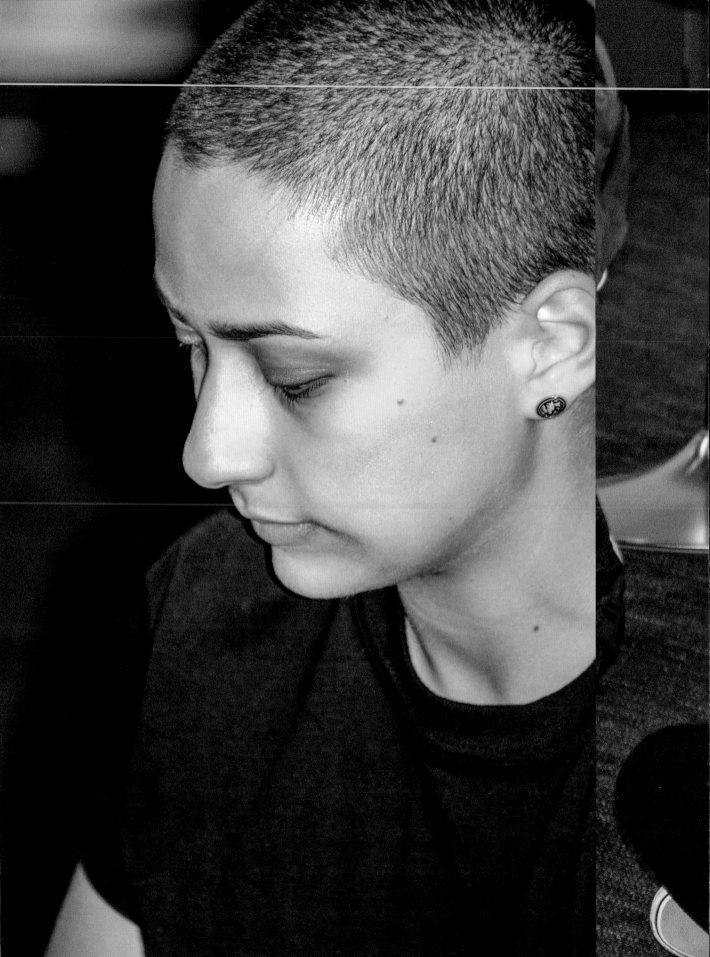

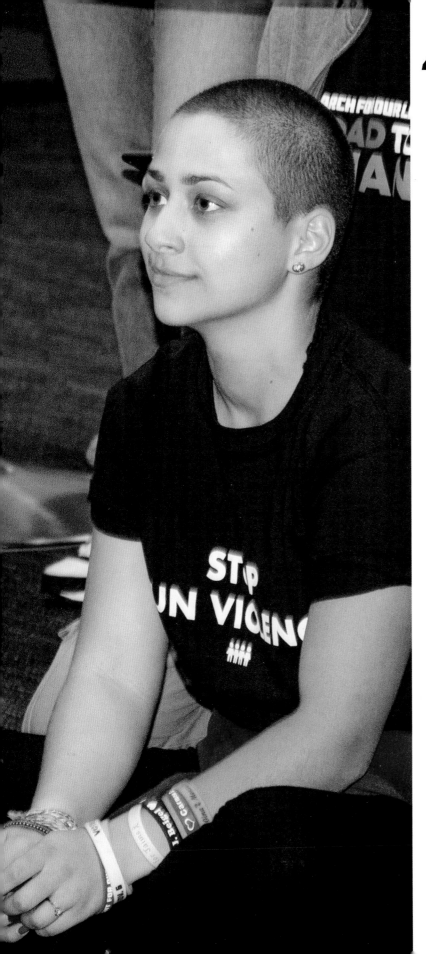

"We certainly do not understand why it should be harder to make plans with friends on weekends than to buy an automatic or semi-automatic weapon. In Florida, to buy a gun, you do not need a permit, and once you buy it you do not need to register it. You do not need a permit to carry a concealed rifle or shotgun.

You can buy as many guns as you want at one time. I read something very powerful recently. It was from the point of view of a teacher. And I quote: 'When adults tell me I have the right to own a gun, all I can hear is my right to own a gun outweighs your students' right to live.'

All I hear is mine, mine, mine, mine."

—EMMA GONZALEZ

Gun Control Advocate, Activist

Emma Gonzalez,
Vote for Our Lives Rally,
University of California Irvine,
2018

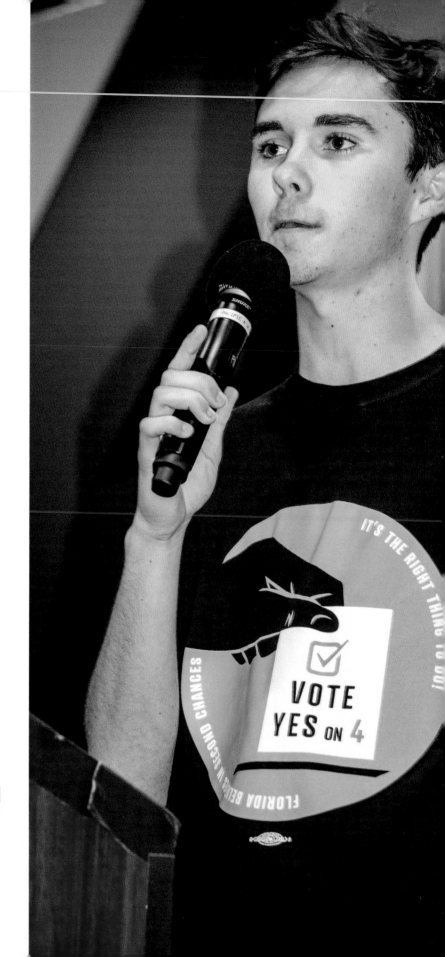

" Every day across America our young people are being killed from gun violence and other issues that affect us that nobody knows about. And every day when young people are being killed their names go unrecognized and untold and to that we say "No More." We are fighting for those who no longer can. We are fighting for the individuals whose names we don't know and none of us ever will, who are murdered and their names are never told. We are fighting for an America that, no matter where you live or who you are, you are a human being. Become involved today to vote for policies that won't get you killed tomorrow. "

—DAVID HOGG

Author, Gun Control Advocate, Activist

David Hogg,
Vote for Our Lives Rally,
University of California Irvine,
2018

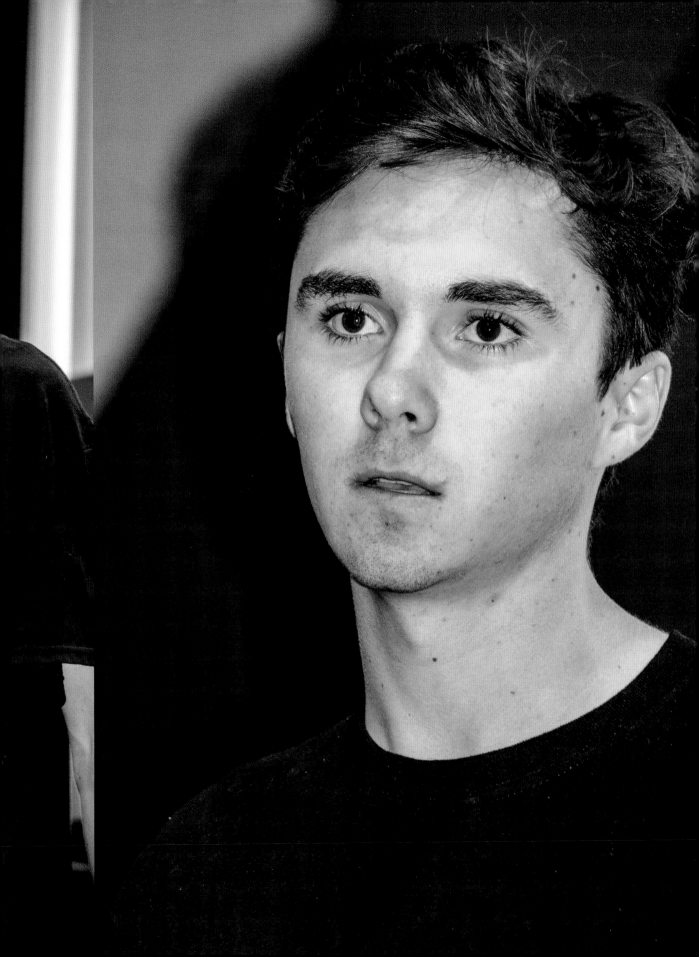

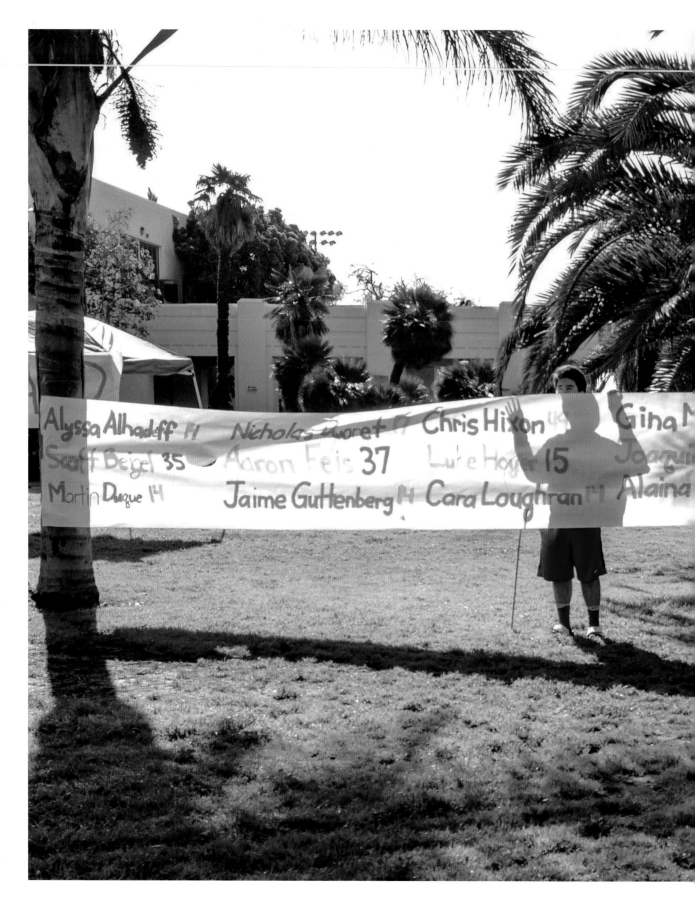

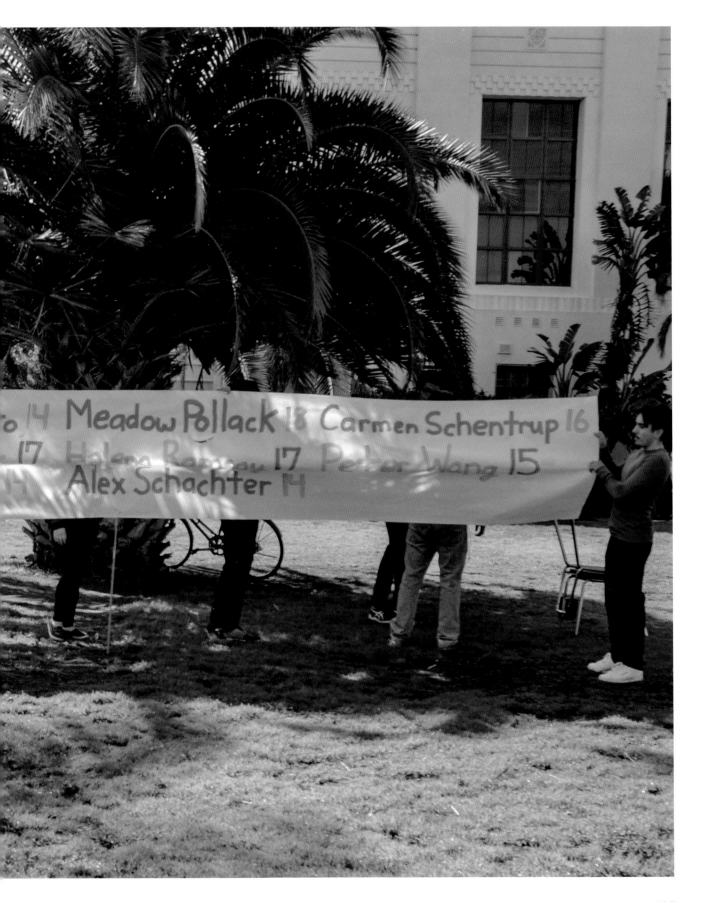

"On February fourteenth, my daughter and sixteen others were murdered in Parkland, Florida. A teenage boy with an AR-15 made his way into our school and created this carnage. Because of what happened to my daughter, I have dedicated my life to fighting for gun safety. I have been joined by other parents who have suffered the worst kind of loss and have not stopped fighting for safety and security. We have seen our amazing kids rise up and fight for their lives and their right to live free from gun violence as part of the March for Our Lives and other groups. The movement that started with the Parkland parents and the Parkland kids will lead to permanent change in our country. Together, we will reduce the gun violence death rate. With our voice and vote we can succeed in memorializing this effort that will spawn new generations to come with lives that are saved."

—FRED GUTTENBERG

Founder, Orange Ribbons for Jaime

OPPOSITE · Parkland Poster by Gracie Lee Art, Anniversary Commemoration, Los Angeles, 2019
PREVIOUS SPREAD · Commemoration of Parkland Students, Venice High School, Venice, California, 2018

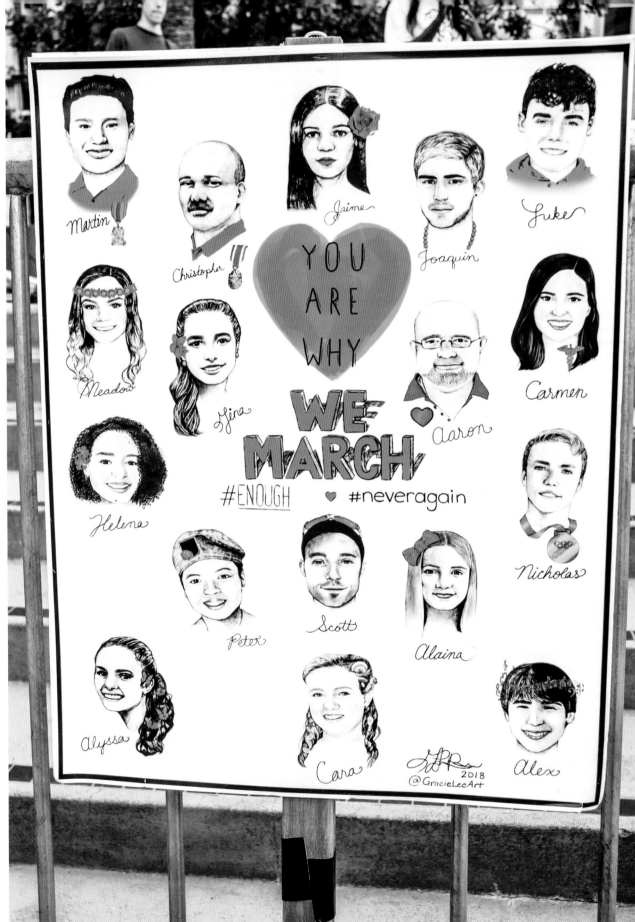

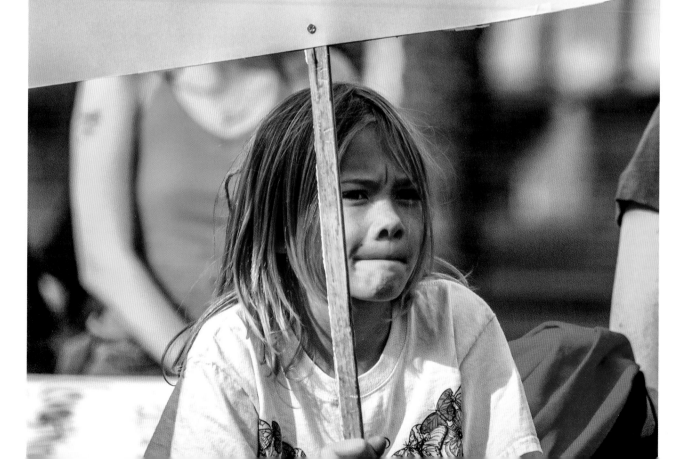

ENVIRONMENT Our planet is at a tipping point. Young people from around the world are no longer waiting for the adults. They are not mired in backroom politics. They have one goal: to save the future. This is their time to pivot. Young planet hawks are inspiring global action to drive sustainability: The environmental justice nonprofit Community Water Center acts as a catalyst for clean water solutions in California. Creative Visions Foundation has launched Planet 911, a dynamic coalition of environmental organizations working with youth to generate greater awareness. Art Miles Mural Project has brought together muralists from around the world to depict renewable solutions. The fight to stop global warming includes groundbreaking legislation such as 'the Green New Deal' that will create millions of new green jobs and reverse the current trend of inaction from compromised politicians. Twenty-one young people in America are moving their protest into the courtroom with the youth climate lawsuit Juliana v. United States. Their claim against the US government is that access to a clean environment is a fundamental right. Today's younger generation is joining with climate scientists and their adult mentors to persuade all of us to make choices that diminish our carbon footprint.

OPPOSITE & FOLLOWING SPREAD · Youth Climate Summit, Phoenix, Arizona, 2019

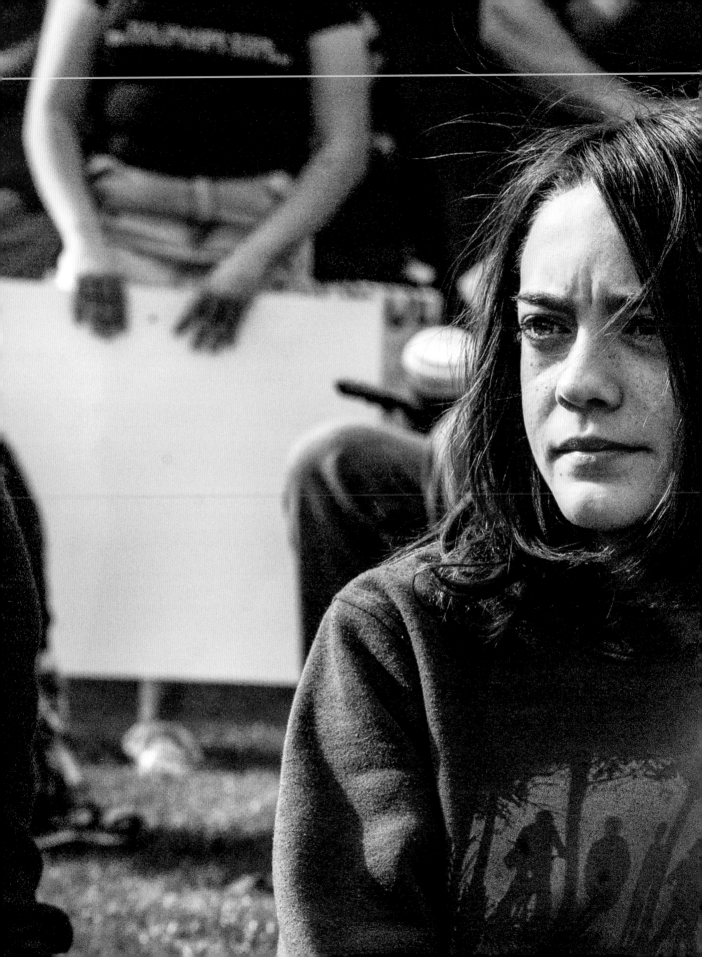

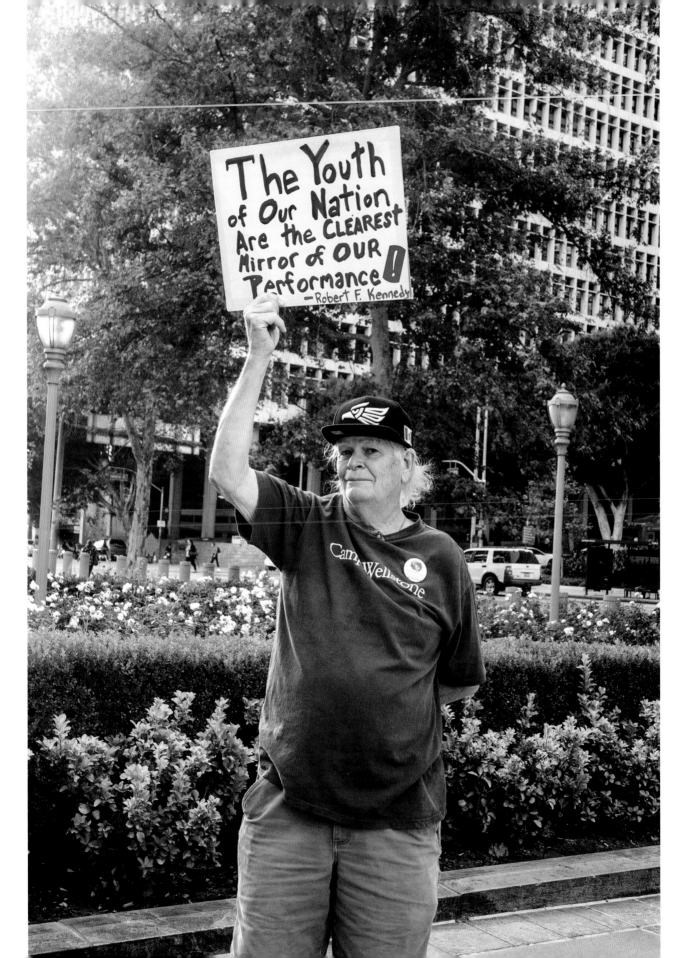

"At eighteen, I signed on as a plaintiff in the landmark climate change lawsuit Juliana vs. U.S. The destruction of the environment is not an issue of legislation like some once thought. It is an issue of our constitutional rights—our rights to life, liberty, and property that cannot be upheld without a stable climate system. We are insisting that the government bring climate science into climate policy and implement a plan to bring greenhouse gases in the atmosphere to a stable level by 2100. If we win, this case will set a precedent for connecting the effects of climate change with constitutional rights. This will pave the way for further action to preserve the resources and climate system we all need. Of the twenty-one youth plaintiffs, we have young people from Florida to Alaska, from preteens to early twenties, indigenous youth and youth of color, all who are facing the real threats of climate change right now. To demonstrate the severity of the case, Dr. James Hansen has signed on to represent all future generations, so technically my co-plaintiffs include thousands of humans who don't exist yet."

—KIRAN OOMEN

Twenty-Two-Year-Old Plaintiff, Juliana v. United States (Our Children's Trust Lawsuit)

OPPOSITE · Protest to Rally Support for the Our Children's Trust Lawsuit, Los Angeles, 2019

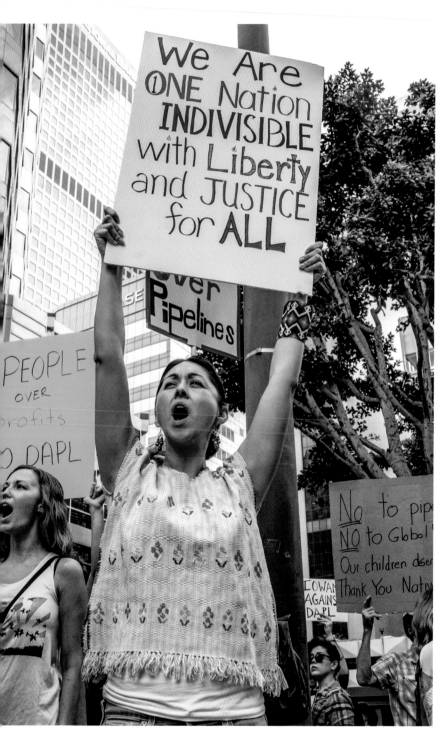
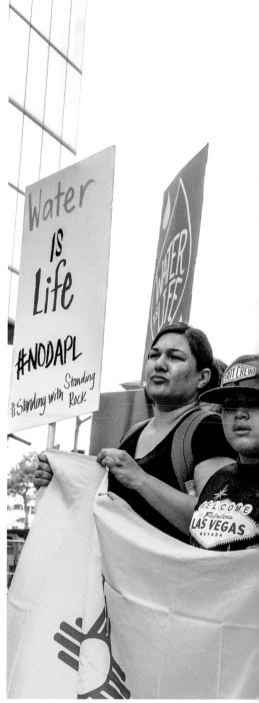

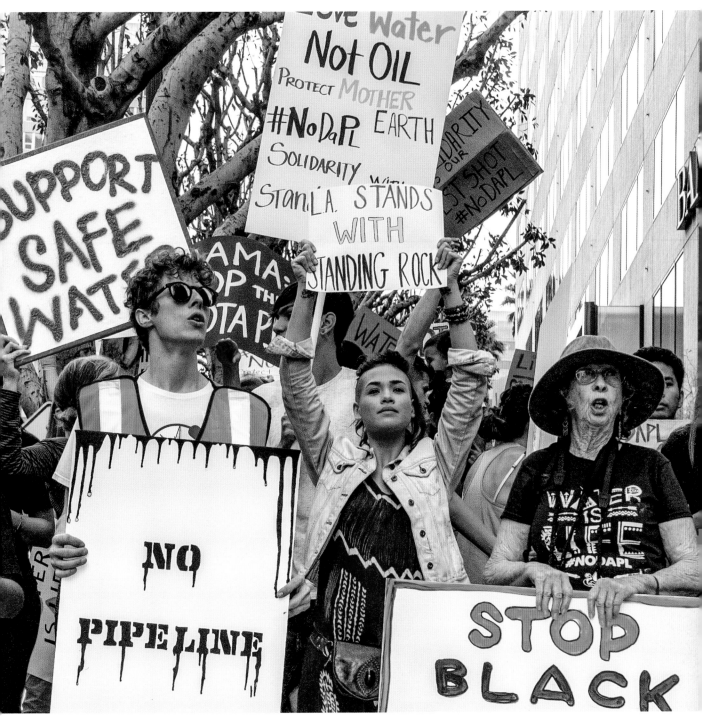

OPPOSITE & ABOVE - Rally for Standing Rock, Los Angeles, 2016

207

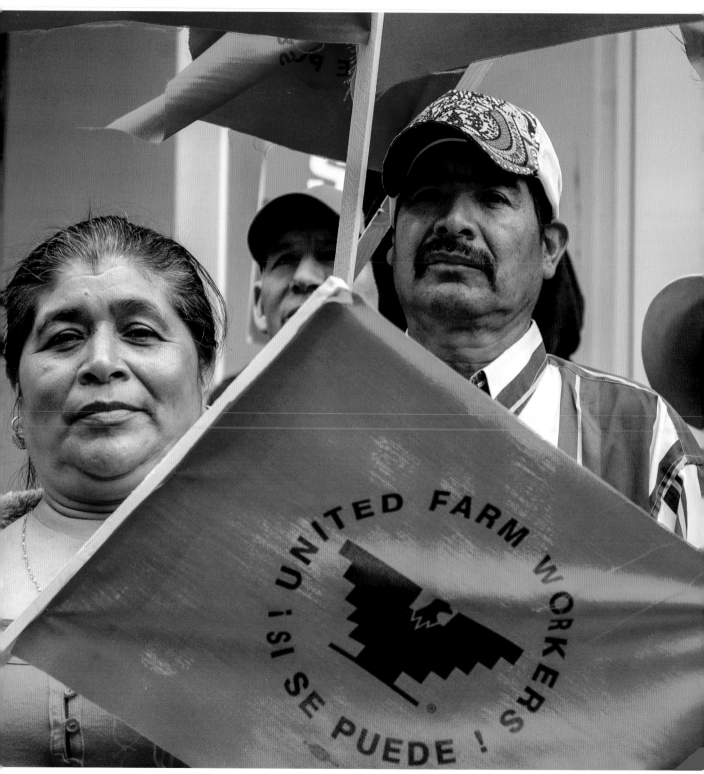

Farm Workers Rally, Los Angeles, 2013

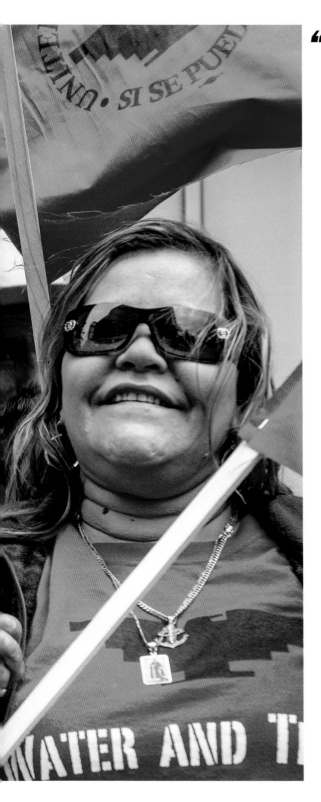

"My activism career began by focusing on issues of environmental racism that were adversely impacting the large population of Mexican immigrant farmworkers in Oxnard. My family was among them. Agricultural fields surrounding this community are still laced with pesticides, a towering power plant sits on the beach, and a toxic superfund site exists less than a half-mile away, polluting the last remaining natural wetlands in Southern California. At that time, a multibillion-dollar mining corporation, BHP Billiton, had proposed a Liquefied Natural Gas facility fourteen miles off the coast near my community. As the organization spokesperson, and only sixteen, I represented my community, opposing the project, by giving testimony to two state agencies at the main hearings, mobilizing people to take action. We won the battle, defeating the richest mining corporation through the political process, concluding with a bill in the state legislature, signed by the governor."

—ERICA FERNANDEZ

Twenty-Seven-Year-Old, Director of Organizing, Community Water Center

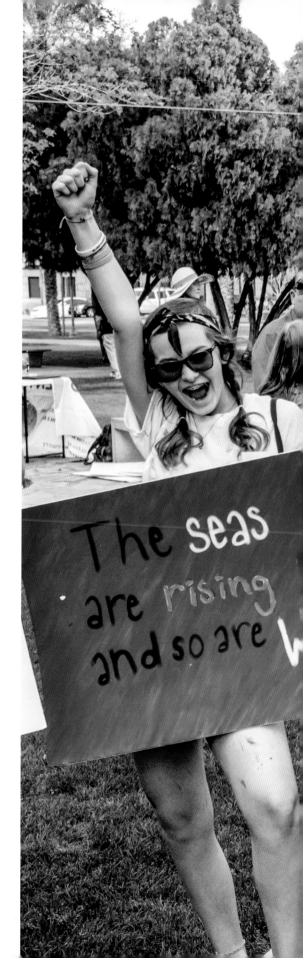

"My heart was broken when my son Dan, twenty-two, was killed in Somalia while working as a photojournalist for Reuters News Agency. To celebrate his spirit, in 1998, my daughter Amy Eldon Turteltaub and I launched Creative Visions to support "creative activists" like Dan, who use media and the arts to tell stories that need to be told about problems that need to be solved. Harnessing the power of the arts, science, education, and social influence ignites positive change and inspires results. It is today's young visionaries who are rising up as one to demand a healthy, happy future for all the children of the planet."

—KATHY ELDON

Founder and CEO, Creative Visions Foundation

Youth Climate Summit,
Phoenix, Arizona, 2019

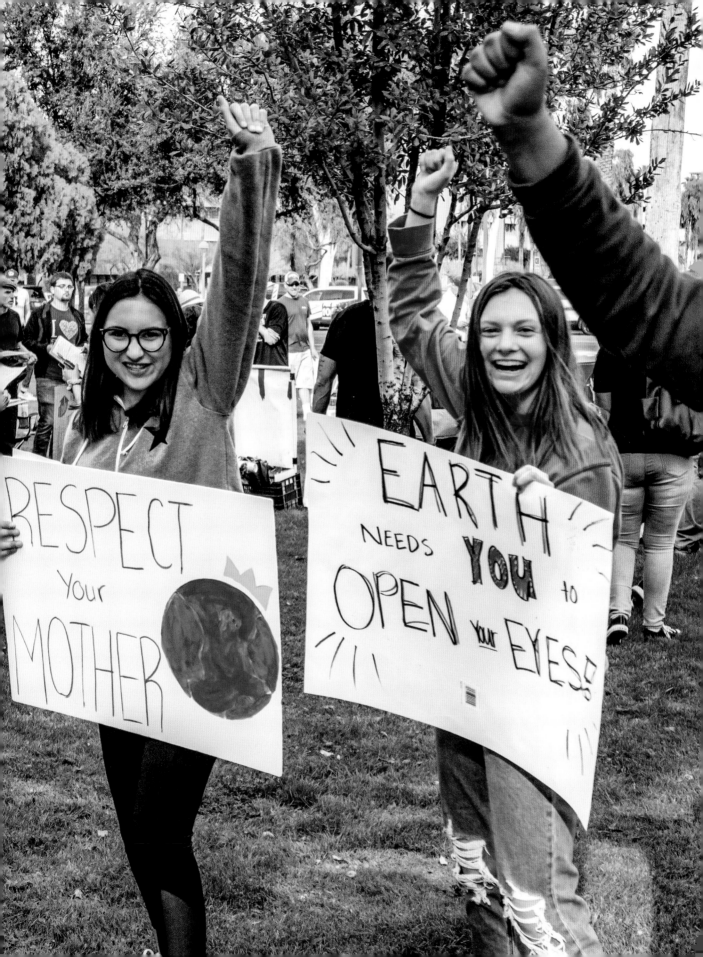

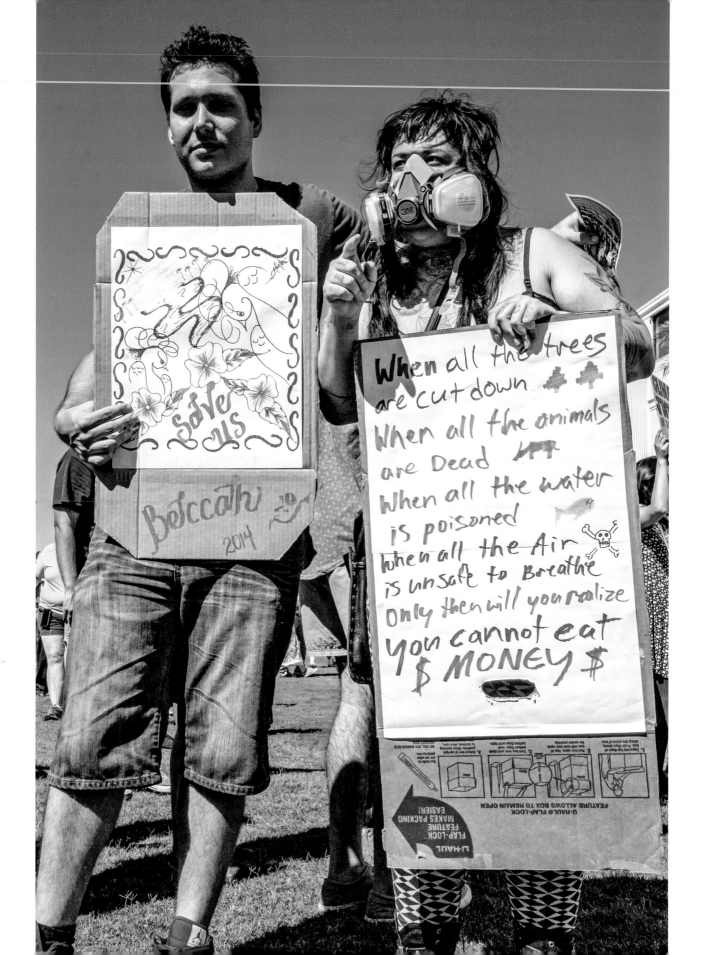

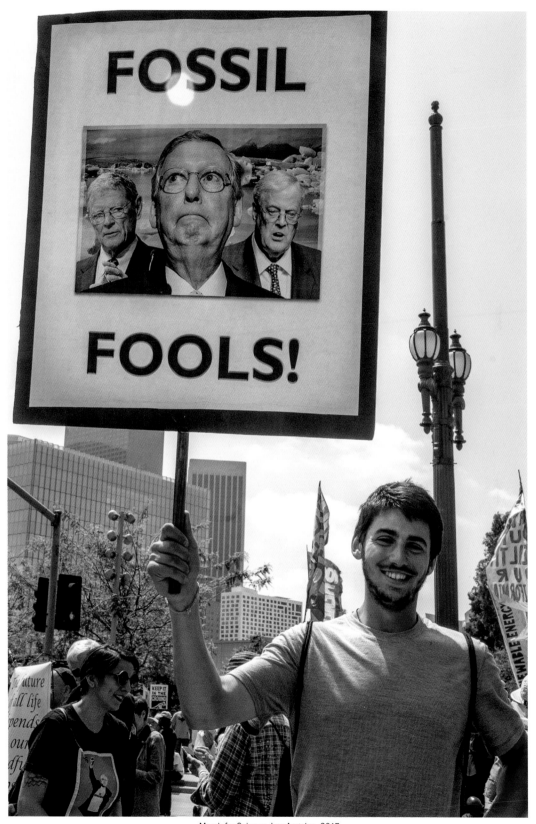

March for Science, Los Angeles, 2017
OPPOSITE - Earth Day Rally, San Diego, 2015

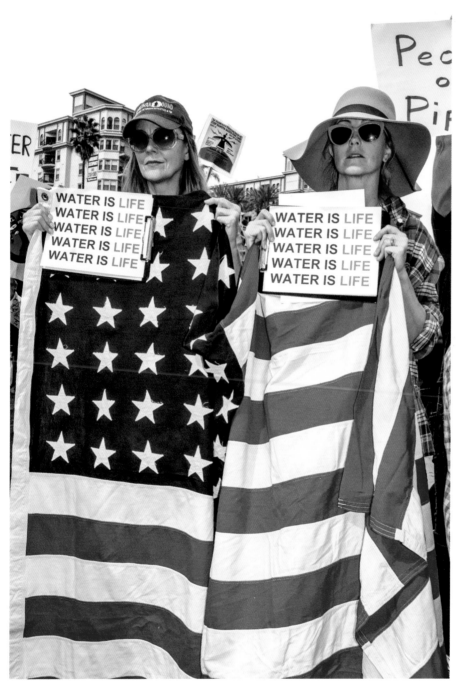

Rally for Standing Rock, Los Angeles, 2016
OPPOSITE · Earth Day Rally, San Diego, 2015

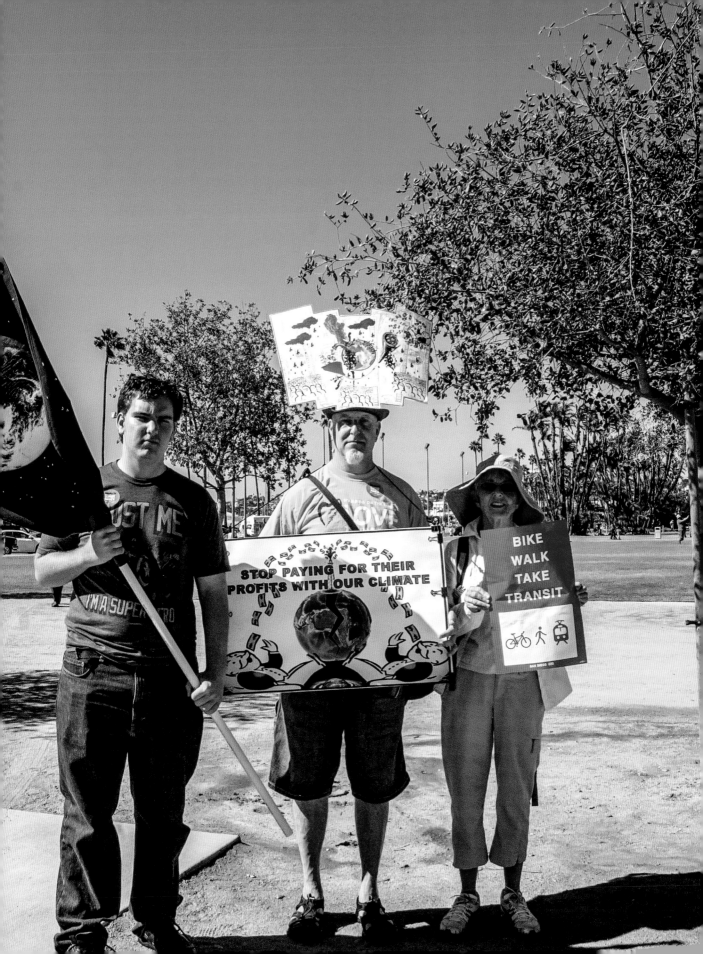

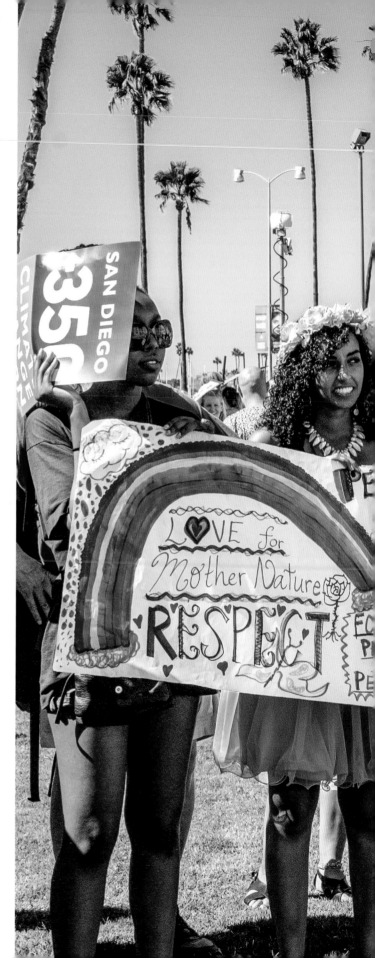

"Greta Thunberg is the Swedish schoolgirl with Asperger's who started Youth4Climate, a worldwide movement in which an estimated 1.6 million young people from over 120 countries left school to protest for our planet. I was one of those students in the U.S. who protested and recognize how important it is for each person to use their vote, protest, and everyday actions to make a difference. When I saw people throwing litter on the ground directly in front of our protest to mock our movement, my desire only grew stronger to make a change. That's why my friends and I carefully checked our birthdays to be sure we could vote in the next election. If we don't vote and protest for what we believe in, our future may not be worth living for."

—SPENCER GREENFIELD

Student Protester from New Jersey

Earth Day Rally,
San Diego, 2015

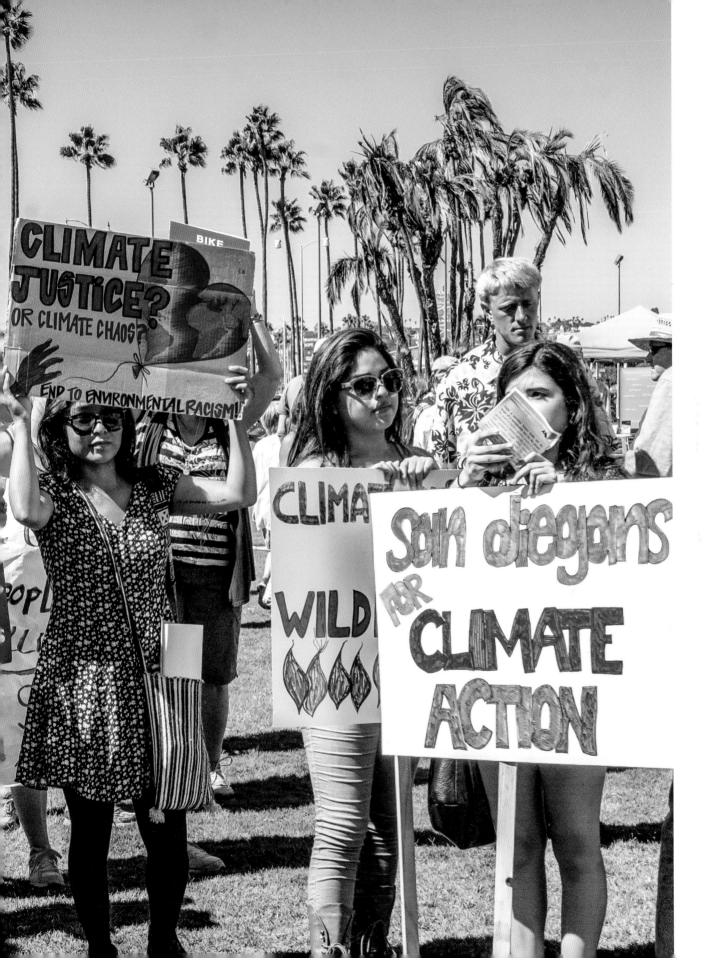

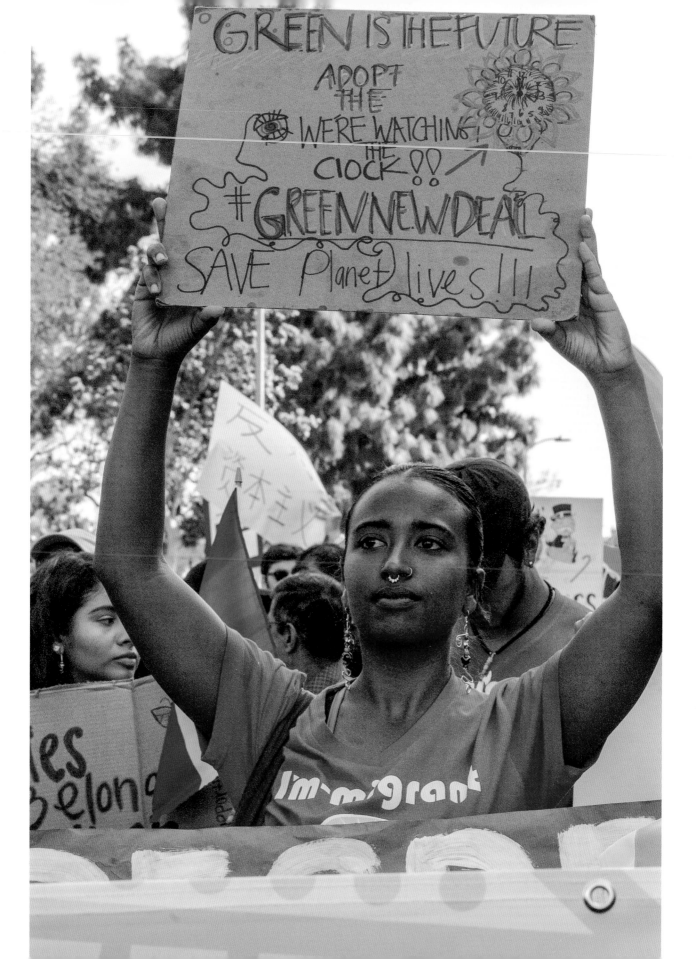

"Science and God both accept that there is only one race, the human race, yet we somehow manage to divide ourselves in fear based on skin color and cultural ideology. For those of us who participated in the struggle for human rights, we are stunned to see where we are today with the rise of fascism, cultural wars, economic and health disparities. My father's generation of the civil rights movement and my generation of "No More War" lulled ourselves into a status-quo stupor and let the baton drop . . .

But there is an awakening occurring and we must once again garner our energy to support 'Generation Enlightenment.' You may label them millennials, generation XYZ, or just young folk, but they see through the negative construct and realize that we are all one race and if we don't work together there will be no race. They are very justifiably angry and not afraid. On their own they have picked up the baton to save our future; from climate change to xenophobia, their voice will be heard. We need to focus our energy not on our differences or our disappointments but rather to help create systemic hope; that positive change, economic balance, and human equality will overcome."

—ADRIENNE BELAFONTE BIESEMEYER

Cofounder of Anir Experience, Psychologist, Philanthropist

OPPOSITE · May Day Rally, Los Angeles, 2019

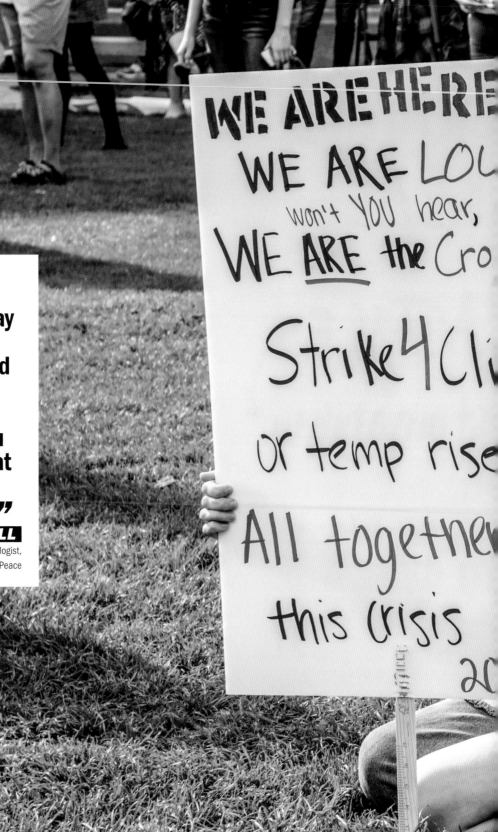

> **"You cannot get through a single day without having an impact on the world around you. What you do makes a difference, and you have to decide what kind of difference you want to make."**
> **—DR. JANE GOODALL**
> Primatologist, Anthropologist,
> United Nations Messenger of Peace

Youth Climate Summit,
Phoenix, Arizona, 2019

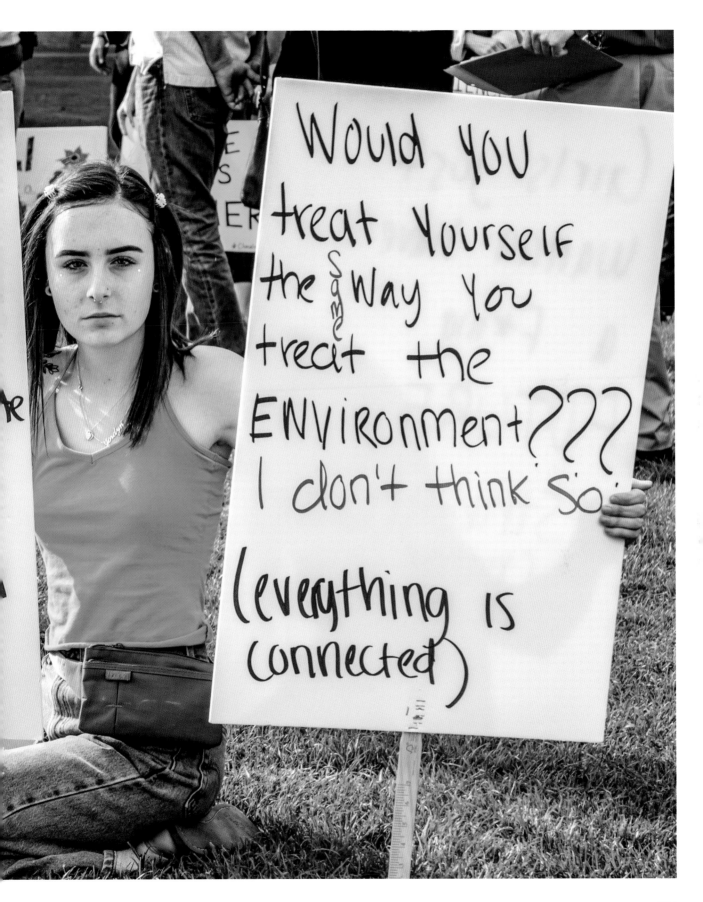

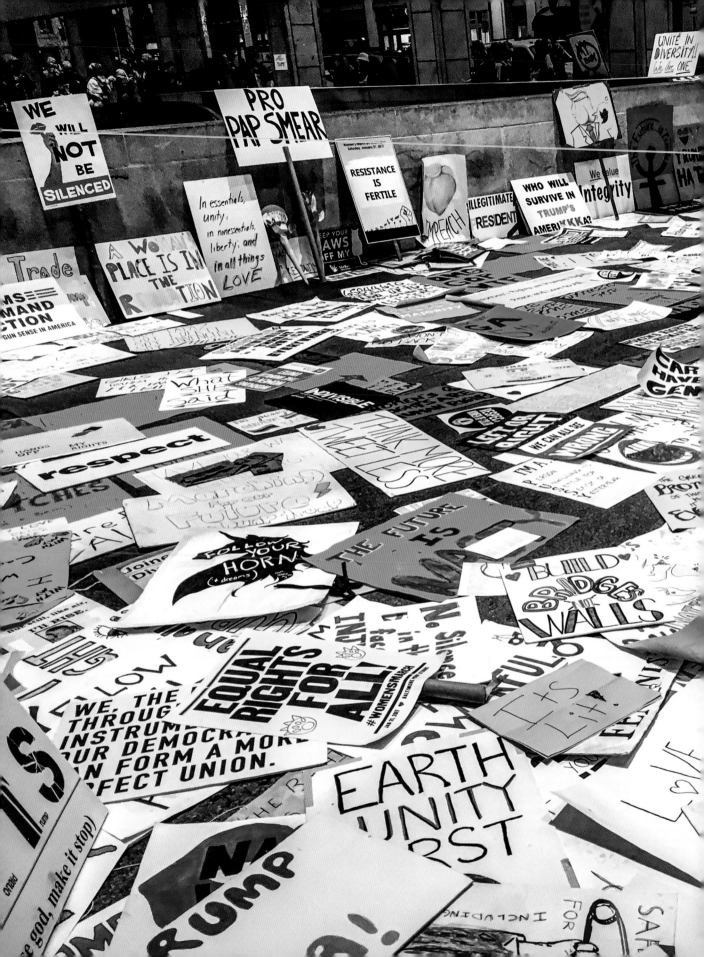

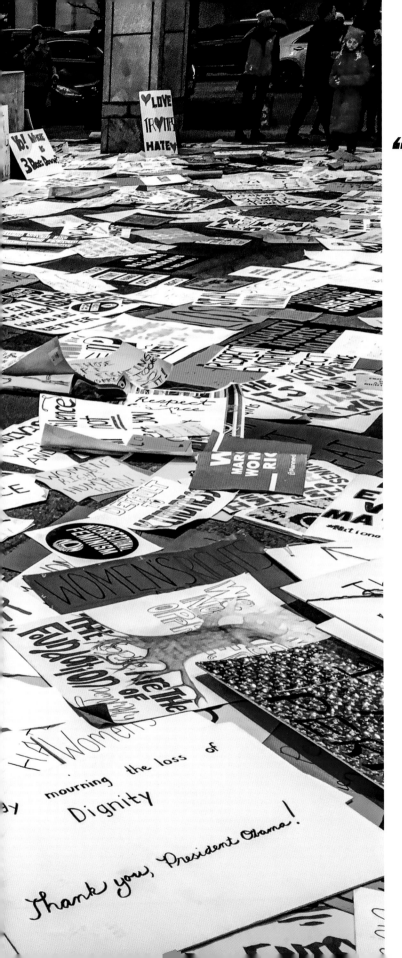

"We are in the last throes of our survival if we don't change the way we live. We are going to lose this great beautiful ball of life. Planet Earth is truly a gift to the universe. Go out to your place of nature. Take a cup and pour water into it. Place it before you and put your intentions into that water. Offer your prayers to all of humanity. It doesn't matter what color skin you are or what faith you believe in. You always come back to that place. It is life. We can create life or we can destroy life. We look at ourselves. Who are we? Where did we come from? And most important, where are we going? Am I going alone or are we going together? When we think of we and we think of us there is nothing we cannot do."

—NORMAN PATRICK BROWN

Navajo Leader, Filmmaker

Metro Station After Women's March,
Washington, DC, 2017

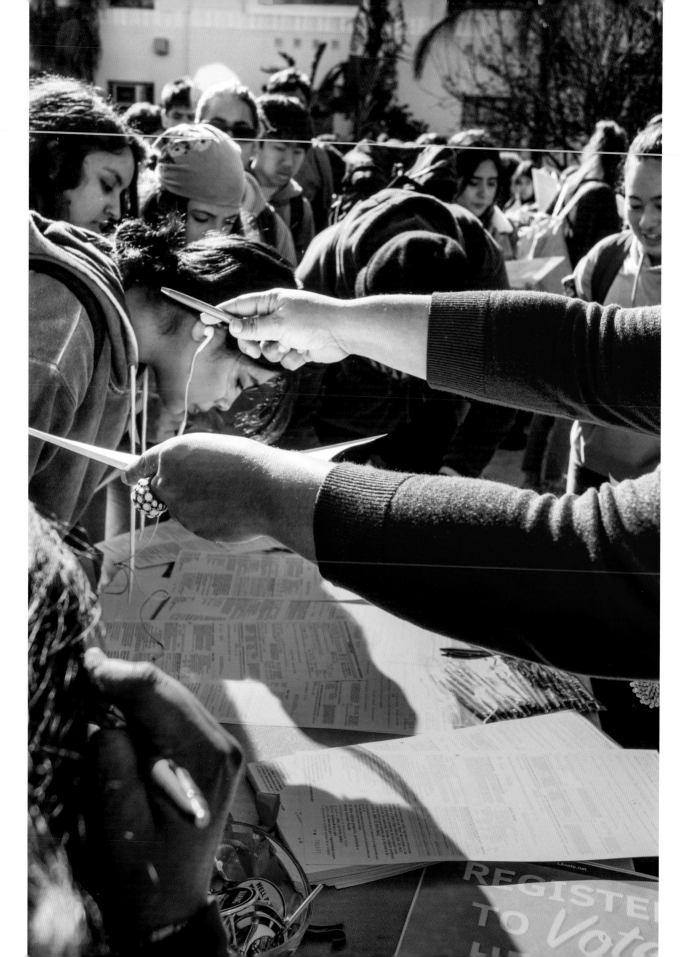

VOTING RIGHTS Our ultimate protest is at the ballot box. We have learned that elections have consequences. Across the United States we are seeing a resurgence in voter registration that produced historic results in 2018. First, women marched, then women ran for office—and because of the unparalleled voter turnout, over 110 women are now legislating in Congress. The most in history.

The March for Our Lives leaders are helping to create record-breaking voter registration for young, first-time voters. Citizen watchdog groups are in every community to help register voters, warn the people of what problems they may encounter, try to stem voter suppression, and identify polling places. No matter one's politics, Americans can all agree that they want to believe in the sanctity of our elections. The best way to make change happen is to vote.

OPPOSITE · Get Out the Vote, Venice High School, Venice, California, 2018

"When you vote, good things happen.

When you vote, you have the power to make sure we strengthen laws to protect women in the workplace from harassment and discrimination. When you vote, you have the power to make sure they are paid equally.

When you vote, you have the power to make it easier for a student to afford college or make it harder for a disturbed person to shoot up a classroom.

When you vote, you have the power to make sure a family keeps its health insurance. You can save somebody's life. That power rests in your hands. Yes you can.

I want to talk about young people. I tell my daughters sometimes that your generation is the one that is going to determine the direction of America for the next fifty, sixty, seventy years. And right now too many young people don't vote.

The good news is, I'm hopeful. I see a great awakening of citizenship around the country right now. I can't tell you how encouraged I have been watching so many people involved for the first time. They are organizing. They are marching. They are making calls. We have a movement of citizens out there. And remember, the antidote to everything you don't like is you voting."

—BARACK OBAMA
Forty-fourth President of the United States

Barack Obama,
University of Nevada,
Las Vegas, 2018

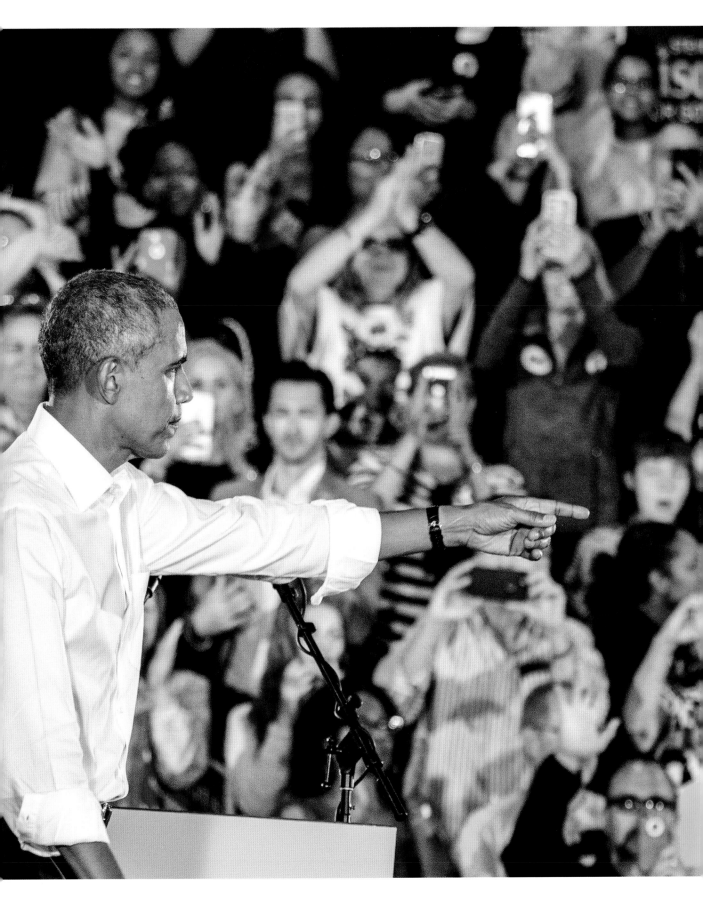

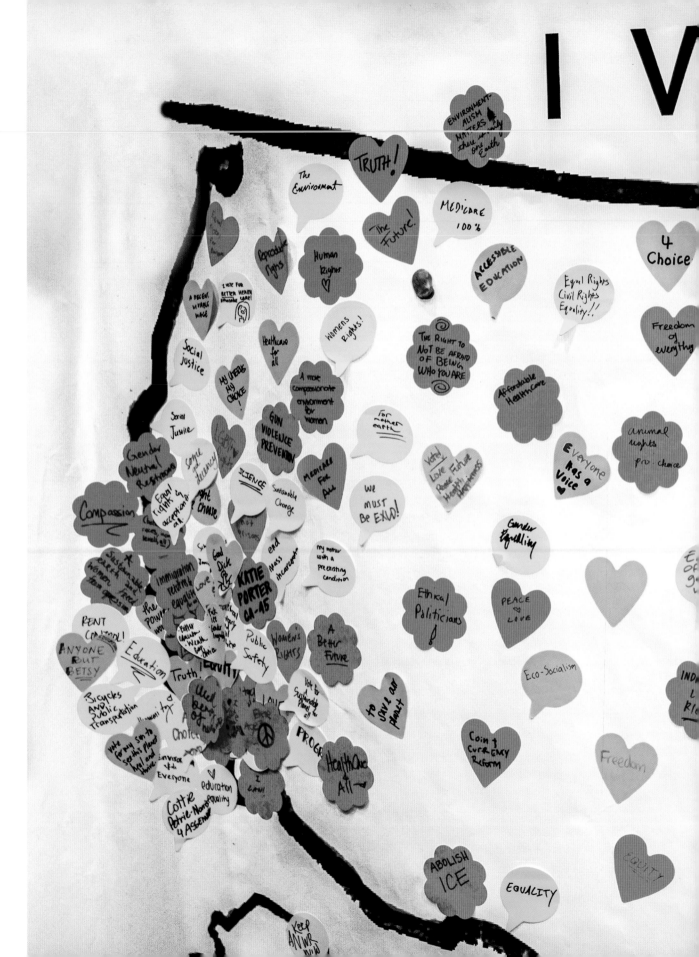

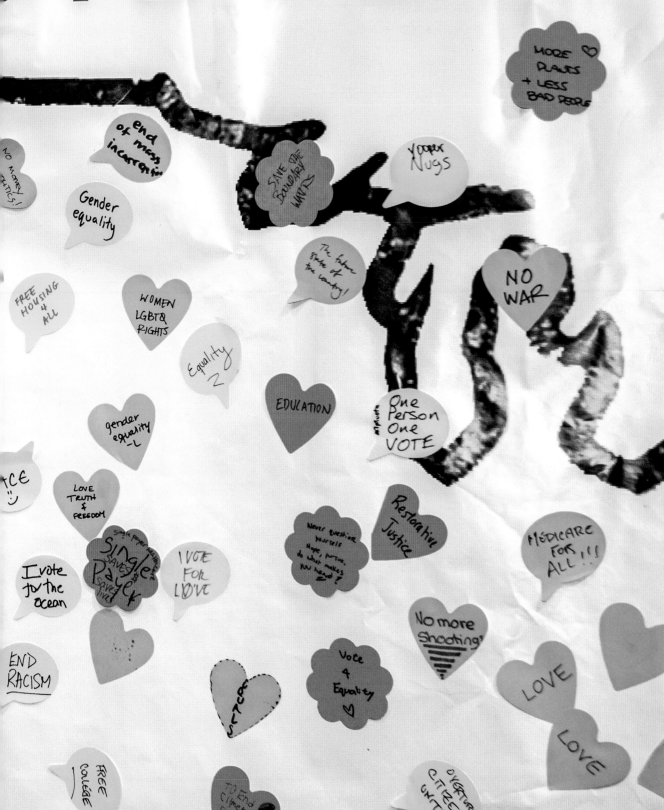

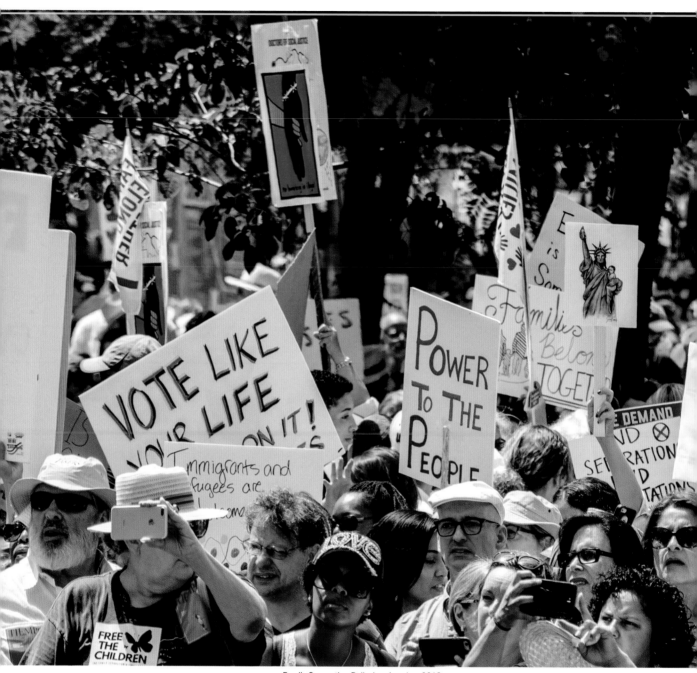

Family Separation Rally, Los Angeles, 2018
PREVIOUS SPREAD · Vote for Our Lives, University of California Irvine, 2018

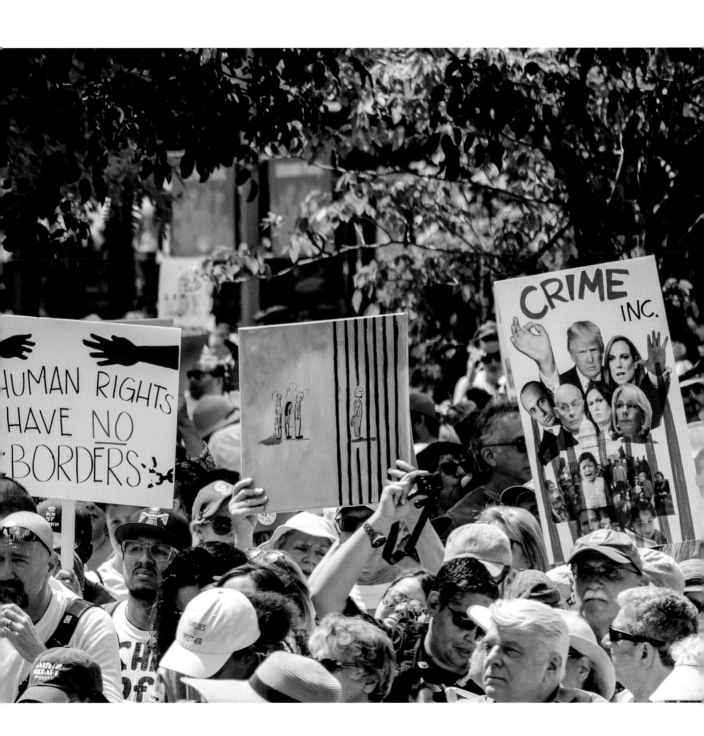

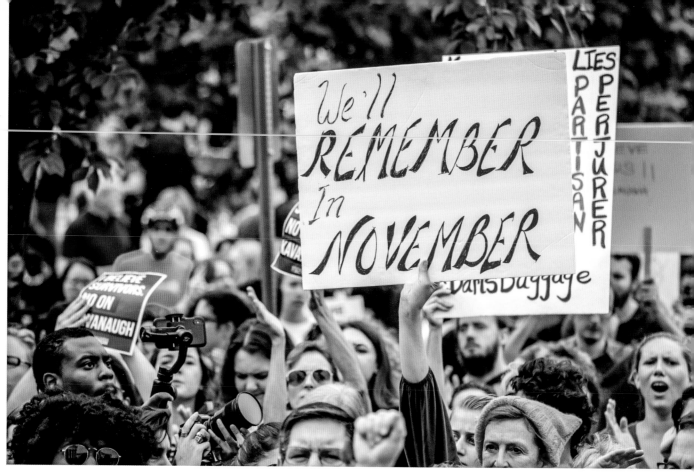

ABOVE, BELOW & TOP OPPOSITE · Kavanaugh Protest, Washington, DC, 2018

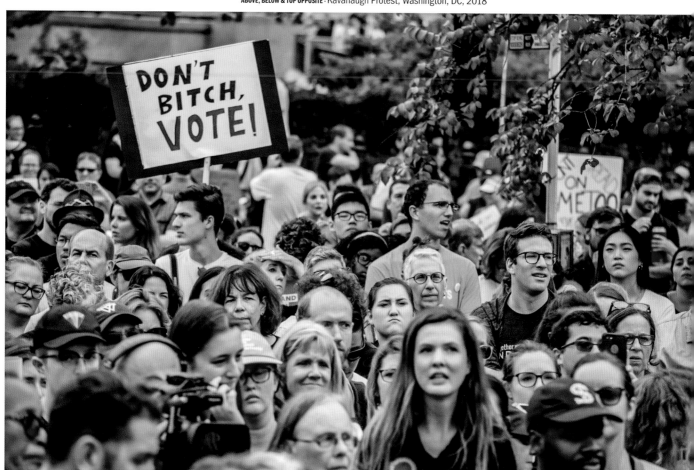

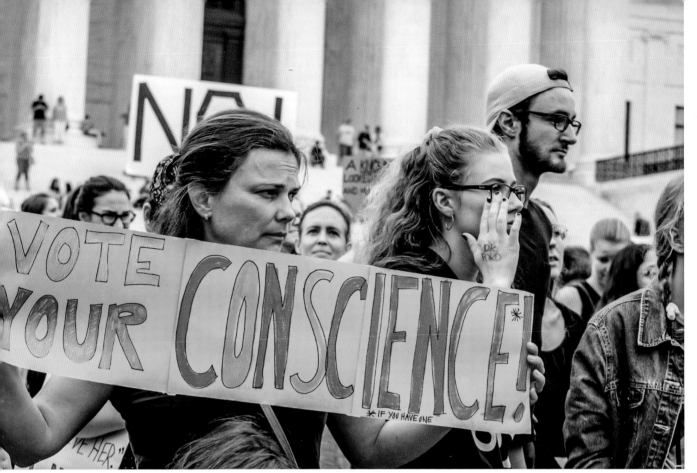

BELOW - Women's March, Washington, DC, 2019

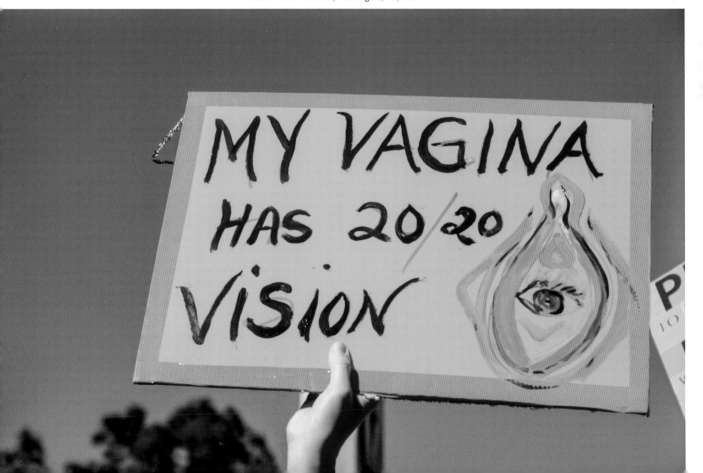

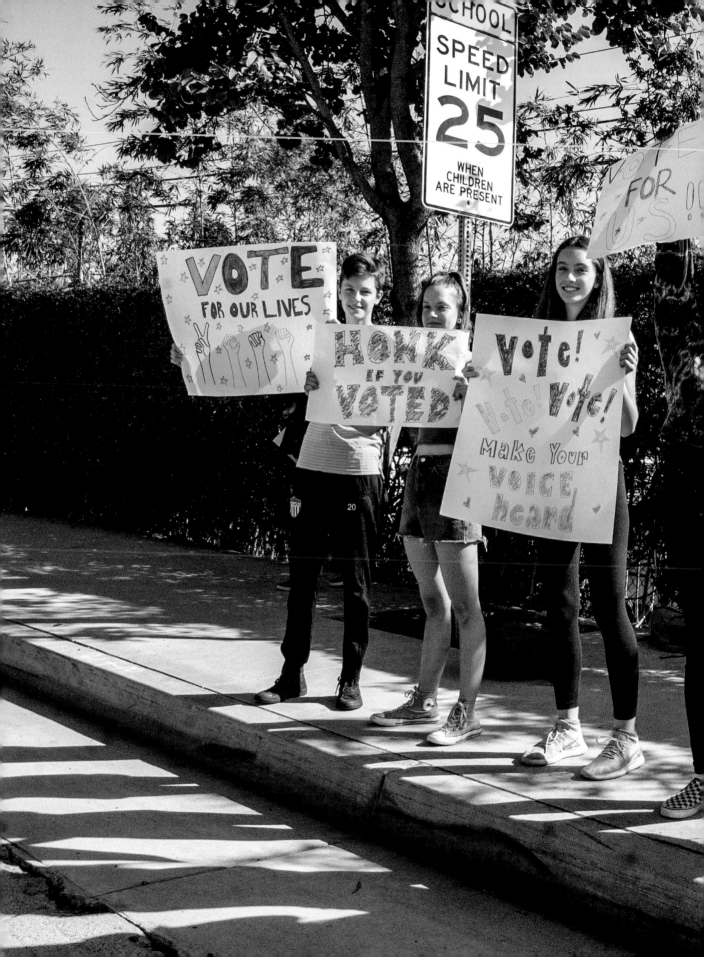

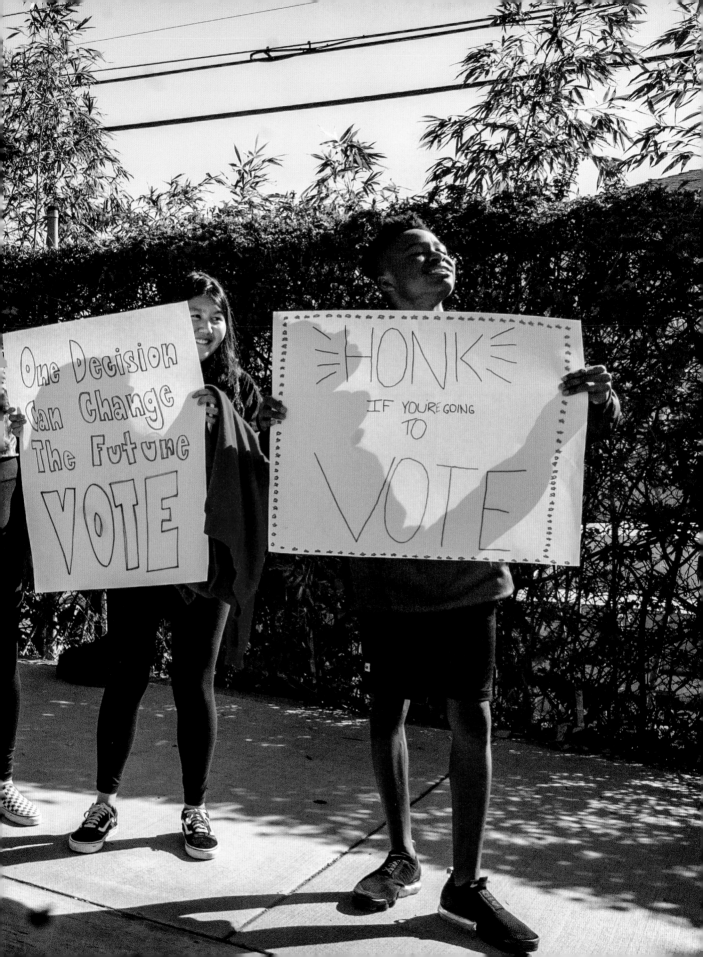

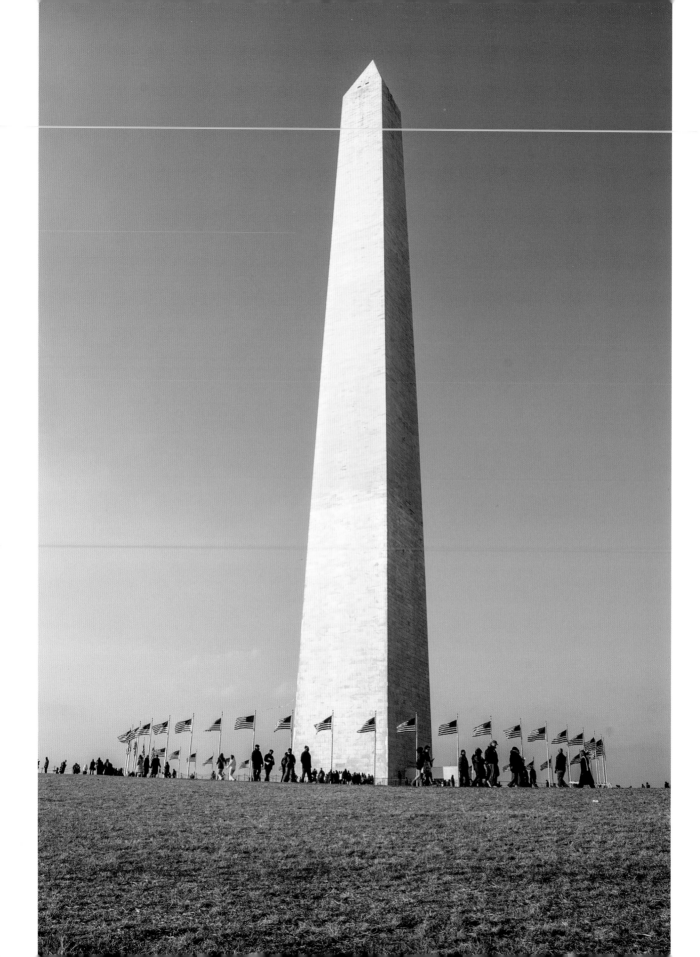

NOTES FROM THE TRAIL

Since the election of our forty-fifth president, we have learned a lot about ourselves as Americans. We have seen how powerful our collective voices are. We are energized by a renewed commitment to stand up and fight for what we believe in. For more than twenty years I have photographed demonstrations where people have come together for a range of issues to demand political action from our elected officials. Over the last three years, growing numbers of new faces have appeared in these crowds, from the very young to the very old.

When interviewed on my podcast, well-known actor and activist Martin Sheen told me: "We came out of the '60s with a sober realization that if you believe in anything of value, it is going to cost you something or you are left to question its value. And it has to be a personal fight, because if it is not personal then it is impersonal, and if it's impersonal then who cares?"

Americans are passionate about what they believe in. The issues come and go, but it is the people I have encountered along the way that fill me with hope for America's journey forward. I met a ninety-eight-year-old woman late in the day at the Women's March in Washington, DC. She told me she was by herself and came from Ohio on a Greyhound bus. On her fixed income, this was an extra expense. She told me that she had never protested before. She wanted me to know that she didn't like the direction our country was going in and couldn't just sit at home and complain. This elderly woman epitomizes the spirit of activism that millions of Americans are embracing to advance change and promote a just society. The ability to protest is a core part of our democracy. The First Amendment endures, allowing us to boldly come together to express our ideals. May *We Protest: Fighting for What We Believe In* be a constant source of inspiration for us to always defend what Abraham Lincoln described as a "government of the people, by the people, for the people."

—TISH LAMPERT
Photojournalist, Writer,
Host of *America Speaks* Podcast

OPPOSITE - Washington Monument, Peace Protest, Washington, DC, 2008
PREVIOUS SPREAD - Get Out the Vote Demonstration, Outside Crossroads School, Santa Monica, California, 2018

"**The Human family can no longer afford to resist the fullest embrace of peace. Without such an embrace, especially in these critical times, we are ensuring humankind's extinction.**"
—HARRY BELAFONTE
Singer, Songwriter, Actor, Activist

Youth for Peace Rally,
Denver, 2008

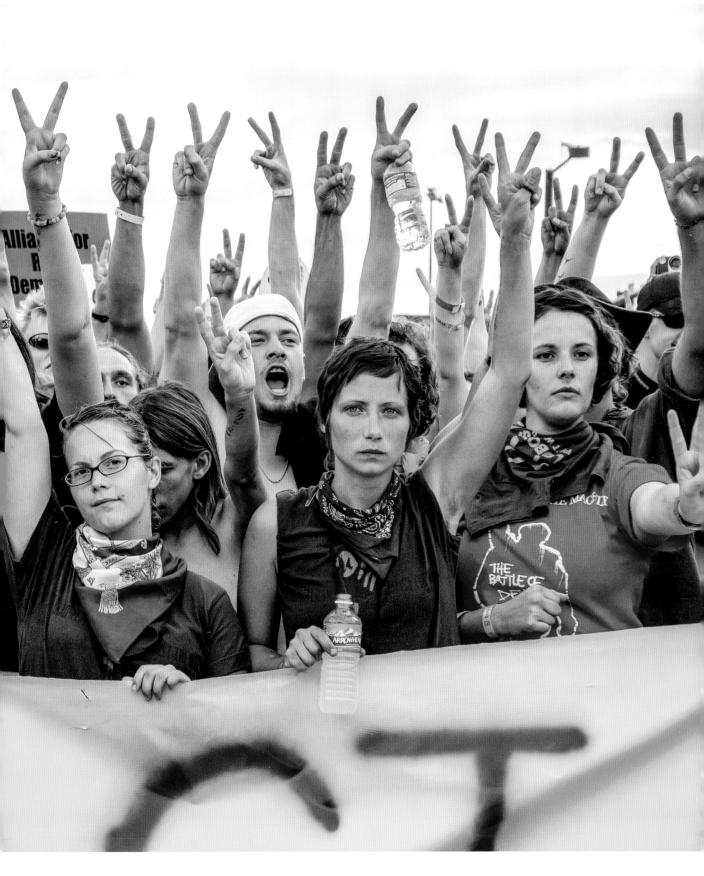

With deep gratitude:

To my literary agent, George Greenfield, for his belief in my work, inspired guidance, devotion to great storytelling, and creative partnership.

To my husband, James Coblentz, for his encouragement and enduring support on my journey to document what is important to me.

To my daughters, Cassandra Coblentz and Alexa Coblentz, for reminding me to focus on the everyday heroes I have met along the way, to stay curious, and to trust my instincts.

To my creative team, who have devoted imagination, insight, and an abundance of time sifting through mountains of imagery, interviews, and commentary: Deirdre Lenihan, literary advisor and content consultant, and Khodr Cherri, photographic consultant, master digital expert, and printer.

To Charles Miers, Rizzoli's publisher, who shared my vision for this project, for his unwavering support to publish this book.

To Martynka Wawrzyniak, Rizzoli's editor, Jan-Willem Dikkers, the book's designer, and Megan Conway, the copy editor: it has been a pleasure to collaborate with each of you on the production of this book.

To my fellow muckraker Dennis McDougal.

To those all across the country who have shared this activist journey with me. Each of you have contributed to this body of work in distinct and amazing ways: Mark Suroff, Kathy Eldon, Emilia Mendieta, Carol Simone, Joan Scoccimarro, Maggie Walker, Linda Posnick, Lori Zamel, Rich Whitley, Kathi Austin, Keith Jeffreys, Lindsey Spiak, Thomas Fay, Phil Goldner and A&I, Kim Langbecker, and Koda.

To Rick Cummings, whose patronage and generosity continues to give me the opportunity to create work.

To all the Americans I have photographed over the years, for their spirit, their willingness to fight for what they believe in, their resistance, and their determination in the face of those who seek to silence their voices.

First published in the United States of America in 2020 by Rizzoli International Publications, Inc.
300 Park Avenue South
New York, NY 10010
www.rizzoliusa.com

Copyright © 2020 Tish Lampert
Foreword © David K. Shipler

Publisher: Charles Miers
Editorial Direction: Martynka Wawrzyniak
Design: Jan-Willem Dikkers
Production Manager: Colin Hough Trapp
Managing Editor: Lynn Scrabis

2020 2021 2022 2023/ 10 9 8 7 6 5 4 3 2 1

Distributed in the U.S. trade by Random House, New York

Printed in Italy

ISBN: 978-0-8478-6795-0

Library of Congress Control Number: 2019945650

Visit us online:
Facebook.com/RizzoliNewYork
Twitter: @Rizzoli_Books
Instagram.com/RizzoliBooks
Pinterest.com/RizzoliBooks
Youtube.com/user/RizzoliNY
Issuu.com/Rizzoli

We Protest is dedicated to Sharon Viljoen